ABSTRACTION

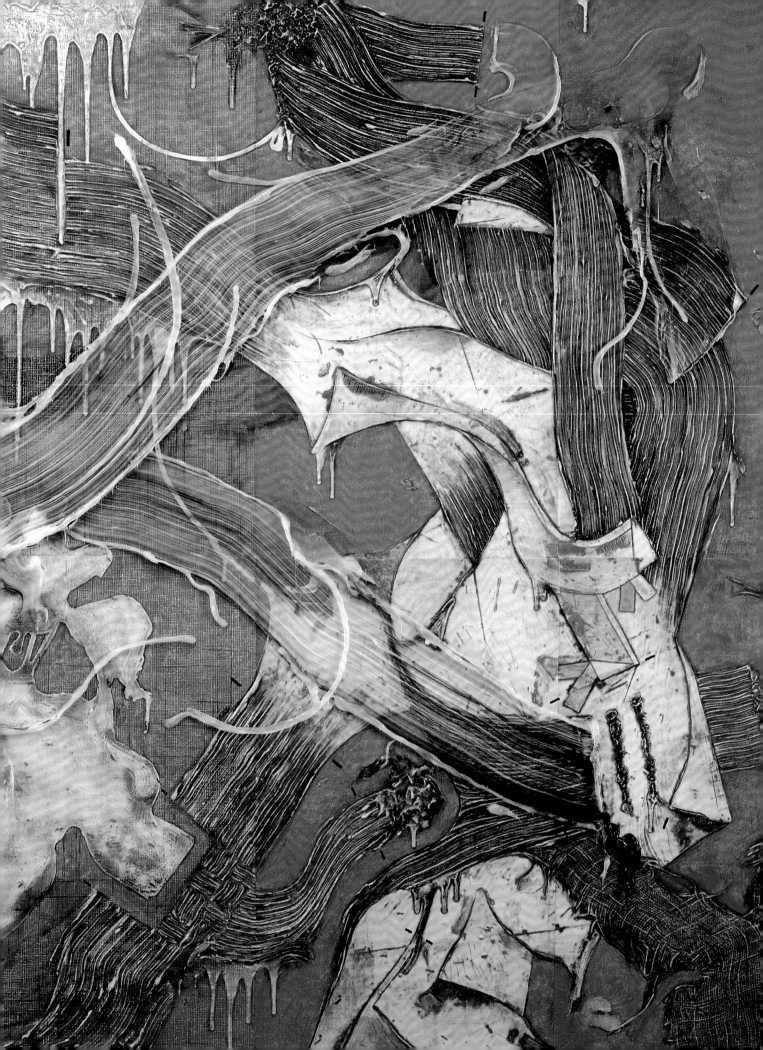

JPVA

JOURNAL OF PHILOSOPHY AND THE VISUAL ARTS NO 5

ABSTRACTION

Edited by Andrew Benjamin

 ACADEMY EDITIONS

ACKNOWLEDGEMENTS

Visual material is reproduced courtesy of the following: pp8-15: Edition Traversière, Paris, we would like to thank Martine Saillard for her help; p8 (above): photograph Alain Longuet; p8 (below): photograph Studio Lemonnier; p11: Collection FRAC Nord-Pas-de-Calais, photograph Gilles Gustine; p12 (above): photograph Mic Lobry; p12 (below): photograph Pierrette Ayme; p14: Collection Crédit Lyonnais; p15: photograph Alain Longuet; p46 (above): Marc Jancou Gallery, London; p46 (below): Galerie des Archives, Paris; p65 Private Collection, United States; p66: courtesy of the architects; p68: courtesy of the artist, photograph Stephen White; p69 (above): courtesy of Max Protetch Gallery, New York, photograph Dennis Cowley; p69 (below): courtesy of Galerie Rolf Ricke, Cologne, Private Collection, Cologne; p70: courtesy of the architects; pp76-77: courtesy of the artist; pp80-81: courtesy of Bravin Post Lee Gallery, New York; pp6, 84-85: courtesy of Marlborough Fine Art, London; p89: courtesy of the artist; p92-93 Marc Jancou Gallery, London; p95 (above left): Collection Corcoran Gallery of Art, Washington, DC; p95 (above right and below) and p96: Galerie des Archives, Paris.

Front Cover: Lydia Dona, **Motors Of Desire And The Flow Of Peripheries** *(detail), 1994, oil, acrylic, signpaint on canvas, 122x122cm, Marc Jancou Gallery, London, (see also p93);*
p2: Fabian Marcaccio, **Between Titles** *(detail), 1993-94, oil, silicone gel on printed fabric, two panels: 199.4x310cm (160x199.4cm and 150x199.4cm), Bravin Post Lee Gallery, New York (see also p81)*

First published in Great Britain in 1995 by
Journal of Philosophy and the Visual Arts, an imprint of the
Academy Group Ltd, 42 Leinster Gardens, London W2 3AN
Member of the VCH Publishing Group
ISBN: 1 85490 402 7

Distributed to the trade in the United States of America by
St Martin's Press, 175 Fifth Avenue, New York, NY 10010

Printed and bound in Singapore

Contents

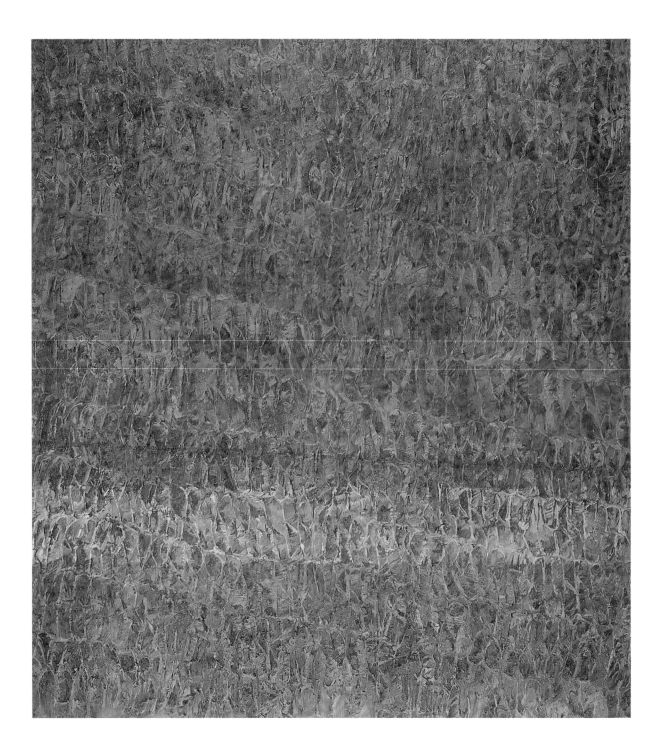

Thérèse Oulton, Transparence No 3, 1991, oil on canvas, 195.6x177.8cm

INTRODUCTION
Andrew Benjamin

The dominant interpretation of abstraction centres around the proposition that abstraction, as a movement in both art and architecture, is linked to modernism. The end of abstraction would therefore announce the advent of the post-modern. Contesting the claim about the end of abstraction – a claim whose force is tied with the claimed death of painting – is equally to contest the philosophical positions that offered the possibility of ends or which worked within the positing of an unequivocal distinction between the modern and the post-modern. The latter would have to be thought of as a development chartered within the frame of chronological time. The project of this the fifth issue of the *Journal of Philosophy and the Visual Arts* is to present the possibility of another conception of abstraction. As part of an overall intention of addressing the question of abstraction this issue will have three interconnected projects. The first is to allow for the argument that developments within abstraction have rendered the traditional theoretical and philosophical understandings of abstraction inadequate. The second will be to develop, in relation to contemporary abstract work, the theoretical and philosophical issues to which it gives rise. The third will be to show in what way these theoretical innovations – innovations sanctioned by responding to the work of abstraction – will allow for a reinterpretation of the tradition of abstraction. Central to this project therefore will be developing an alternative conception of the art object. While these developments are philosophical in orientation they will touch on wider concerns such as the relationship between different forms of art work.

The impetus for this project comes from two interrelated sources. In the first instance it arises out of the impossibility of maintaining philosophically the conventional construals of modernism and post-modernism and with them their philosophical basis. It is thus that the dominance of a Kantian legacy mediated through the art criticism of Greenberg and which still finds favour in the criticism surrounding painting and in particular abstraction, has been displaced in favour of philosophical positions that take becoming, movement and a certain economy of painting as their point of departure. The second source comes from developments within abstraction itself. In broad terms the argument would be that the limit of the standard approaches to abstraction have been established by the work of painting. Philosophy has had to invent because of the nature of the challenge presented by contemporary abstract painting. Part of the complexity of these developments is that abstraction, after having freed itself from its incorporation into the singular theme of autonomy, is able to lend itself to a number of philosophical possibilities. It is this particular setup which reflects both developments within abstraction and the contemporary nature of the philosophical task.

The contemporary within philosophy is given here in its relation to what insists within contemporary art. Part of that insistence is the necessity for an attempted understanding of that which is at work within the visual arts. Responding will work to renew philosophical thinking. Outside of the play of reduction what is being offered here is another possibility for philosophical and critical activity. Within the opening up of that possibility what figures with equal insistence is the presentation – always presented within and as part of an interpretive field – of recent work. Rather than operating within the space of lament that is given by demonstrating what is no longer possible, this issue of the *Journal* offers the possibility of thinking renewal, and in so doing of allowing for the reworking of philosophical concepts that were thought to have been exhausted. In other words the reworking of painting, in the necessity of the philosophical response which it enjoins, opens up the possibility of a concomitant philosophical reworking.

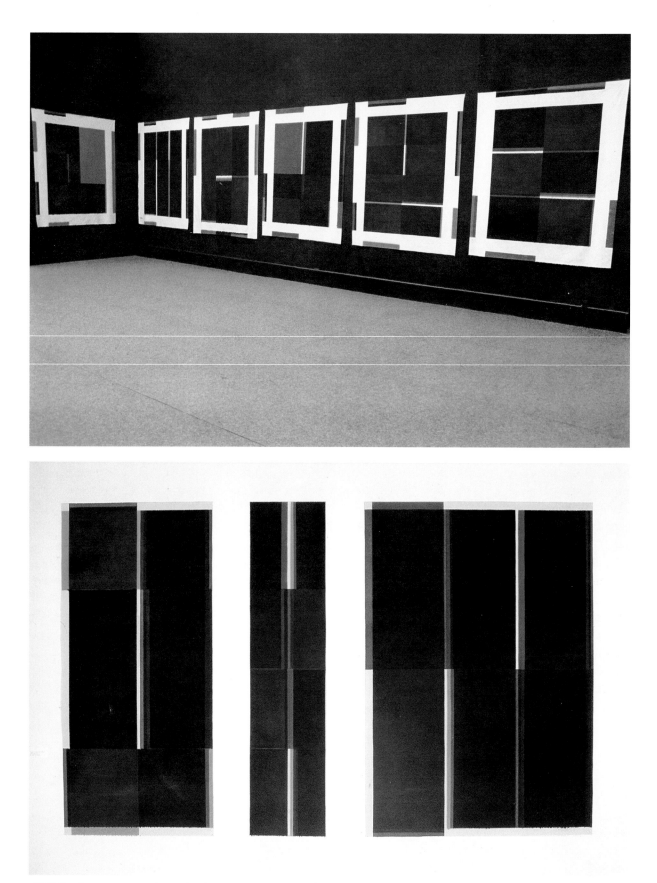

ABOVE: Albert Ayme, Paradigme du Bleu Jaune Rouge, *1978, free canvas, 180x140cm; BELOW: Albert Ayme,* Triptyque No 1, *1990, free canvas, 170x280cm*

FAIT PICTURAL
Jean-François Lyotard

It might be that any great work of painting demands that the visible be sacrificed so that be granted to human eyes the grace of seeing what they do not see. AA has no more faith in appearances than any great artist: he waits instead for apparition. Blue is blue, yellow is yellow, so the rumour says. Thanks to the ceremony of the pictural gesture, the colour that was given us with the world is withdrawn from view and returns to awaken in each of us, sometimes, an *anima*, a thought of the body, that was being stifled by the organisation of discourses and the vital functions.

Colours so ordinary, so smoothly natural and cultural, servants of the gaze busy getting its bearings in its field and enjoying it: here they are banished by the eye that is about to paint and plunged into the darkness of its doubt. The pictural gesture would not take place without this blinding. The artists of Lascaux worked deep in caves. The visible is plunged into the bath of night, to be polished. There must be a moment during the ceremony of the work, when the officiant sees colour naked, unclothed of its adornments and finery, indecent, absolute: the moment when he can no longer see it since, *ex hypothesi*, it has broken with the gaze and the discourse of humans, and no longer enters into the peaceful commerce they entertain with their objects in the world.

The red and the blue he sees at that moment have nothing to do with him. Like the victim, bloodless on the stone, has nothing to do with the sacrificer. The sacrificer sees the victim absolute, freed from the trade of life, dying. This putting to death of colour exalts its truth. It emancipates it from the agitated and precarious life of appearances. Among the very first watercolours by AA, there are *Vanities*.

The pictural gesture is moved by despair and anger as regards permitted sight and visible bodies: by an abjection for deceived life. The painter (in anybody) is what shouts to the light of the world: why hast thou forsaken me? Song of Shadows, Friday of anguish. Even the greatest colourists who celebrated the shimmer of the Earth did so in spite of the spell cast on their eyes, and against it. The celebration of colour is won against its abomination.

And then the tomb opens and the colours appear in glory. (*Tomb* and *Glory* are titles of works by AA.) It is not Christmas, but Easter. I said 'ceremony' because the pictural ges-ture requires the desire that colour appear *in spite of everything*. This desire, or this will, is a grace. The grace accorded Lazarus.

The pictural ceremony draws from I know not where, from the depths of disgust with the visible, the resolution to absolve it. Blues and yellows come out of nothingness and are born to the visible, transfigured. Not clothed differently, travestied, nor loaded down with new meanings but, so to speak, novices, purified by initiation, sanctified.

AA makes a promise, and a vocation, of only giving the right to vision to the three so-called primary colours. They can traverse night and day intact. The other colours are mixed ones which do not tolerate lustration, which cannot show themselves naked. They are the result of a mixing of indistinct neighbouring tones on the continuous spectrum of solar light polarised by a refracting medium. They are as precarious as the meeting of a prism and a sun.

Blue, red and yellow stay separate, owing nothing to their surroundings in the spectrum, nor to each other, save their perfect discretion. No primary is the complementary of any other. They shelter eye and mind from the temptation to complement, complete and be complacent. They do not gesture towards some natural harmony from which some melodic landscape or some fable would inconsiderately be engendered. They remain set in their chaste isolation, like a point in space keeps its distance from another point and knows nothing of it.

It's from this maniacal discontinuity that the ceremony officiated over by AA takes its mode of operation. As classical as it is modern. And first of all the resolution to forbid any subjective intervention. The human individual bows out, Monsieur AA retreats. If the colours are to awaken the *anima* by the violence of their surrection, this will not be by the wish of the officiant. Just as Kleist's marionettes are all the more gracious and graced because their movements obey gravitational mechanics alone, so the three chromatic entities will attain their sensory truth, the grace of their incarnation, only by following the simple rules of distinct thought.

On the other hand, these entities (yellow, blue, red) are refused any referential function, since the world has been placed in abeyance as much as the subject. 'Nature takes

Albert Ayme, Carré Magique No 13, *1978, 60x60cm*

Albert Ayme, Paradigme du Bleu Jaune Rouge, *1978, free canvas, 180x180cm*

ABOVE: Albert Ayme, Le Dialogue sans Fin, *1962, free canvas, 180x660cm; BELOW: Albert Ayme,* Suite en Jaune No 1 à la Gloire de Van Gogh, 10 Variations, *1981, free canvas, 160x120cm*

place', said Mallarmé, 'we shall not add to it.' Yellow does not refer to lemon, nor red to blood. They refer (however one conceives this reference) to nothing: they are *there*. The question is that of this *there* that they are and the *now* of their being there, and it does not find its answer in a reality *already* come about *somewhere else*, and is neither objective nor subjective. 'Pictural fact', 'poetic fact': that is how Braque and Reverdy named the enigma that *there are* appearings in the space-time of colour or language. Square or rectangular, canvases or papers are here hung without a frame, free from any contextual attachment: see, here.

And then another rule: a rule for carrying out the work, but one that is still limpid for thought: Heraclitus and Parmenides conjugated to dig and raise the marine cemetery. Canvases or papers are divided into equal units, rectangular or square. I call them zones. The rule, which is called paradigm, determines the order in which the colours are placed on the zones. Take the three primaries, B, Y and R, and 1,2,3, n, the zones available on the picture. The paradigm fixes the placing of the colours in the order BYR, or in the (reciprocal) order RYB, or in one order followed by the other, etc. In Greek, *paradeigma* also designates the example, the case in declension from the model. A piece by AA is always a case thus declined.

But the principle of order is not sufficient. It merely determines the so-called ordinal succession of numbers, physical time: *two* comes after *one* by simple addition of the unit to itself, like on the dial of a clock. But it is not necessary that blue come thus after red, for they have no common unit. They are not numbers. If they are to be what they really are, chromatic events, then they *come upon*. They come one *upon* the other, and do indeed make a temporality, but such that the colour, in the instant that comes, retains beneath itself, behind itself, the chromatic instant that preceded it, and modifies that instant. For example, blue was put down on the first zone of a piece, in a first moment. When red comes later, on the second zone, it also covers the blue on the first. It thus affects the blue past with a nuance that might be called that of 'lost time'.

The paradigm determines the order of appearances, arbitrarily. This order is not only an order of succession, a diachronic one, but *at the same time* synchronic, not a time of storing, but of memory and forgetting, one of modulation. A braid of colours is thus knotted. It is finite only when the rule of allowed transformations in the order of colour appearances allows a determinate number of combinations. But there are many rules of possible transformations. An indefinite potential of singular chromaticisms, obtained by superimposition of the primary colours, is thus offered actualisation. The *œuvre* of AA, the whole of it, is the essay of this act.

Like Reverdy's or Braque's *fact,* the fact worked by AA's work is a *musical fact* in colour. Music is time made into eternity, the *Musical Offering* by Bach or Boulez's *Répons*. Not 'the sea gone with the sun' as Rimbaud prophesied, but sound, and here colour, gone with number.

People think they've done with AA's work by judging it to be the result of a combinatory procedure and a tradition of abstraction. But there is no procedure in his case, but a monastic rule (an ethical one, he keeps saying), a quasi-Pythagorean virtue. Except that being a painter, thought is here not satisfied with refusing the earth in favour of the presumed celestial order. AA paints, I repeat, or something is painted through him, so that the misery of the sensory order be redeemed in the sensory order itself. Nothing is less abstract, less 'Malevichian' than these concretions of chronic chromatisms. The rule of his order, requiring him to disappear as individual, does not require meditation, but charity. Be it sumptuous or banal, the visible is always struck by poverty. The wish of the paradigm, in its logical simplicity, is a wish of poverty with respect to the world, thanks to which the gift of being susceptible to colour can be rendered to the greyest, most despairing eyes.

'The enigma I'm tracking down through painting,' confesses AA, 'is that of woman.' Marcel Duchamp tried to approach that enigma through non-Euclidian or *n*-dimensional geometries, in the upper part of the *Large Glass*. AA sustains himself, tracking, with axiomatic logic. 'Woman' is not something given, but no more is it something refused. It is, in everyone, the Thing that demands that what is given be exceeded, by subtraction or proliferation, or both. The Thing that demands the impossible.

A systematic beggar is here giving us the pictural offering of this demand for impossible colours. It needed night to give them to the light. *Strasbourg, 30.11.93*

(Translated by Geoff Bennington)

Albert Ayme, Sept Chants de Ténèbres, Chant No 3, *1988, 102x75cm*

Albert Ayme, Suite en Jaune à la Gloire de Van Gogh No 3, Variation No 5, *1986, free canvas, 160x120cm*

ANOTHER VIEW OF ABSTRACTION
John Rajchman

What is Abstract?

Today one is told that abstraction can still surprise us, that its history is still before it, that it is still a live question. It is as though the *world* of abstraction had been reopened. But this means that it must be *rethought*, breaking loose from conceptions that have long framed its discussion. For not so long ago, abstraction seemed a 'dead' question, even a question of 'dying' – it was supposed to play a fatal if heroic part in a drama through which painting exposed and exhausted all its formal possibilities, leaving it with no other game than an end-game. But we don't *have* to conceive of abstraction in this manner; we don't have to see it as an avant-garde post in a progressive advance to extinction. We may think of it rather as an untimely point in a complicated history, which goes off in several directions at once, redistributing the sense of what comes before it, and what may yet come after. But for this, we need other, lighter, less morbid ways of thinking. To rethink abstraction, we need another *kind* of theory, another picture of what it is to think 'abstractly'!

In this situation, the philosophy of Gilles Deleuze becomes quite telling. For, rather in the manner of fellow 'anti-Platonist' Ludwig Wittgenstein, Deleuze advanced another image of what abstraction means in philosophy: more 'empiricist', more 'immanentist', more 'experimental'; at the same time, he sketched another view of what abstraction means in art: more 'chaotic' or 'formless', no longer defined in opposition to figure or image. These two kinds of abstraction intersect in many ways, forming part of a new way of doing art-connected philosophy. In both cases, we find a departure from the view of abstraction as a process of extracting pure or essential Forms, emptying a space of its concrete contents, towards another kind of abstraction, and another sense of 'abstract': an abstraction that consists in an impure mixing and mixing up, prior to Forms, a reassemblage that moves towards an Outside, rather than a purification that turns up to essential Ideas, or in towards the constitutive 'forms' of a medium. For Deleuze, philosophy itself becomes a practice of this abstract mixing and rearranging, a great prodigious conceptual 'And . . . ' in the midst of things and histories. Thus he says philosophy is impoverished when reduced to being merely *about* the arts, reflecting on their forms of judge-

ment; for it has a much more vital role to play together *with* them, linking up with them in odd places, interfering and intersecting with them through 'encounters' prior to settled judgements. To transform the picture of what it is to think abstractly is to transform the picture of the relations abstract thought may have with the arts, and so with abstraction in the arts. And it is thus that Deleuze arrives at a picture of abstraction unlike the one that comes with the tragic story of this strange, self-possessed Purity in the sea of Kitsch, calling out to the Painter-Hero, obliging him to surrender until death.

Nots and Ands

The standard story of modern abstract painting which tells of such a heroic fatality rests on a particular conception of it, haunted by the empty canvas as Mallarmé had been by the blank page. Abstract is what is *not* figurative, not narrative, not illusionist, not literary and so on, to the point where one arrives at a sanctifying negative theology in which 'art' (or 'painting') takes the place of 'God' as That to which no predicate is ever adequate, and can only be attained via the *via negativa*. Such things as the decline of religion, or the rise of photography, are commonly said to be responsible for this turn to the negative way, which would lead, through various routes, to the endpoint of the monochrome – Malevich, Ad Reinhardt, Stella's Black Paintings, etc . . . After such monochromatic emptiness, all would be parody, quotation, 'irony', eclecticism – in other words, 'post-modernism'. Thus abstraction would bring an end to the canvas authorising a turn to 'art' in an unspecific sense, without painting or instead of it – a turn from being (just) a painter to being an 'artist' or 'anartist' with no particular medium – which would be consummated in New York in the sixties, after abstract expressionism, with pop and minimalism.[1]

In this now all too familiar drama, abstraction means stripping away of all image, figure, story, 'content' to reach the empty or flat canvas. That is the root of many familiar ideas: abstraction as illusionist space from which the illusion has been removed, pure 'form' without 'content', pure self-referential 'literalness' opposed to any 'decoration' or 'theatricality', a bride stripped bare. What the late Clement Greenberg called 'modernism' is perhaps the most influential variant of

this conception – a variant connected to a story about cubism and the flattening of classical illusionist space, which Greenberg adapted from Hans Hofmann, adding, as motivation, a horrified escape from the world of kitsch towards a kind of optical puritanism, in which the eye, 'abstracted' from all admixture with the other organs of the body, would itself become pure, 'formal, and so 'abstract'.

Yet, despite Greenberg's 'eye' for the 'quality' of the likes of Noland and Olitsky, the heroes of abstract expressionism would come to see the last heroes of this kind of abstraction, this kind of 'modernism'. 'After abstract expressionism' there would be instead various attempts to depart from the whole idea of the painter-hero who creates from nothing – from the 'anxiety' of the blank surface or from surrender to the 'seduction of the virgin canvas' and, therefore, from an aesthetic erotic analysed by Lacan, around the same time. For in this Seminar of 1960, Lacan defined sublimation as an attempt to re-create in an object the emptiness of the lost Thing, much as God had created the world from out of nothing, *ex nihilo*. That would be why the strange things we call art objects incorporate an emptiness surrounded by affects of anxiety, melancholy, mania or mourning; it is why the fame that accrues to creators of such objects would be such an odd one, rooted in envy.[2]

And yet it is not clear that the work that prides itself on coming after the supposed monochromatic end-game of abstraction (after 'modernism' or 'formalism') really breaks with the anxious-heroic erotic, this negative theology of Art, this 'not'. On the contrary, one can argue that 'post-modernist' art remains, as it were, haunted by the spirit of the abstract painting; it only repeats this game as farce, through quotation, parody, irony, alternating between mania and melancholia. Indeed the very idea of 'appropriation', and of what Baudrillard called the 'simulacrum', is fully impregnated with the tradition of melancholy and panicked reaction to Loss or Absence; in this respect it is quite unlike the idea of the simulacrum that a forgetful Baudrillard had 'appropriated' from Deleuze, which involves not a loss but an *intensification* of the real, linked to a condition of things prior to Forms. In short, it is as though first in 'modernism', and then in 'post-modernism', the tale of abstraction were a long, sad illustration of Nietzsche's thesis linking asceticism and nihilism: that one would prefer to will nothing than not to will at all.

Of those who have written on abstraction, Deleuze is perhaps the one least affected by such ascetic 'nots'. He remains singularly unseduced by the secrets of the 'virgin' canvas – by the whole of the negative theological picture of abstraction, and its anxious erotic of an imperious Art one approaches only through negation, this virgin whose purity

means death. Instead of the 'nots' of negative theology, he likes the 'folds' of Neo-Platonic *complicatio* as a source for abstraction. For in them he sees something that cannot possibly be made to 'participate' in the purity of Forms, and the sorts of abstraction that attain them. He finds another minor tradition of such abstract 'complication', seeing it in Proust's signs, in Leibniz's 'minimalist' monads, or again in Spinoza's treatment of divine names, where it is linked to 'the problem of expression', important for Deleuze's own view of abstraction. And one finds something of Spinoza's 'god or nature' in the manner Deleuze comes to formulate the problem of 'abstract expressionism' in Pollock – as a problem of expressing something which can't *possibly* be figurative (hence can't possibly be a mere absence or lack of figuration), which can be shown only in an 'ungrounded' (*effondé*) space, through a 'plane of composition' rather than a 'plan of organisation' without beginning or ending, finality or totality. Pollock's 'all-over' would be like Spinoza's 'infinity' – a substance that just *is* the endless composition, decomposition and recomposition of its 'finite modes', rather than something static which would underlie, enclose or 'organise' them.

Deleuze's view of the 'space' of abstraction is, in short, not based on the great 'not' – on the absence of figure, image, story. Rather than absence and negation, abstraction has to do with the affirmation of 'the outside' in the sense of this notion which Foucault developed in the thought of Maurice Blanchot in the sixties, explicitly contrasting it with the tradition of negative theology.[3] In effect, Foucault argued that 'modernism' does not consist in an internalising reversion to the medium, but, on the contrary, in an opening of the medium out from itself, to the point where it becomes 'beside itself'. And he thought that this externalising 'madness' in modern works – this *absence d'œuvre* opening to an 'outside' – entails a certain blindness that enables a whole art of seeing.[4] Thus 'modernity' doesn't consist in a melancholy purification of the means of representation, turning within to proclaim an enclosed autonomy; on the contrary, it is about untimely forces which announce other new 'outside' possibilities, and so introduce a certain 'heteronomy' in mediums. For Deleuze the basic question of modernity becomes how to think, how to write, how to paint such 'other' or 'outside' forces. Thus, in the 'minority' of Kafka, the 'chaosmos' of Joyce, the *épuisements* of Beckett, he identifies an abstraction quite different from the self-purifying kind – that of those 'abstract machines' that push artforms beyond and beside themselves, causing their very languages, as though possessed with the force of other things, to start stuttering 'and . . . and . . . and . . .'. He connects this stuttering abstract 'and' not with dying or heroic self-extinction, but with

a strange an-organic vitality able to see in 'dead' moments other new ways of proceeding. And *this* sort of vitality, this sort of abstraction, he thinks, is something of which we may *still* be capable, something still with us and before us.

And so Deleuze declares the page is *never* blank, the canvas is never empty.[5] To think in those terms is to have a mistaken idea of what it is to paint (or to write), and so of abstraction in painting (or writing). For before brush is put to canvas, there is the 'avant-coup' of a long preparatory work which consists in getting rid of the ambient clichés in the studio and beyond; the canvas thus always starts off covered over with too many 'givens', too many 'probabilities', from which one must extract a singular space that allows for the chance of an 'après-coup' of strange new 'virtualities', unpredictable or unforseeable. This is what makes the act of painting always an 'hysterical' one. To paint one must come to see the surface not so much as empty or blank, but rather as 'intense', where 'intensity' means filled with the unseen virtuality of other strange possibilities – one must become blind enough to see the surface as 'mixed' or 'assembled' in a particular transformable and deformable manner, rather than as just 'flat'. One can then see abstraction not as elimination of figure or story, but rather as an invention of other spaces with original sorts of mixture or assemblage – a prodigious And which departs from classical illusionism, and eventually even from figure/ground principles of composition. 'Flatness' thus becomes only one possibility of the canvas among others, quite compatible with figuration. In fact Deleuze finds one sort of flattening spatialisation in Francis Bacon: the use of *aplats* to make the figures appear next to, rather than within, the space that surrounds them, thus allowing the force of their strange 'matter of fact' *figurality* to emerge.[6]

Another modernity, another abstraction. When, in 1980, writing with Guattari in the last plateau of *A Thousand Plateaus*, Deleuze asks directly the question, 'What then should be termed Abstract in modern art?'.[7] It thus comes after a long rethinking of the very idea of the modern and the abstract, whose logic Deleuze had set out in the sixties – around the same time 'after abstract expressionism' in New York, when it was thought that painting might be coming to an end. And this logic (later re-elaborated in terms of 'abstract machines') describes rather well the unheroic almost automatic *series* one sees emerging in pop and in minimalism at that time in New York. To understand properly the answer Deleuze and Guattari give in *A Thousand Plateaus* to the question of what should be called 'abstract' in modern art – 'a line of variable direction, that traces no contour, and delimits no form'[8] – one needs some sense of this larger change in conceptual terrain. One needs to have rethought abstraction in its *logic*.

The Two Abstractions

The central frame for the notion of the abstract in the philosophical tradition has been that of a taxonomic 'tree' of distinct classes or kinds. One 'abstracts' as one moves up to higher levels of generality, just as one 'concretises' or 'instantiates' as one moves downwards towards particulars or specific instances of 'types'. Thus the 'dialectic' Plato attributed to Socrates consisted in the effort to track down the higher, more general Forms in the lower, more particular things which 'participated' in them, by making sure the lineages are pure or unmixed, following the divisions of the tree; ideas of both analogy or resemblance, and of force or potential (*dynamis*) would be made to conform to this 'arborescent' picture. Deleuze argues that neither the transcendental idea of *a priori* conditions nor the dialectical idea of a Whole of contradictions would in fact really break away from such 'Platonism'. For neither allows a sense of 'abstract' that permits one to move away altogether from general taxa, transcendental categories or dialectical totalities and find things for which there exists no such 'abstract' model or type (what Deleuze terms 'multiplicities' and 'singularities'). For that, one must 'reverse Platonism' and see Forms (and later Conditions or Totalities) as belonging to an unlimited abstract space which precedes and escapes them – a space that is 'larger' than the highest genera and has components 'smaller' (or more 'minimal') than the lowest species (such, in the terms of Duns Scotus, would be the indifference of Being, and the existence of 'haecceities').

Thus Deleuze draws a picture of an abstract logical space anterior to the divisions and up/down, high/low movements within the great Platonic tree – a space that includes a force or potential which constantly submits its branches to unpredictable, even monstrous variations. In his *Logique du sens*, he offers a picture of such variations as 'series'. A series differs from a set, class, type or totality in remaining open to such forces of divergence and deviation, which serve to alter its contours, and the sorts of things to which it can be linked.[9] A series may then be said to be composed of indistinct 'singularities' rather than the distinct 'particularities' from which general 'abstractions' are made; and, conversely, a 'singularity' is what enters into a series rather than falling under a class or particularising a universal. Series are thus impure mixtures that complicate and depart from pure lineages of given ones, and in this respect are like the deviations or swerves of what Lucretius called the *clinamen*. *Logique du sens* is Deleuze's attempt to show that the potential for such deviation and ramification forms an uneliminable anonymous layer of meaning, prior to sense, reference and elocution. *Différence et Répétition* is, then,

the attempt to show that when 'difference' is freed from making 'distinctions' or 'oppositions' within or among the fixed classes of the tree, it discovers a 'complex' sort of 'repetition' – a whole 'complicated' time and movement that includes a non-probabilistic 'nomadic' kind of chance, which no throw of categorical dice can ever abolish.

One might then say that there are two sorts of abstraction in Deleuze, two senses of what it is to 'abstract' and to be 'abstract'. The first is the 'Platonic' sense of abstract Form. It is the object of the 'critique of abstractions' which Bergson shared with his contemporary William James, and which Deleuze himself formulates when, saying that he is an empiricist in the tradition of Whitehead, he declares: 'the abstract does not explain, but must itself be explained'.[10] To explain *by* abstractions is to start with abstract Forms and ask how they are realised in the world or extracted from it. But to explain those abstractions themselves is to re-insert them in a larger (and smaller) 'pluralistic' world which includes 'multiplicities' that subsist in Forms and induce variations in them, altering their connections with other things; in this way one shows *that* they are 'abstract' in the invidious sense of being incapable of complication or movement – such is the 'critique'. Thus one attains a 'complicated' condition in things prior to Forms, which Deleuze likens to the space traced by one of Pollock's lines, which 'does not go from one point to another, but passes between the points, ceaselessly bifurcating and diverging'.[11] And one arrives at another question: not how are Forms extracted from or realised in things, but under what conditions can something new or singular be produced 'outside' them? Thus one comes to the second sense of the abstract in Deleuze, developed along with Guattari through the concept of 'abstract machines', and 'opposed to abstract in the ordinary sense'[12] – the And which moves outside. To pass from the first critical sense of the abstract to this second 'affirmative' one is to transform the very idea of the *abs-tractus* – the act of withdrawal or turning away.

For as long as one thinks of the *abs-tractus* as Form withdrawn from Matter, one thinks in terms of 'possibilities' and their 'realisations' (or later transcendental or dialectical conditions of such possibility). The basic assumption remains that the world is logically congruent with possibilities given by abstractions, even if all such possibilities are not realised or instantiated, or all the categories under which they fall are not known. But once one allows for a world that is disunified, incongruous, composed of multiple divergent paths, one can think in terms of abstract 'virtualities' which, in contrast to such abstract 'possibilities', are quite real, even though they are not 'actualised'. One starts to see the force or potential of things for which there exists no abstract concept, since their 'effectuation' would go off in too many directions or 'senses' at once. Deleuze calls such *potentia* 'virtual' in a sense that contrasts with the 'possible' developed by Bergson in his critique of abstractions.[13] Thus the virtual may be said to be 'abstract' in a different sense from the possible: unlike abstract 'mechanisms', abstract machines are said to be 'real although not concrete, actual although not effectuated',[14] comprising a sort of 'real virtuality' in things. They have the abstraction of immanent force rather than transcendental form – the abstract 'virtuality' within things of other different things, of other 'possible worlds' in our world, other histories in our history. That is why they are 'rhizomatic' rather than 'arborescent'; serial, differential, complicating rather than categorical, generalising and purifying. That is why they can be expressed only through abstract 'diagram' and not abstract 'code'. The whole problem is how to put them first, how to *see* them as first. For the two sorts of abstraction do not exist apart from each other. They are two inseparable forces at work and at odds within any logical space, including that of Plato himself (for example, in the aporia of the 'bastard logic' of the *chora* in the *Timaeus*). The 'reversal of Platonism' is thus a reversal in which one is put first, and in what it thus means to come first or be prior (priority of immanent condition rather than of transcendental form). That is why the passage from one kind of abstraction to the other involves a change in seeing: rather than seeing the Forms the sun illuminates above or the ideas natural light illuminates within, one must learn to see this prior immanent condition that illuminates through multiple paths outside, 'ceaselessly bifurcating and diverging', like one of Pollock's lines.

It is, then, this second sense of 'abstract' which Deleuze brings to the discussion of modern art – for example, to Jean-Luc Godard. For if he sees Godard's films as 'abstract', it is not because they remove all narrative or 'diegesis' and retreat into pure filmic self-reference, but because they take singular elements from all over, past and present, and reassemble them, mixing them up in the strange non-narrative continuity of a sort of 'abstract machine'.[15] The motivation is thus not the removal or 'absence' of narrative, but an attempt to attain an 'outside' of other odd connections through a free, abstract AND, which takes over the movement and time of the film. That is one source of Deleuze's quarrel with the film semiology of Christian Metz. One must put this sort of abstraction first, see it as first, and so take narration as only 'an indirect consequence that flows from movement and time, rather than the other way around'.[16] For film is not a 'code' of which abstraction would be the self-reference; it is an abstract 'machine' that has movement and time as spe-

Demdag two logics

19

cific abstract 'virtualities', which then get 'effectuated' in particular social and political conditions; narrative is only one restricted possibility of it. Thus what Deleuze counts as most 'specific' to film – the forces of its time- and movement- images – is at the same time what opens original connections with other mediums, for example with architecture, which Deleuze then sees as closer to film than is theatre.

But it is no different with the question of abstraction in painting. There too we find an abstraction of the And rather than of the Is, of 'the outside' rather than of the absence of figuration and narration; and there too the problem is to see such abstraction as first. Much as with Metz in film theory, in painting theory one might thus draw a contrast with Clement Greenberg's attempt to see in abstraction an apotheosis of autonomy and 'opticality'. For following Lessing's classical division of the arts, Greenberg argued, in effect, that abstraction in each artform (for which abstract painting takes the lead and shows the way) would achieve an absolute separation where each would stay in its place, and appeal to one and only one sense organ; thus the 'eye' of painting would at last be freed from all 'theatricality', and be shown only what is purely 'optical'. Greenberg's contrast is with the Wagnerian *Gesamtkunstwerke* which tries to put all arts and senses together in a totality. But the logic of this contrast, which opposes clear distinct elements to total expressive forms, is one which Deleuze is concerned to undercut. In his own logic, he allows for things to be inseparably connected while remaining singular and non-totalised, and so remains undisturbed by 'paradoxical' objects which fall in between the supposed bounds of specific mediums, mixing them up anew; and he thus envisages other, lighter Nietzschean paths out of Wagnerite totality.[17]

Pollock's Lines

As narrative in film depends on the abstract 'virtualities' of movement and time, so figuration or image in painting may be said to depend on how pictorial space is held together and comes apart – on the way it achieves an 'order out of chaos'. There are thus different kinds of abstraction and different types of 'figurability' in painting, and these differences are more important to its 'logic' than the bald gross opposition between the abstract and the representational. It is this 'logic of sensation' in painting, which Deleuze then tries to spell out.

One can think of pictorial space as built up from distinct simple elements, or else as held together by expressive wholes or by figure/ground *gestalten*. But Deleuze's logic envisages another 'complicating' possibility, prior to these, or subsisting within them – he thinks pictorial space can become 'ungrounded' (*effondé*) and 'disparated' in its composition, allowing thus for the force of indistinctions, in-between spaces, or 'leakages' (*fuites*). In this case, pictorial space attains an uncentred, unbounded and formless condition; it discovers the workings of non-probabilistic chance in its composition; and it departs from the predominance of purely *optisch* frontal vision to discover more *haptisch* sorts of spatialisation, which have multiple entrances and exits rather than being given to a single point of view. Thus Deleuze proposes to distinguish fixed visual plans of organisation in delimited spaces from free tactile planes of disparate distribution in unlimited or formless ones. What he finds important about Pollock's abstract line is a passage from one to the other, or a reversal in which one is put first; he sees a turn from the centred, framed, figure/ground sort of organisation which European classicism took to be universal, to another uncentred, unlimited, *informel*, multiple sort of distribution in space, and space of distribution. He says that Greenberg was quite right in pointing to the importance of the abandonment of the easel in this shift, for it is what made possible a 'reversion' in pictorial space from 'visual horizon' to 'tactile ground'.[18] But to give up the easel was more than to abandon the 'figurative' or 'illusionistic' relation to nature. It was to depart as well from delimitation (frames or borders), perspectival distance, and presumptions of symmetry or of organic centring; and it is therefore very odd of Greenberg to say that these changes result in a pure 'opticality'. For what in fact was at stake was the discovery of something *prior* to the contoured or delimited figure – something 'first', which comes 'before' the horizons of frontal vision, and cannot simply be derived from a purification or flattening of the classical *optisch* perspective space. What Pollock discovered, according to Deleuze, was rather the 'catastrophe' of the visual – catastrophe not as a content (as in Romanticism), but as a force or potential inherent in pictorial space as such. For all painting passes through an experience of 'the collapse of visual coordinates', as a condition bringing other singular visual sensations into being; such is the 'blindness' which lets a painter see and show the things unseen before him. Remarking on how such 'catastrophe' figures in Cézanne and Klee, Deleuze declares that painting is the artform closest to it. Thus he calls painting inherently 'hysterical' in his study of Francis Bacon, where the catastrophe is shown in the operational cluster of 'a-signifying' features, *taches*, zones, which Bacon termed the 'diagram' in his works.

Because Pollock's line is thus a line with variable direction, which traces no contour, and delimits no form, ceaselessly diverging and bifurcating, it requires a rethinking of

drawing

20

the very idea of the abstract. Greenberg's story based in cubism, and the sort of three-dimensional space that allows one to see depths and contours, figures and grounds, is not sufficient. For just what matters in Pollock's 'abstraction' are lines and *taches* of colour, which don't limit anything, which have no inside or outside, no convexity or concavity – and so are after all 'gothic' in a sense Deleuze finds in the writings of Worringer rather than in surrealism. For this is an abstraction that departs from a geometric, rectilinear shape; it is less a spiritual purification of Form than a sort of expressive decomposition of Matter. It is thus 'abstract' in a peculiar sense, which makes Mondrian's squares or Kandinsky's points, lines and planes still seem strangely 'figurative', since they after all remain 'figures' with delimited contours.

Indeed, it is as though such earlier rectilinear kinds of abstraction were an attempt to reduce the forces of abstract 'diagram' in painting, in order to attain the purity of an abstract 'code' of primitive visual elements – a sort of spiritualising escape from the potential 'catastrophe' of the visual towards a fundamental language of the organisation of colour, form and shape. Pollock then helps restore the 'diagram' to abstraction, allowing one retrospectively to see a pre-figurative formless 'materialism' already at work in the geometries of the earlier abstract work. Thus Deleuze detects 'nomadic contourless' lines in Kandinsky, while the unequal thickness of the sides of Mondrian's squares suggest to him the possibility of a contourless diagonal. Moreover his student Bernard Cache has gone on to try to see such possibilities in the Baroque 'inflexions' of Klee's pedagogical sketchbooks, as well as in a strange Lucretian materialism which would precede Kandinsky's official rectilinear spiritualism; in both cases Cache finds an abstract space composed through inflexion, vector and frame rather than organised by point, line and plane.[19] But, at the same time, the contourless, unlimited kind of abstract space Pollock attains, serves to change the terms of the contrast between the abstract and the figurative. It helps to see other relations to figure, other kinds of 'figurality', like that Deleuze then finds in Bacon. Thus Deleuze says Bacon departs from images-given-in-classical-perspective distance in yet another way, different from the abstractions of either Kandinsky or Pollock – from a cliché-ridden 'photographic' world, he extracts an original kind of Figure placed on a strange intolerable surface from which it is always seeking release, as though subjected to the violence of invisible forces, which undo its 'faciality' and expose its 'meat'.

In *A Thousand Plateaus* Deleuze and Guattari thus declare that the emergence of the abstract line 'with variable direction, that traces no contour, and delimits no form' requires that what counts as abstract be itself rethought along several lines at once: (i) the gross exclusive opposition between figurative and abstract loses its centrality, and a good deal of its interest, in favour of kinds of pictorial space, and the kinds of figurability they permit. For images or figures are not created out of nothing to match with external models; they 'come into being' from a compositional space which always departs from visual coordinates, creating strange new sensations. Abstraction is thus not in the first instance to be understood as the emptying of illusionist space of figures and stories; it is, rather, a sort of 'sensation' of this other larger sort of abstract space which precedes and exceeds them. 'Figuration' is a limiting case of the original abstract potential for 'figurability' in painting. (ii) But this requires a change in the presumed 'motivation' of abstraction. That motivation is not one of stripping everything away in self-referential abnegation, but of offering sensations of those things that can be seen only through the experience of 'the collapse of the visual' or the 'blindness' of painting. In that sense, *what* one paints is always otherwise unseeable abstract *forces*. (iii) The 'space' of abstraction is not originally or fundamentally geometric; 'the abstract line is not in the first instance rectilinear'.[20] Geometric form loses its centrality in favour of more tactile, dispersed, uncentred and unlimited sorts of space. Thus Deleuze and Guattari suggest that we think of the classical Athenian preoccupation with geometric or rectilinear form as only one possibility, preceded, according to Riegl, by an Egyptian one, and followed, according to Worringer, by a Gothic one; one can then see the classical space of perspectival distance in terms of the *optisch/haptisch* distinction, rather than in simple terms of form and content. And yet there remains an Idealism in the *Kunstwollen* offered by Riegl or Worringer, linked to the preoccupations of a sort of German 'Eurocentrism'. For in fact painting *starts* as abstract, and is such already in 'prehistoric' times. Deleuze and Guattari draw attention to the argument advanced by Leroi Gourhan that 'art is abstract from the outset and could not be otherwise at its origin'.[21] Classical European illusionism is thus only a late development in an inherently abstract art. For all these sorts of reasons, Deleuze and Guattari say that, far from being the result of stripping illusionist space bare, abstraction is something prior to it – something that comes first. It is first historically as Leroi Gourhan shows; it is first in 'motivation', since all painting passes through a pre-figurative or pre-formal 'blindness'; and it is first logically since the classical distanced, centred way of showing contours and forms is only a limited case of the larger potential in painting of a centreless, contourless, boundless, formless space.[22]

Bataille
Goevens

The World of Abstraction

What is then abstract? Today the question arises in relation to what is known as the 'information' age; and perhaps some new pragmatist will apply the critique of abstractions one finds in Bergson and James to the very idea of 'information' and the computational paradigm to which it belongs. Two related postulates might be distinguished. The first says that 'information' is independent of the material medium through which it is transmitted; the second says that simulation and reality come to the same thing. Thus one 'abstracts' from material support, and, by replicating processes, 'abstracts' them from the particularities of their real existence; even 'life' becomes only abstract information, which can be replicated and so made artificially. The two postulates of immateriality and irreality then combine in the great conceit of the info era: that electronic devices will abolish real or material space and time, and transport us all into another abstract, bodiless 'space' or 'reality', consummating the triumph of silicon over carbon.

By contrast in Deleuze one finds an abstraction concerned not with extracting 'information' from things (as though the material world were so much clumsy hardware), but rather with finding within things the delicate, complicated 'abstract' virtualities of other things. Such abstraction doesn't entail independence or transferability from material support and doesn't operate according to a logic of simulation. Rather, inherent in materials, it supposes the subsistence of connections which exceed the messages of a medium, and ourselves as senders and receivers of them. Thus the 'abstract' use of a medium is not when it itself becomes the message but when it starts to stammer 'and . . . and . . . and . . . ' prior to message and transmission. In this way, abstraction belongs to the bodily material world, and its unpredictable 'chaosmotic' processes – processes so formless as to permit the operations of 'abstract machines' with which computational devices may then themselves be connected. Thus Deleuze has little sympathy for the reductive proposition dear to computational neuroscience, that the mind just *is* the information-programme of the brain. To the Cartesian 'ghost in the machine' which Ryle ridiculed, he prefers what Spinoza called 'the spiritual automaton' – this finite manner of being which composes and recomposes with others in an unlimited field, ever connecting and reconnecting the mind *and* the body through a whole 'technology of the self'. If then the brain is a connection-device, it is not mind-programmed, but plunged in a multiple, disunified, formless world. Its logic is therefore not the purely computational one of which Alan Turing dreamt, but operates instead with form and formlessness, order and chaos, rather like

that which Deleuze finds in abstract painting and Pollock's line. The question of abstraction then becomes: to what sort of 'abstract machines' do Turing-machines belong; with what sort of 'desiring machines' are they connected?

One can then imagine other links to the space of abstract painting than the one proposed by 'neogeo' (where 'geo' simulates the irreality of 'info'), or than attempts such as Mark Johnson's to redescribe Kandinsky's abstract spiritual code in a language of cognitive psychology.[23] Rather, Deleuze is drawn to models in science and mathematics that come with strong software capabilities, which depart from distinct sets and expressive totalities to envisage things like catastrophe, chaos and complexity; they can be used to generate topographical spaces more like Pollock than Kandinsky – non-geometrical or non-rectilinear, prior to the 'simulation' of things. For info-devices don't *have* to be used to assist smart weapons or to imagine what it was like to walk about in the Egyptian Pyramids. There are other 'abstract' uses.

The situation of our 'post-industrial' info-devices today is thus something like the one in which Deleuze sees the new 'industrial art' of cinema at the turn of the century, when Bergson proposed his own critique of abstractions. Bergson feared a 'cinematographic illusion' of continuity. But in fact already the real problem of cinema was not that of image and reality any more than medium and message (or medium *being* the message). It was a problem of time and movement in the composition of space, and so of other, more 'diverging and bifurcating' conceptions of continuity, taken up in Bergson's own philosophy. And it was just when cinema made such 'abstract' connections in its new industrial 'material' that it discovered its most intense relations with 'abstraction' in the other 'materials', in architecture and dance as well as painting and sculpture.[24] Such were then the abstract 'virtualities' in the medium, irreducible to messages, which unfolded within particular socio-political situations, punctuated by the experience of the War; such were the abstract forces in the medium that would figure in larger 'abstract machines', connected to an Outside, exposing things unthought in our ways of being, seeing and doing.

Perhaps the most intense relation our current info machines might have with abstraction in painting – old, new, yet to come – is of this sort. For the relation between 'mediums' (and abstraction in mediums) is not one of negation, but of connection – of And rather than Not. A new medium with its specific 'materiality' never simply takes over the functions of older ones, as though abstract 'information' were being transferred from one means of 'delivery' to another – photography depriving painting of its functions, video images killing off film images,

everything being replaced by 'interactivity'. Thus, for his part, Deleuze refused to join certain influential directors and critics in blaming video for the decline of the kinds of 'abstract' cinema that came after the war with Italian neo-realism, French new wave, or American experimental film. He thought the problem was more general. What was at stake was a loss of the taste for the *world* which the new descriptive spaces of such 'abstract' film had opened up – a loss shown in philosophy at the same time, by a retreat from any conceptual 'movement' into a sort of meta-reflection on abstract norms of communication, in a replay of the neo-Kantian denunciation of Bergson by Julien Benda.[25]

For this *world* is what abstraction is all about: abstraction as the attempt to show – in thought as in art, in sensation as in concept – the odd multiple unpredictable potential in the midst of things, of other new things, other new mixtures.[26]

Notes

1 See Thierry de Duve, 'The Monochrome and the Blank Canvas'. De Duve has analysed different ways in which the problem of painting and the 'pictorial' continues to haunt works that are supposed to follow its death or end, even and especially, those said to be 'an-aesthetic' or 'an-artistic', going back to Duchamp. In this essay, De Duve focuses on the moment 'after abstract expressionism' when a sense of 'art' and 'artist' emerged that no longer makes reference to any specific medium; he connects the turn to some remarks of Barnett Newman, very much in the negative-theological mode, and to Mallarmé, declaring that he himself continues to be 'seduced' by the Mallarméan scheme. To understand the turn to art-in-general, he thus proposes to extend the 'privilege' or 'lead' of painting beyond the point to which Greenberg in effect took it: the blank canvas. For painting on canvas is no more 'essential' to the medium than illusionist depth; indeed, it is a relatively recent convention, linked to a freeing of the pictorial object from its ambient architecture. Why not, therefore, continue the monochromatic reduction of abstraction by other means, 'abandoning' the canvas itself, opening other ways of 'naming' the pictorial?

2 See Jacques Lacan, *The Seminar on Ethics*; I discuss this view of sublimation in my *Truth and Eros* pp 71-7. There is of course a Heideggerian element in this notion of primal emptiness of lack, and perhaps one might thus distinguish, in Japanese traditions, the negative theology of Nishida and the Kyoto School from the arts and practices of *ma* or the interval. In any case, it is the space and time of *ma* (and not the great Void) which Roland Barthes likens to Cy Twombly's 'wisdom' in introducing into pictorial space a sense of time or event quite different from mythical narrative or 'theatricality', shown rather through a 'scattered' sort of space. For such *espace épars* is not the result of dispersing something enclosed, grounded or totalised, leaving one with simple disorder; it is, rather, a pre-existing anorganised virtuality, subsisting in the intervals of enclosures, grounds and totalities, through which to attain, says Barthes, what Nietzsche had called the 'lightness' of things. Thus Twombly's 'scattered spaces' have something of the light innocence of the surfaces on which things are remixed in Lewis Carroll, or the amorphous element which led Heraclitus to declare 'time is a child playing'.

3 Foucault / Blanchot (Zone books). The idea of *absence d'œuvre* is the one Derrida at first admired in Foucault. Later, he himself would try to distinguish it, and its role in his own thought, from negative theology; similarly of Lacan's *manque* he complains that it stays *à sa place*. ('Comment ne pas parler.') Yet he wants to preserve a sort of mystical unrepresentable Law, akin in some ways to Levinas, and so does not want to go all the way to Spinozistic immanence, or the atheist, materialist Jewish tradition with which it is linked (including a whole aspect of Marx). In this regard, Wittgenstein is an interesting case. The 'silence' in his early work, linked to his logical atomism, and to Loosian austerity, is in the negative-theological mode; whereas the rambling deliberately non-explanatory remarks of the later work moves towards an 'immanence' of 'tacit' disunified rules of language-use. As he puts in the exergue of *Remarks on Psychology,* 'I show you the differences'.

4 See my 'Foucault's Art of Seeing' *October*, Spring 1988, reprinted in *Philosophical Events, 1991*.

5 *Logique de la Sensation* pp 57ff; Deleuze repeats this view in *What is Philosophy?* where it is connected with another view of monochromes (181ff).

6 Drawing on the notion introduced by Jean-François Lyotard in his *Discours, figure*, Deleuze opposes 'figural' and 'figurative', *Logique de la sensation,* p 9; thus he says that Bacon 'isolates' his figures from any 'figurative' composition, submitting them to another sort of space, whose 'logic' is connected to various abstract spaces. The relation with *discours* thus ceases to be an 'illustrative' one – such would be the sense of Bacon's well known aversion to 'illustration'. In this way Deleuze introduces the notion of a 'sensation' of worlds of non-illustratable things, to which he returns in *What is Philosophy?*, where he declares: 'Like all painting, abstract painting is sensation, nothing but sensation' (p 182).

7 Gilles Deleuze and Félix Guattari, *A Thousand Plateaus*, trans Brian Massumi (London: Athlone, 1987), p 499.

8 *Ibid*.

9 This view of series seems to fit with a number of different art practices. In particular in the sixties, one sees the emergence of various serial practices – in pop, where Deleuze, at the time, proposed to see the possibilities of a sort of mad 'simulacral' repetition; and in minimalism, where series were used to empty Forms and discover a kind of neutral, non-expressionist 'anti-form' as with the trance repetitions of minimalist music, or the routines of minimalist dance, employing the sorts of strategies Deleuze analyses in his study of Beckett's *épuisements*. Benjamin Buchloh also draws attention to series in the work of Gerhard Richter. Starting in the sixties, Richter would introduce a number of strange new 'indifferent' or 'neutral'

procedures into painting, that depart from working from models or motifs, and make the question of *how* take precedence over the question of *what* to paint, leading to a particularly large and 'open' *œuvre*. In sixties analytic philosophy as well, one finds discussion and development of Wittgenstein's problem of following a rule, or of what it is to continue a series of numbers; one can see Goodman's grue paradox as an example. Thus Saul Kripke would generalise the paradox of possible divergence in continuity in his account of Wittgenstein's 'scepticism', seeing it as a key to the private-language argument.

10 Preface to *Dialogues* with Claire Parnet, p vi. The formula is taken up again in *What is Philosophy?*. In his lecture 'Bergson and his Critique of Intellectualism', first delivered in Oxford in 1908, William James tries to find a logic that departs at once from the totalities of the British Hegelians and the atoms of Bertrand Russell, seeing such totalities and atoms as 'abstractions' from a prior 'pluralistic' composition of 'things in the making'. James' attempt to find a multiple flow of things prior to the 'block universe' finds resonance with the various views at the time, for example, with Virginia Wolff, and perhaps also with Matisse, who admired Bergson, and who invented what Yve-Alain Bois analyses as a circulation-tension-expansion principle of filling pictorial space, leaving no 'holes' and affording a sense of expanded scale. But there is also another sort of 'Bergsonism', more compatible with holes and *fuites*, connected to contemporary complexity and chaos theory. See Bruno Paradis, 'Indetermination et mouvements de bifurcation chez Bergson', in *Philosophie no 32*, 1991.

11 *Dialogues*, p viii.

12 *A Thousand Plateaus*, p 511.

13 See 'Bergsonism'; and on the concept of the virtual *Différence et Répétition*, pp 269 ff.

14 *A Thousand Plateaus*, p 511.

15 *Pourparlers*, pp 64 ff.

16 *Pourparlers* p 84, cf also 73 ff.

17 Lessing's doctrine of the separation of the senses, and, in particular, of eye from ear, belongs with what Foucault analysed in *The Order of Things* as a 'classical space', preceded by a 'complicated' Neo-Platonism and a Baroque. For Deleuze, one might add that such classical 'representation' is followed as well by a 'modernity' captured in Klee's remark that to see 'movement' in painting as in the universe, he had to rid himself of Lessing's misguided separations. At one point Deleuze thus refers to what Rimbaud called the *dérèglement des sens*. He is talking about the 'modernity' of Kant. In his view, it is not that Kantian 'self-criticism' points the way to what is 'modern' or 'modernist' in art; rather, it is through the notion of an 'unregulated' (*déréglé*) use of faculties in its connection with two other 'poetic formulas' ('Je suis un autre' and 'the time is out of joint') that Kant's philosophy opens to a modernity he did not yet imagine. ('On Four Poetic Formulas which Might Summarize the Kantian Philosophy' in *Kant's Critical Philosophy*, pp xiff.)

18 *Logique de la sensation*, p 69. Rosalind Krauss has elaborated the link between 'formless' space and the floor or *sol* in Pollock in an original manner. See Krauss, *The Optical Unconscious* (Cambridge, MA: MIT Press, 1993).

19 Bernard Cache, *Earth Moves* (Cambridge, MA: MIT Press, 1995).

20 *A Thousand Plateaus*, p 497.

21 *Ibid*.

22 One might try to associate this distinction between a figurative geometric abstraction and a more 'topographical' one, prior to it, with certain passages in the modern philosophical discussions of geometry. There is Wittgenstein's attempt to rid himself of the 'Platonic' view that geometric forms are ideal entities against which reality is compared (or from which they would be 'abstracted'), and see geometric and 'ordinary' forms instead as quite incomparable, belonging to different language games. There is also the problem of the 'origin of geometry' in Husserl analysed by the young Derrida, and connected to certain non-geometrical notions of 'force'. As with the young Derrida, Deleuze finds such 'Baroque' force in Leibniz; but he connects it as well with models that depart from the sets and functions dear to Frege and Russell to describe things like continuous variation or topological points of singularity. For a critical discussion of this view, see Alain Badiou, 'The Fold, Leibniz and the Baroque' in *Gilles Deleuze and the Theater of Philosophy*, eds Boundas and Olkowski (London: Routledge, 1993). On the possible impact of such 'dynamic' non-rectilinear models in architecture, see Greg Lynn, 'New Variations on the Rowe Complex' in *ANY 7/8*.

23 See Mark Johnson, *The Body in the Mind* (University of Chicago Press, 1987). Today one might see Johnson as part of a sort of phenomenological reaction to the 'functionalist' thesis (the mind as brain-programme), to which Hilary Putnam, changing his mind, also comes to object. For his part Deleuze looks at the way the phenomenological theme of the 'flesh' (in which 'the mind' would be incarnated) took art or aesthetics as a privileged domain; in particular, he admires Maldiney . . . And yet he finds the idea of 'the flesh', with its religious overtones to be rather too *tender*, and so to miss the mad non-cognitive *violence* of the visual one sees for example in Bacon.

24 Stan Allen finds another, more 'cinematic' logic in Le Corbusier than the official 'mechanical' one, which in turn connects with certain 'light' features in contemporary architecture. ('Le Corbusier and Modernist Movement; in *ANY 5*, March/April 1994). Along similar lines there is perhaps a more 'Jamesian' or 'Bergsonian' logic to be found in Wright than the official organicist one.

25 See Gilles Deleuze 'Mediators' in *Zone #6*, eds Jonathon Crary and Sanford Kwinter. The same kind of problem concerning the fate of 'abstract thought' in politics is taken up in discussion with Tony Negri, where Deleuze declares: 'To believe in the world, that is what we most lack; we have completely lost the world, it has been taken from us.' *Pourparlers*, p 239.

26 Or, in Gerhard Richter's words in a well known interview with Benjamin Buchloh, the aim is 'to bring together in a living and viable way the most different and the most contradictory elements in the greatest possible freedom. Not paradise'.

THINKING THE REALITY OF ABSTRACTION
John Lechte

Introduction

Maybe it is the greatest of errors to pretend to speak *about* abstraction. For perhaps abstraction is indeed Mallarmé's *page blanche*, or the absolute emptiness upon which both the poet (Mallarmé) and the mathematician can only speculate. This is the emptiness that embraces us: the place that has taken place, the place as an 'event', as it were.[1] This could not be a place to which we are attached, however. On the contrary, what 'occurs', as an abstraction, is an entirely mobile universality: place as the purity of its own movement, which means that it is not limited in any way, that it continues never to be the same as itself.

Abstraction transcends limits. Is abstraction then a model – a formal entity based on (to speak mathematically) 'well-formed-formulas'? The chief weakness of this proposal is that such a model is a closed system, a system that thus rules out the other. Put simply: model A, by definition, cannot include model B and still be model A. The rule of 'well-formed-formulas' would seem to be the law of contradiction. Could abstraction have anything to do with myth, the body, imagination, language, and even thought itself? Let us, without further ado, propose that it does, and that were this not the case, abstraction would inevitably be a dead and sterile thing; it would collapse in upon itself. Indeed, such a view of abstraction as free of contradiction is the product of a Newtonian world. In such a world the model and the so-called physical world are entirely reversible: there is no remainder, no impurity, no rupture between model and world. This is abstraction without 'body'. Here, the model does not 'translate' the world into a formal system, thereby retaining the difference between world and model; for the Newtonian model *is* the world. Much later, Gödel's theorem would show that there is an undecidable point in every formal system, and that this point renders fragile any claim to eliminate contradiction. One can wonder whether abstraction, in its most essential being, does, or does not do justice to the undecidable.

Would abstraction be classification itself, and therefore the basis for distinguishing one set (of things) from another. Indeed. But let us also acknowledge that abstraction is in no sense reducible to the set (an identity) as such. On the contrary, abstraction is the condition of possibility of every possible set. Abstraction becomes an infinite multiplicity, and thus an infinite mobility. In mathematics there is the 'fuzzy sub-set' between zero and one where the set emerges out of the milieu being studied. The set is not prior, in any transcendental sense, to the milieu itself. Now it becomes clearer as to why abstraction is irreducible to any possible example of it. Instead, it is – in addition to being an infinite and mobile multiplicity – infinitely permeable. Hence the pertinence of Mallarmé's *page blanche*, provided we conceive of it as the *spectre* in abstraction: something that is both there and not there; something that is not reducible to a material substance. And so 'the veil of illusion' reflecting the 'haunting' character of engagements in immemorial time, the 'phantom of a gesture', the 'unique number' and 'chance' – all of these evoke abstraction in Mallarmé's poem.[2]

Hence the pertinence, too, of Freud's *wunderbloc* (magic writing pad) – an infinitely permeable surface, always ready to accept new marks while conserving existing traces – as an image of memory. Memory, according to this 'model' of it, would be abstraction – writing becoming abstraction: the 'concrete' becoming translated into the abstract thereby producing something new.[3]

Abstraction and classification, abstraction and writing – abstraction and the name – receive a further twist when the nature of the *khôra* is analysed. As is known, Julia Kristeva considers the *khôra* to be a 'nonexpressive totality formed by the drives and their stases'.[4] For Kristeva, as for Derrida (to whom we shall turn in a moment), the *khôra* is prior to nomination, prior to One and any form of unity; rather, it is radically indeterminate and outside meaning and interpretation. Is this materialistic, yet entirely unrepresentable, entity the true basis of abstraction – the concrete (a place), yet imperceptible and barely conceivable entity which gives abstraction its ambivalent status? Certainly for Kristeva the *khôra* constitutes the real basis of abstract expressionism in painting. The *khôra* is that indefinable, yet material, mark; it is the impure source of Kristeva's semiotic.

For his part, Derrida sees the *khôra* in Plato as the entity *par excellence* of ambivalence. The *khôra* is precisely what cannot be named. And so there is not even *the khôra*

– only *khôra*. 'Deprived of a real referent, what in fact resembles a proper name is also found to be called an x which has a property for *physis* and for *dynamis* the text will say, of having nothing of the proper and of remaining formless (*amorphon*).'[5] Derrida spells out aspects of the *khôra* which remain implicit in Kristeva. The *khôra* is an 'x' because it cannot be named; it has no 'sensible or intelligible, material or formal' determination, and thus no 'self identity' (*identité à soi*).[6] As with Kristeva, the *khôra* 'is' the (impure) mark: the mark as the mark of ambivalence. On the other hand, Derrida declines to link the *khôra* to the drives and thence to the formation of subjectivity, where – following Plato – the *khôra* would be predominantly feminine. To be avoided at all costs is a potentially anthropomorphic – and therefore interpretive – conception of *khôra*, which would be at the origin of meaning.

Out of Derrida's brief commentary comes the sense that Plato's *œuvre*, instead of being an unproblematic advocate of a transcendental notion of abstraction illustrated by the theory of forms, is in fact ambivalent regarding the nature of abstraction, as well as regarding the nature of 'origin'. Both the form and the formless are beyond experience and representation, as they are equally irreducible to any simple material manifestation.

We have thus arrived at the point where abstraction is simultaneously 'full' and 'empty'. It is potentially ready to accept new contents, but is never definable in terms of those contents. As a result, abstraction is not simply a transcendental entity. It remains to explore this view of abstraction, firstly through the writing of Michel Serres and his commentary on Turner; secondly, through an examination of the notion of aesthetics as Kant outlines it; thirdly, through a commentary on the paintings of 'writer' painters (Cy Twombly and Fred Williams); and finally, in considering the paintings of Pollock, and especially Rothko.

Serres Reads Turner

Rather than see abstraction (for example, mathematical abstraction), as fixed and transcendent, Serres explains that any abstraction that is to offer up something important is a form of invention. Synonyms for invention in Serres' writings are: 'translation', 'communication', and 'metaphor'. To be confronted by an enigma, or an entirely new problem, raises the possibility of invention in thought – whether this be a new mathematical axiom, or a new philosophical concept or set of concepts. Very often, Serres argues, the arts present the sciences with the material necessary to enable invention in thought to take place. The arts are the source of the renewal always necessary to the vitality of science and philosophy.

Similarly the arts enable science and concepts to be translated into images and poetry. So now, neither art, nor science, nor philosophy is predominant; rather, transport (= translation) between these fields predominates. The movement between art and philosophy or science is what is at stake today. Philosophy is a mode of transport in this sense, Serres claims.[7] The task is no longer to discover something, but to translate: to move between different regions. Scientific method, for its part, is no longer concerned with an isolated object, but with relations: 'inter-rogation', 'inter-subjectivity', 'inter-ference' – the last-named being what calls for translation. To reiterate: to invent is now not to produce, but to translate.

For Serres, too, the *khôra* has its place in relation to invention. Referring to Plato and the *Timaeus*, he presents the khôra as 'matter form' (*hylé amorph*) which calls for a concept – a mode of translating it into something communicable – into something 'morphous'. 'The morphous . . . is transportable, communicable, applicable, importable and exportable, it has this double and paradoxical characteristic of being independent and conservable, detachable and attached or individuating.'[8] Echoed here is the model of abstraction outlined above. Let us now move to a different field.

With the emergence of thermodynamics in the nineteenth century, the issue of chance takes on added importance. Stochastics develops as a method of studying random formations. Stochastics does not try to force recalcitrant matter into the prison of the schemata, but instead offers a way of translating randomness into order. Rain, ice, smoke, steam, clouds, waves, fire all take random forms. Turner translates the randomness of these formations into the paintings for which he is famous. Turner's geometry is no longer that of the Newtonian system with its exact angles, 'levers, balances, winches, pulleys, hoists, ropes, weights and blocks'.[9] Rather than being a 'pre-impressionist', Serres says, Turner is a 'realist, or, properly speaking, a materialist'.[10] He provides a vision of what 'no one had yet perceived . . . neither philosophers nor scientists (and who read Carnot anyway?) . . . With Turner we can date the introduction of igneous matter into culture. Turner was the first real genius of thermodynamics'.[11]

No one can draw the borders of a cloud: there is no representative model that can precede the randomness of the cloud's shape. In effect, randomness and Euclidean geometry cannot be reconciled with one another. No transcendental sphere exists in relation to which randomness may be ordered. With regard to chance, randomness, and aleatory processes of all kinds (cf John Cage's music) the Kantian division of 'noumena' (transcendental realm, the realm of unity), and 'phenomena', breaks down. The 'new'

abstraction is tied to materiality in a way that the old one never was. As a way of summarising this we can say that chance has no transcendent dimension.

As a result, with Turner, 'matter no longer lingers in the prison-houses of the schematic (the transcendental realm). It is dissolved by fire; it vibrates, trembles, oscillates and bursts forth into *clouds*.'[12] Turner paints the forge of the Industrial Revolution; he paints the age of steam – the age of thermodynamics and random processes. Turner's sea, sky, sun and fire become the embodiments of the irreversible time that seemingly fuels the Revolution, just as surely as the huge turbines of the steam technology. Let us add that Turner also paints abstraction; he is indeed the first modern abstract painter, one for whom the difference between transcendental reason and the material world no longer holds. On the contrary, chance holds. Chance and aleatory processes introduce a new mode of abstraction – one in which the abstract is the material element. Or rather, this new abstraction is the translation of a disordered materiality into concepts invented for the purpose of communication.

If, thermodynamically, energy is order and entropy is disorder, it is possible to see that Turner 'orders' (therefore provides the energy for) the 'disorder' that is steam etc. Turner's 'concept', in short, is the energy embodied in the order of the canvas itself. Turner paints (orders) chance. How can this be so? How can Turner paint the disequilibrium to which his canvas gives a certain equilibrium? Indeed, we have said above that abstraction is not reducible to any example of it; rather, it comes out of the milieu. Do Turner's paintings do the same? We need to explore these questions.

If Turner's paintings themselves embody a certain disequilibrium, this implies the possibility of multiple interpretations. Similarly, a mark can give rise to infinite meanings. In writing, too, the mark is called upon to give rise to a multiplicity of meanings. This holds for language in general: the mark is a form of abstraction in the sense of being both a generalisation and a reduction. The mark is the condition of possibility of classification and therefore of a multiplicity of meanings. The mark is the basis both of an economy and of abstraction. Turner's paintings, however, raise the question of the shape of a cloud, of steam, of fire, ice and snow. Because these are embodiments of random processes, there is strictly speaking no model that can be followed. Rather, the presentation of them in art is the model itself. The question that Turner's paintings raise is: can these phenomena be reproduced by a technique? Art schools and academies iron out chance elements and modelise clouds. We have just argued, by contrast, that a cloud is to be distinguished by that fact that it cannot be modelised. It is the epitome of

irreversible time. A way through, perhaps, is to paint a cloud purely by chance. We shall see later that Rothko's painting, in this respect at least, is the culmination of what Turner inaugurated.

At a more abstract level – and in light of Serres' insight – Turner paints turbulence; or rather, he translates turbulence and renders it communicable. Historically, this is a new way of seeing. Turner's technique for rendering the invisible visible could not have been predicted by a Newtonian framework. Turner, as we have seen, went beyond the sharp edges of geometrical figures which form the basis of Newtonian physics. Turbulence of the object becomes connected to the turbulence that always accompanies a truly innovative technique. This is a technique which, at every moment, recalls the brush strokes that gave rise to the images – such as they are – on the canvas. In other words, Turner's technique recalls the mark (the trait = stroke) at the heart of his painting. To this extent, Turner's paintings are *khôra*-like: they recall the unrepresentable materiality which constitutes them. They recall, too, the irreversible time which, at the very point that it is evoked by the swirling mists of paint, suddenly disappears into a representation and the technique. This means that the mark, the trait – the brush stroke – is ambivalent: it is both the object evoked (representation) and the chance effects of the paint itself on the canvas. Turner may well have been the first artist to paint the materiality of painting. Or – because materiality is a disorder (noise) that cannot be painted – Turner's paintings are the first to point towards the structure of the impossibility which gives rise to communication as an open system. As a result, Turner might translate Carnot, but can we really translate Turner? – can we really translate the chance effects to which his canvases give rise? The answer is: not entirely. For abstraction in Turner always leaves something that cannot be assimilated. And this is because abstraction here is neither ideal nor real, but both simultaneously. In short, Turner's paintings of mist and fog are open systems.

Surrealism and Abstraction

While keeping Serres' principle of translation in mind, it is worth recalling that surrealism also invoked chance and chance relations in its attempt to subvert conventional aesthetic principles and practices. Was surrealism therefore founded (without necessarily making this explicit) on the very principle of translation Serres has brought to light through reference to the history of science and its connection with philosophy? The question is complex, not least because even the key players in the founding of surrealism (Breton, Aragon, Soupault) did not provide any fully worked out philosophy of

the movement. Nevertheless, two things are clear: surrealism was interested in the unforeseen effects in poetry and painting brought about by the principle of juxtaposing apparently unrelated things – of, in short, inducing new effects by associating 'un-alike' with 'un-alike', of associating what was hitherto never associated, of bringing heterogeneity into the light. This is the principle embodied in Lautréamont's 'sewing machine and umbrella on a dissecting table'.

Secondly, as a mark of its resistance to conventional aesthetics and academic conceptions of artistic merit, surrealism opposed the measure of the value of art and literature by its exchange value. Thus, the *trouvaille* and items such as Duchamp's urinal were intended to counter the possibility of the art object being reduced to exchange-value and so being appreciated – or not appreciated, according to the case.

Closely connected to the interest in the *trouvaille* is the surrealist concern with so-called primitive art objects.[13] For such an object, although often displayed in a museum, defies exchange value; its interest is rather found in the exotic attraction of its material quality derived from its status as a use value. This is to say that the primitive art object is far from being abstract; indeed, it is, in principle, untranslatable. As I have tried to show elsewhere,[14] Georges Bataille's critique of this surrealist approach to the art object as defying exchange value, shows that surrealism forgets that the sacred object, once removed from its context, is by definition translatable – that is, conceptualisable. In short, it becomes abstract. For Bataille, then, surrealism forgets that materiality entails untranslatability: the object in the museum is just not the same object as one 'in its place' in the cultural context from which it has been removed.

Be this as it may, one might still hold that the surrealist principle of refusing easy substitutions or equivalences for the sacred object while still, in some sense, claiming that object as subversive of a flagging aestheticism forces the limits of abstraction to be expanded and the nature of abstraction to be transformed. In short, the sacred object would be equivalent to the destabilising effects of a chance encounter. The issue, then, centres on whether or not one can *translate* the sacred without it becoming a commodity.

This situation teaches us that the aesthetic object is abstract in that it is not fixed to any particular place. The aesthetic object (to the extent that an object is recognised as such) is thus endlessly translatable: it travels well. It is always in its place when there is no particular place that is specific to it. But what object exactly are we talking about? Not to specify any object is to turn the aesthetic object into an unchanging and, therefore, sterile abstraction.

The Aesthetic Object According to Kant

As Lyotard, Krauss and others have noted, Kant is canny in his presentation of the aesthetic object in the *Critique of Judgement*.[15] Any judgement of taste simultaneously reflects essentially subjective delight (ie beauty is not in the object), and yet commands, qua judgement, universal ascent as to its validity. This is its peculiarity. In a summary statement Kant writes of the judgement of taste that:

> although it has merely subjective validity, still it extends its claims to *all* subjects, as unreservedly as it would if it were an objective judgement, resting on grounds of cognition and capable of being proved to demonstration.[16]

There can be no science of the beautiful, nor can there be any concept of the beautiful in any judgement of taste, for only cognitive judgements (derived from the understanding) are subject to proof, only they have their own concepts which make them communicable, and are thus scientific.

Despite this, aesthetic judgements are essentially communicable although the aesthetic cannot be contained in a concept. Their communicability is, Kant claims, implied in their universality. In addition, however, communicability is part of any judgement of taste because taste is integral to man's social being. The point of any judgement, then, is that it be communicated. The merely agreeable is, by contrast, an entirely individual matter, deriving from the inclination of the subject, and for that reason perhaps it is difficult to communicate, if it can be at all. The beautiful pleases universally and is autonomous and so is undetermined by empirical considerations. This is the basis of the purity of the judgement of taste which has the beautiful as its concern. 'A judgement of taste, therefore, is only pure so far as its determining ground is tainted with no merely empirical delight.'[17] To be detached from, or undetermined by, the empirical means that the aesthetic object has no purpose other than itself. It is its own end, or finality. Such would be the basis of its purity, communicable as a purity of form.

We should be careful here. For while Kant speaks about 'pure form' he does not mean the purity of a geometrical form such as a circle; he does not mean, either, the form of mathematics or anything like the commonly agreed upon, and therefore stereotypical, forms of beauty. Neither does he mean that beauty is the outcome of the form produced by the rules and strictures of the Academy. There is no prior model for beauty. Beauty constitutes its own model. This is why poetry (the basis of genius) is where beauty lies. Beauty is not knowledge – whether this be everyday or mathematical knowledge. To be sure, Kant wants all the communicative power of mathematical or philosophical knowledge invested in an analytic of the beautiful, but without its con-

cepts or knowledge structure – without the proofs that make cognitive statements scientific. Judgements of taste are to have the same power to convince as scientific judgements, but they are essentially *sui generis*: unique, autonomous, without rules. 'There is no empirical *ground* of *proof* that can coerce anyone's judgement of taste.'[18]

Beauty cannot be taught, and only the *judgement* of taste can be communicated. To say what is beautiful is possible; but to define beauty is not. The judgement of beauty commands universal assent, but beauty is the universal as contained in the particular. Nothing is beautiful a priori, and yet the judgement of taste has all the force of an a priori judgement. In light of all this, is beauty also the embodiment of abstraction? To the extent that Kant says that beauty is the beauty of form (and not of content) it would seem so; however, this form (unlike a circle) does not exist prior to its specific realisation. Furthermore, beauty, Kant emphasises, is not in the object, but in the judgement of taste itself. Beauty is a judgement of taste which has all the force of an objective statement (ie all the force of a cognitive statement which can be verified through proofs).

From this it follows that the aesthetic object becomes a simulacrum of the judgement of taste itself. Its existence, in Kantian terms, is not its most essential quality. Of course, judgement needs an object – otherwise there would be no communication of judgement. But by contrast to the empirical object which is verified by reason and understanding, and which assumes a unity through its encounter with consciousness, the aesthetic object is completely dominated by the judgement of taste. The aesthetic object, then, is simply the necessary condition of the judgement of taste. Although Kant never says it, the implication is clear: the judgement finds itself an object in order to manifest itself. Apparently, like music, the aesthetic object is intelligible but untranslatable, mobile and yet absolutely specific.

The abstract aspect of judgement is, then, beauty. For Kant, this means that beauty (even though it is not confirmed by a cognitive judgement) is the universal unity capable of comprehending the 'manifold' of beautiful objects. Although no limit can be given regarding what beauty is (for the prototypical object of beauty is poetry, and truly beautiful poems are, to reiterate, the product of a genius for whom no model or rule can be adduced), beauty excludes ugliness, although the judgement of taste surely recognises what is ugly. Undoubtedly, aesthetic judgement includes the judgement of ugliness. Kant, however, entirely excludes the ugly from his *Critique*, although he does, to be sure, acknowledge that a work of art can treat of an ugly content and yet be beautiful. But this content is entirely accidental and so

quite irrelevant to the constitution of beauty itself. Like beauty, then, ugliness would be the result of a universal, subjective feeling as to what was ugly. The judgement of ugliness, too, in effect, would be distinct from a cognitive judgement. Recognition of the ugly immediately broadens the possible sphere of the Third Critique as far as the aesthetic object is concerned, but limits it with regard to the object of beauty. For although the aesthetic object (the beautiful *or* the ugly object) remains indefinable, a priori, we now see that the object of beauty excludes ugliness, a priori. However, such broadening is merely analytical: it necessarily follows from the terms of Kant's philosophy itself.

From Kant we learn that although the beautiful is subjective, it calls for translation – that is, it calls to be communicated; although beauty exists in the first instance essentially 'for me', *qua* beauty it must have a universal aspect; although beauty raises the question as to what is beautiful, there is no model of beauty on the basis of which an answer could be given. For Kant, therefore, beauty – the aesthetic object – is not exclusively ideal, it is also real. Or least it should be. With the exclusion of the ugly, however, Kant severely limits the sphere of the aesthetic object. He limits its reality.

What we seek to formulate, then, is an aesthetic which is truly aesthetic, which indeed 'translates' the object and at the same time shows itself to be a process of transformation. We turn now to painting in search of this aesthetic which would offer further insight into abstraction.

Writing/Painting

Our task, then, is to grasp abstraction in paintings. Before we attempt this, though, such a commentary must first set out the angle of vision to be developed. In particular, if we are alerted to the element of writing in, for example, the *œuvre* of Cy Twombly (as we are, thanks to Roland Barthes' commentary), are we to understand writing semiotically, as a system of visual signs? Indeed, is the linguistic model the one to be imposed onto the canvas? The answer is that we have to free ourselves from this temptation from the outset. For it would be the first step towards seeing a message in a painting; writing cannot be reduced to a message, or to an interpretation. Indeed, if writing there be, it is writing in its materiality that is at stake. Writing is the repetition of the mark, and the mark cannot be idealised. Writing is not, then, reducible to a message, even if the mark is the precondition of the message. Is it possible to see the mark as a mark – or have we not always already begun the semiotic process in recognising the mark? The latter is no doubt the case. As Derrida has shown, the mark does not, strictly speaking, have a phenomenal form. How can a painter show it to us

then? The answer is to be found in the relationship between gesture, technique and repetition.

Gesture reveals itself when the mark's significance is its presence on the canvas. Jackson Pollock's paintings thus reveal themselves *as* the trace of the gesture that brought the paint to the canvas. Pollock painting (cf the film by Hans Namuth) is therefore a Pollock painting! The meaning of Pollock's painting, strictly speaking, is that there is no meaning. However, an entirely meaningless gesture is incomprehensible, and even imperceptible. Non-meaning has to work through meaning, or *signifiance* – as Julia Kristeva has said in drawing attention to the semiotic, or drive dimension of art and language. In Paul Klee's terms, chaos has to be put on a scale and represented by order.[19] Put another way: the trace of the gesture has to emerge through a technique and then through a style. Technique and style enable the trait to be repeated. To repeat the trait, paradoxically, does not mean repeating any particular trait. The generality of the trait entails the impossibility of repeating exactly any individual instance of it. This is because chance and the irreversibility of time are integral to the trait. Through chance the brush stroke evokes the gesture (but not the artist) that gave it a phenomenal form. Turner's paintings of smoke and fire mentioned earlier must therefore also bring the trait to the fore. The difference between Turner and Pollock, or between Turner and Twombly, however, is that with Turner chance is located on the border between one colour and another, or between one tone of the same colour and another within a framework of representation: Turner, after all, is attempting to represent chance effects; Pollock and Twombly are producing them. One has to find, in Turner, the trait concealed by the representation; whereas in Twombly and Pollock, one has to find the representation concealed in the trait.

Strictly speaking, the trait is a pure contingency. It is Baudelaire's transient, fleeting and contingent moment. As such, the trait becomes the epitome of modernity. The trait thus defies the principle of reproduction consonant with reversible time. The trait is what is lost, not what is retained. The trait, viewed from this angle, is chance at its most profound; chance defies the possibility of art as re-presentation. But chance is precisely what is rarely taken into account. From this discussion the question arises as to what the phenomenal form of Pollock's painting really is. On one level, for example, we are in the presence of a phenomenal object, just as we are with Turner's paintings. However, while Turner clearly remains wedded to a framework of representation, Pollock moves out of it. Or rather, while Turner adheres to the principle of mimesis (even if he sets up conditions for going beyond it), Pollock refuses the principle:

Pollock's 'action painting' 'is' the object itself. It is just that this object is quite invisible. For Pollock paints the 'trait' – the general and indispensable principle for every painting – at the very moment of its actualisation. Pollock thus paints a lost moment; indeed, Pollock paints loss. This is the import of his contribution to abstraction. In what sense does Pollock paint this loss?

Clearly, Pollock's approach is different from that of the attempt to capture the frozen image – the moment as frozen – in the Newtonian sense. This is the sense embodied in *Las Meninas* by Velázquez, where the artist, in Foucault's words,

is standing a little back from his canvas. He is glancing at his model; perhaps he is considering whether to add some finishing touch, though it is also possible that the first stroke has not yet been made. The arm holding the brush is bent to the left, towards the palette; *it is motionless, for an instant*, between canvas and paints. The skilled hand is *suspended in mid-air, arrested in rapt attention on the painter's gaze*; and the gaze, in return waits upon the arrested gesture.[20]

Such would be the instant as it is 'caught' by the Newtonian painter of the mid-seventeenth century. This is the instant as it is reproduced, represented and so subjected to the imperative of reversible time. Effectively, then, the irreversible instant is forced into the imperative of the reversible time of representation. Or, to put it differently: to a late-modern gaze, Velázquez's painting is a representation and a codification of the moment, while Pollock's painting (eg *Number 32 1950*) is an analogue of time.

Two gestures thus confront each other in the history of art and thought: one brings the gesture into being by way of the principle of reproduction (*Las Meninas*), the other *is* the uncodifiable gesture itself, in all its (relative) immediacy. Gesture can be translated into mark, mark into trait, trait into gramme, and gramme into writing. Looked at in still another way, the difference between the two gestures centres on their repetition – that is, reproduction. To repeat the gesture that is *Las Meninas*, is to reproduce the painting so that the distinction between the original and the reproduction no longer exists. That art history determines that the original cannot be reproduced derives no doubt from the insight brought by Pollock to the effect that originality is constituted by the gesture which produces the object and not by the intrinsic nature of the object. For, to be sure, the perfect reproduction of a classical painting is certainly within the capacity of modern technology.

One thing should be made absolutely clear here. Although the gesture comes into view in Pollock's work, this gesture *does not* belong to Pollock, and even less does it

refer to Pollock himself. Were this the case, we would be dealing with a sign, and not with the gesture. Within this semiotics, the gesture would remain invisible – much as the word 'tree' becomes invisible when the image of an actual tree predominates. The gesture does not belong to Pollock, and this is why his painting brings it into the light. Or again: because the gesture is essentially abstract, Pollock's painting renders it visible.

If Pollock brings the inimitable gesture to the fore in his work, Fred Williams, as I have shown elsewhere, brings the trait to the fore in his encounter with the Australian land.[21] Like Pollock, Williams, too, shows what cannot be shown. For the trait, like the mark, is not linked to any context because it is not a sign; it is, rather, the condition of possibility of context. The trait, like the mark and the gesture, is produced immediately in circumstances which are absolutely specific; and yet, as such, all these are bound by no particular context. The trait, therefore, 'is' the abstract in the material instant. The trait in itself defies interpretation, but is the basis of every interpretation. Like the *khôra*, then, it is simultaneously concrete *and* abstract.

Practically, this means that with Twombly, Pollock and Williams – and no doubt with certain other so-called abstract expressionist painters – there is an aspect of the painting which explicitly defies interpretation. This is the aspect of chance and indeterminacy brought into view, the aspect which both calls for, and defies, interpretation. *Las Meninas* stands at the threshold of modernity in the midst of Newtonian physics, and resplendent in the claim that it is representation incarnate: not a brush stroke out of place (that is, the trait is invisible); perspective is developed to the full through the frame; time as the moment, is caught – determined – and, in principle, made fully present to the hypothetical viewer whose place is clearly implied in the closed system of perspective. The thought of the age holds out the prospect that there is a single geometry which can be read, a single system of formalisation and interpretation, and this is it. To recall Serres, we can say that this is entropy defeated in the total order and determinacy of reversible time. Understood in these terms, abstraction becomes a formal system capable of including itself in its own formalisation. This is a system, in short, where there is no 'other'.

Sculpture and Abstraction

The writer–painters find their counterpart in sculpture with, amongst others, Giacometti and Beuys. In a film made about his career a few years before his death, Giacometti was asked why his sculptures had a certain repetitive quality, particularly his post-war figure works. In reply, the sculptor said that when confronted with a unique individual which he tried to represent, he realised that the task was impossible:

> The strange thing is, when you represent the eye precisely, you risk destroying exactly what you are after, namely the gaze . . . In none of my sculptures since the war have I represented the eye precisely. I indicate the position of the eye. And I very often use a vertical line in place of the pupil.[22]

Giacometti recognises, in effect, that with a human being uniqueness is not of the order seen in *Las Meninas* where the moment is frozen and closed off from other moments, perhaps for a millennium. Repetition in Giacometti's work means that the human is an index of the chance effects of individuality – that individuality is the material moment which is as abstract as it is concrete. Similarly, Julia Kristeva's theory of the *sujet en procès* and the subject as an open system entails that the artist is transformed by the challenge thrown down by his or her art. In Giacometti's case the challenge centres on how to represent individuality. Above all, though, indeterminacy is vital to Giacometti's sculpture in the period in question. It opens the way to interpretation, but will never be fully interpreted. Translated into what have become familiar terms: the identity of individuality (determination) gives way to difference (indeterminacy). Care is of course needed so as to avoid reducing difference to something that is essential to identity. What Giacometti shows is that difference is inessential and contingent: it is always possible, and yet can never be taken into account.

As concerns the sculpture of Joseph Beuys, Gregory Ulmer has pointed out – against Kant, in effect – that genius no longer pertains to the creation of a unique work by an author, but in performing: performing the language, performing the script inspired by an object, performing the dramas of one's psyche, etc. As a young man Beuys wanted to study the natural sciences but was discouraged by their narrow and specialised nature – by their attempt, perhaps, to be equivalent to a perfect representation of their operations. As against the sterile mode of positivist science, Beuys has used autobiography and detritus as instruments for thinking. In *The Pack*, for example, a VW bus ended up as the rescue vehicle loaded 'with children's sleds each carrying a roll of felt, a flashlight, and a glob of fat'.[23] In sum Beuys' sculpture amounts to new ways of thinking with a large diversity of objects. Instead of being categorised and forced into certain categories – that is, classified and given a certain formal identity – Beuys uses diverse objects as thought objects. Thought, then, does not illuminate the object, as did the science from which the sculptor once sought to escape. Rather, thought and the object fuse in a process of

generating thought. Similarly, Beuys does not use sculpture to illuminate and understand his biography – that is, to understand himself – but instead uses his biography to generate new openings in thought and sculpture.

Again, as Ulmer also shows, just as Derrida uses a great range of contexts, meanings, and objects to highlight a general, and much expanded notion of writing as inscription, so Beuys uses sculpture to expand the range of the term *Plastik*. In Ulmer's words: 'Working in terms of their respective points of departure – theory of language and the art of sculpture – Derrida and Beuys each formulated the highest generalisation yet produced to account for human creativity, which may be seen as the equivalent in cultural studies of Einstein's formula in the physical sciences (they function at the same level of generalisation).'[24]

Rothko Translates Cantor: Rothko Magic

A profound insight into abstraction is also opened up by the paintings of Mark Rothko. When looking at Rothko's multi-coloured painted surfaces, we can ask whether or not painting has here become an end in itself and therefore fetishistic. That is, might not Rothko's works (perhaps along with those of other abstract expressionists) signal the end of painting as a medium? Surely not. Rothko paints obscurity and constantly alludes to the struggle for illumination. He does not paint paint – the medium – but the obstacle to mediation: the noise of mediation. His surfaces of darker hues are not therefore a sign of the artist's depression, or, more generally, an intimation of death, as some have claimed the blackness to mean. Nor does Rothko's work lend itself to the paranoid style of Dali's surrealism (perceptible in some of Rothko's early work) where the viewer would be free to read his or her fantasies into the surfaces in question. The absolutely minimalist titles can be read as an initial indication of that. On the contrary, if Rothko is after an experience of the void, it is not a void as represented, but as confronted in the absence of representation. Rothko's work, in this sense, is at the very limit of thought. Is this limit also that of the infinite? Before going on to answer this question, let us repeat that the point to which Rothko's paintings bring us is not the materiality of paint as such, nor is it to the point of presenting the void, but to the point, as Lyotard would say, of the impossibility of presenting the void, or, as we prefer to say now, of translating the void.

As the history of mathematics shows, the infinite, from Aristotle to Cantor, is premised on the impossibility of ever presenting a completed, empirical infinity. To do so, it was thought, would mean establishing a limit, whereas the infinite is precisely without limit: it is limitless. This is an infinity which cannot be thought because it is deemed to be beyond the capacity of the human mind. A finite being cannot think that which is unlimited: infinite. After Cantor, modern theories of the infinite focus on the infinite constituted by a limit, and on the notion that there is more than one infinity (cf transfinite numbers). For, indeed, were Aristotle correct, the infinite would be a unity or Oneness – an identity, in short. As Kristeva has shown in the more neglected of her writings,[25] One – unity – is what signifies; it is representative discourse. The subject of this discourse identifies with the law. The infinite, by contrast, includes what cannot be included in a representation. In short, the infinite includes what does not belong to it. It is contradictory and not identical with itself. The infinite is the class which contains a member which is of the same power as itself. Or: the infinite is that number which is the first number after all finite ordinal numbers have been counted. In other words, the infinite is not the sum of all finite numbers, for the sum of all finite numbers is still finite. A qualitative leap is necessary to arrive at the infinite. As a receptacle, the infinite evokes the *khôra*, as discussed by Kristeva in *Revolution in Poetic Language*. A receptacle here is neither the thing (content) it contains nor is it a thing itself. The logic of the receptacle is different from the logic of the content. This is the logic indeed of poetic language. Its space is 0-2 in contrast to the space of science which occupies the 0-1 (1 = unity) space. The logic of poetic language turns on constituting a set which is discontinuous with its members – that is, a set which is qualitative and not quantitative in nature.

Looked at from an infinitist perspective, poetic language is not a quantity of words or utterances, however organised (by grammar, syntax and rhetoric) these might be. Indeed, from an infinitist perspective, poetic language is not just language. An infinitist perspective breaks the bonds of relations in order to constitute something entirely unique. In short, the poetic word is not just another word. It is singular. To utter the poetic word, therefore, is not a matter of indifference. It is equivalent (even if to speak of equivalence is paradoxical) to the 'magic' word – the word which has effects in its being uttered. A number of things come together here: the notion of a speech act where one *does* things with words; the importance of the level of *énonciation* over that of *énoncé*; and the fact the poetic word constitutes its own grammar: it is autonomous and not part of another system; or rather, the poetic word is a set which has a member equal to itself (the part and the whole coincide). Psychoanalysis (inspired by Lacan) uses an infinitist perspective in its practice. It has discovered that words can have definite effects as individual entities in their own right, independently of the code of (natu-

ral) language. Let us now turn to Rothko's paintings and consider whether or not the infinitist perspective is illuminating.

In the viewing of his paintings, Rothko insisted on two things: 1) that they were not exercises in the use of colour, and so did not only refer to themselves; they were not abstract in this sense,[26] and 2) they were not simply communicating a spiritual message – they were not self-expressive.[27] In other words, these works are subject to a quite different logic. They are not closed systems referring only to themselves, and yet neither are they signifying something in any conventional sense. Significantly, some of Rothko's earlier works of the 1940s (see *The Omen of the Eagle,* 1942), were influenced by Dali's paranoiac-critical method, where a painting would be intended to stimulate a myriad interpretations in a kind of simulation of the paranoid person's tendency towards over-interpretation. As Dawn Ades writes in her book on Dali, 'Dali defined the paranoiac-critical method as a form of "irrational knowledge" based on a "delirium of interpretation". It lies at its simplest in the ability of the artist to perceive different images within a given configuration'.[28]

Rothko broke with the Dalian method in the late 1940s and developed a strategy which would reduce interpretation to a minimum, or at least that is the point for those capable of refusing to give in to their nascent paranoia. Whereas the surrealist aims to generate many meaningful images from a single configuration – or 'grammar' – Rothko aims to make each painting equivalent to the 'grammar' alone. Although an obvious feature of his work from the 1950s onward, it is worth reiterating that there are no images in Rothko's paintings of the post-surrealist period. Or again: it is to miss the uniqueness of his contribution to painting if one projects images – and thence a narrative – onto Rothko's works. Of course, this is precisely what has been done. Thus in an otherwise informative commentary on Rothko's *œuvre,* Diane Waldman begins her concluding remarks in her introductory essay to the 1978 Rothko retrospective exhibition catalogue by comparing Rothko with Caspar David Friedrich: 'Both artists stand in awe of the spirit, both use nature (sic) to express the spirit.'[29] Waldman characterises Rothko as an expressive artist even though she also acknowledges that one of the 'universal truths' Rothko's work expresses is the relationship between the finite and the infinite'.[30] Here it is difficult not to think that Waldman was unaware of the implications of what she was saying. For the infinite and the finite are indeed at stake, if not necessarily in terms of a relationship, since the infinite is that towards which the finite has no relation.

Even if, in order to appreciate the profundity of the infinite in them, Rothko's paintings are no longer to be grasped as an expression *of* something, it is also true to say that they – to speak in the manner of Heidegger – disclose something never seen before. This 'something' is a certain way with colour. Is colour itself essentially abstract? When Serres discusses Turner's paintings in terms of random distributions, he does not discuss colour. But colour is there. Colour is there without any clearly defined border. Colours flow into one another. In fact, colour could well be defined as flow, as movement. Any line – any border – on the other hand, is ambivalent. Pure colour approximates the semiotic in Kristeva's sense.[31] It is prior to the (symbolic) law, prior to the symbolic in its *khôra*-like existence. Rothko, need we add, uses colour in the mode of the *khôra,* but in order to show the effects of chance, or the infinite. Let us be more specific.

From Turner, Rothko recalls the colour of the random, chance configurations that Serres reveals to us. Rothko shows that pure colour is a random configuration, a configuration founded on chance effects, a configuration which cannot be 'predicted' by the series of infinite numbers. If such a framework is valid, how does it enable us to 'read' Rothko's works? In the first place, the grand artist of American expressionism cannot be read as though each of his works formed a series to be read from beginning to end. This would be tantamount to denying the specific differences between each work, a point that Rothko began to insist upon with his demand that each painting be shown under strict conditions, away from other paintings and with light of a certain brightness. Rather we have to 'read' Rothko's *œuvre* as though as each work were disconnected from the others. Far be it for this author to claim that Rothko cannot be 'read' within the framework of what constitutes a series. The finite is always there for those who would prefer the security it offers. What is being argued, however, is that the 'finite' and the 'series' evoke the author of the works. Instead of a painting before us, the notion of a finite series says that 'this is, above all, a Rothko'. By contrast, the approach that Turner set in train, is that in focusing on chance, it is the irreversible elements, those which could never be repeated, that permeate each work of the later Rothko. It is not just that each work is different; for what artist does not paint individual works? Rather, Rothko paints difference and in so doing, perhaps, puts his very being into question. Consequently, the uniqueness of the 'relation' between *Three Reds*, 1955, and *Yellow, Blue on Orange*, 1955, is their non-relational aspect, or what gives each work its own 'being' – what makes each work singular. For this reason, to analyse a single Rothko painting becomes an enormously complex task, one that might even have to find a new vocabulary for each work.

Surely, therefore, we are saying that Rothko's works are

untranslatable, that the one cannot be compared to the other. No; this is not what we are saying. For to be able to translate is a condition of possibility of the critical process. Instead, it is necessary to understand that the Rothko paintings which break away from surrealism attempt to grapple with the untranslatable. They attempt to translate the untranslatable. When I look at *Yellow, Blue on Orange*, 1955, I see the merest suggestion of orange under the blue. When I look at the blue, I see – amongst many other things – that this blue turns to whitish yellow along the middle of it bottom edge. When, again, I look at the blue I notice its uneven saturation. Light comes through and, indeed, I could be in a suggestive mist. This blue moves, as if by chance, unevenly into a reddish border on the right-hand side and into an orange border on the left. An uneven white wash could have been put over the entire blue area thereby accentuating the jagged nature of the edges. Yellow, in a subtle and wispish fashion, penetrates, as if by chance, into the blue, and the whole of the yellow expanse unevenly occupies the space of the orange. Tonality, based on modulation as much as on contrast, also has its own unique being. In *Blackish Green tone on Blue*, 1957, the tonality of the green changes from lighter at the edges of the difference between the black and the blue border, to darker through again to lighter. The blackish green is edged by lighter green, a green through which the blue background comes through in uneven chinks in the surface. Here we have a cloudy – that is, random – surface. Through the jagged edges and the varying tonality, Rothko gives the impression of having produced a controlled randomness – for these canvases obviously are not without order nor are they arbitrary. They evoke, with their hazy borders and fuzzy sets. Nothing is sharp; everything is out of focus, blurred, slightly out of kilter, asymmetrical and impure. This is the true – because unreproducible – mark of beauty. There is more – but we need to summarise.

With regard to a work such as *Blackish Green tone on Blue* no other Rothko painting has such a blue. In no other painting do these colours interpenetrate in the same way. This is how colours constitute the chance uniqueness of this painting. Rothko's wager, to be sure, is a high one: nothing less than a revision of the way in which paintings are 'read'. And maybe this is why critics have been silent when it has actually come to analysing Rothko's works. This mode of reading, which is indebted to the principle of the infinite, also enables us to see that each work has a magical quality: it has effects in its own right and not simply in terms of the relationship of each work with every other. To speak of the magic of Rothko's *Blue Cloud*, 1956, is to allude to the effects it has as a unique work. Every truly unique work has

effects if only because it calls to be understood and thus begins to transform the one who attempts to understand it. The painting ceases to be another instance of the same and becomes truly 'other'. Each painting in fact counts (has the value of) the series of which it is a part. It is the part which is equal to the whole, and chance confirms this principle.

There is much more to be said – more than can said here before the full effects of Rothko's painting can be fully appreciated. However, we can set out some possible implications. First of all, we note that Rothko's contribution to painting does not reside in bringing the uniqueness of a work of art to the fore. The history of art over the past two centuries is precisely about how the uniqueness of a work might be represented. By contrast, Rothko's painting takes uniqueness as its point of departure. It makes uniqueness the subject of painting. Rothko's works bring uniqueness into the light through magnifying chance, contingency and irreversible time. This is not because Rothko is an action painter – although the mark is also present, as it is in Pollock. Rather, it is because Rothko, painting within a problematic opened up by Turner, relates colour to chance effects and to the infinite. Each work is both unique and a kind of sign of uniqueness. Each thereby has a magical effect – an effect which seems to introduce a disembodied aspect, as though these Rothko works were in fact painted by no one. This is, to conclude, painting itself in all its autonomous force. Or, to put it in terms consonant with the theme of this essay: Rothko's painting is abstraction realising itself in the unique object.

Conclusion

Through the approach taken above, abstraction has not been defined so much as elaborated and constructed. An attempt has been made to push an understanding of abstraction beyond the metaphysical and transcendental realm where it has often been located. This is the realm of purity (cf pure theory) where the complexities – the noise – of externality is kept to a minimum. Abstraction as *khôra* is far from being pure and simple, as Descartes hoped knowledge would be. Instead, abstraction has come to be muddied: it deals with things it literally cannot deal with. In this, it begins more and more to assume the features of an open system, the system emerging in complexity. Even though we have continued to associate abstraction with conceptualisation – a move which might encounter objections of thinking of a Heideggerian kind – this conceptualising is not closed, but remains the harbinger of future possibilities. It is the opening up of concepts to the genuine coming-into-being of objects. The object (and not objectivism) is at last being given its due in the complex activity which Europeans still call 'art'.

Notes

1 Stephane Mallarmé, *Un Coup de dés,* in *Œuvres Complètes* (Paris: Gallimard, 'Bibliothèque de la Pleiade', 1945), p 475.

2 *Ibid*, p 464.

3 See Jacques Derrida, 'Freud and the Scene of Writing' in *Writing and Difference*, trans Alan Bass (University of Chicago Press, 1978).

4 Julia Kristeva, *Revolution in Poetic Language*, trans Margaret Waller (New York: Columbia University Press, 1984), p 25.

5 Jacques Derrida, *khôra* (Paris: Galilée, 1993), p 33.

6 *Ibid*, p 35.

7 See Michel Serres, *L'Interférence* (Paris: Minuit, 1972), p 10.

8 *Ibid*, p 121.

9 Michel Serres, 'Turner Translates Carnot', trans Mike Shortland, *Block* 6, 1982, p 49.

10 *Ibid*, p 51.

11 *Ibid*.

12 *Ibid*, p 52.

13 This is discussed at length in Rosalind Krauss, 'No More Play' in *The Originality of the Avant-Garde and Other Modernist Myths* (Cambridge, Mass: MIT Press, 1986), pp 42-85.

14 See John Lechte, 'Bataille, le sacré et l'autre', in Christopher Thompson (ed), *L'Autre et le sacré* (Paris: L'Harmatton, 1994).

15 Immanuel Kant, *Critique of Judgement*, trans James Creed Meredith (Oxford University Press, Reprinted 1978).

16 *Ibid*, p 141, Kant's emphasis.

17 *Ibid*, p 65.

18 *Ibid*, p 140, Kant's emphasis.

19 See Paul Klee, *Notebooks Vol I: The Thinking Eye,* trans Ralph Manheim (London: Lund Humphries, 1961, reprinted 1973), pp 2-3.

20 Michel Foucault, *The Order of Things*, translated from the French, (New York: Vintage 1973), p 3 (my emphasis).

21 See John Lechte, 'The Obscure Poetics of Fred Williams', *Journal of Philosophy and the Visual Arts* 3, 1992, pp 82-90.

22 Cited in Reinhold Hohl, *Alberto Giacometti* (New York: Abrams, 1971), p 171.

23 Gregory Ulmer, *Applied Grammatology: Post(e)-Pedagogy from Jacques Derrida to Joseph Beuys* (Baltimore and London: Johns Hopkins University Press, 1985), p 240.

24 *Ibid*, pp 241-242.

25 See Julia Kristeva, 'Pour une sémiologie des paragrammes' in *Séméiotiké: recherches pour une sémanalyse* (Paris: Seuil, 'Points', 1969), pp 113-146.

26 '"I'm not an abstractionist . . . I'm not interested in relationships of colour or form or anything else."' Rothko in Seldon Rodman, *Conversations with Artists* (New York: Devin-Adair, 1957), p 93, cited in Anna Chave, *Mark Rothko: Subjects in Abstraction* (New Haven and London: Yale University Press, 1989), p 25.

27 '"Painting a picture is not form of self-expression. Painting like every other art, is a language by which you communicate some thing about the world."' Transcription by Dore Ashton of lecture by Rothko given on 27 October 1958 at the Pratt Institute, cited in Dore Ashton, *About Rothko* (Oxford University Press, 1983), p 144.

28 Dawn Ades, *Dalí* (London: Thames and Hudson, reprinted 1991), p 119.

29 Diane Waldman, 'Mark Rothko: The Farther Shore of Art', in *Mark Rothko, 1903-1970, A Retrospective*, catalogue (New York: The Solomon R Guggenheim Foundation, 1978), p 69.

30 *Ibid*.

31 Julia Kristeva, *Revolution in Poetic Language*, p 26. Although colour is not explicitly mentioned here, it would correspond to the 'raw material' of the image as a representation. For an explicit reference to the notion of 'un espace sémiotique' as this relates to the 'pulverisation' of the image; see also, Julia Kristeva, 'Jackson Pollock' in *Art Press* 55, January 1982, pp 5-6.

THE THIRD EYE
Nick Millett

Towards the end of *What Is Philosophy?* Gilles Deleuze and Félix Guattari give what is, in effect, their definition of abstract art:

> Abstract art seeks only to refine sensation, to dematerialise it by setting up an architectonic plane of composition where it would become a pure spiritual being, a radiant thinking and thought matter, no longer a sea-sensation or a tree-sensation, but a sensation of the concept-sea or the concept-tree. (187)

Abstract art nonetheless creates sensations and not concepts. *What Is Philosophy?*, within its delimitation of the domains and procedures of philosophy, science and art, partially rehabilitates abstract art. What calls for this rehabilitation is primarily Deleuze's antipathy to abstract art as it is expressed in his book *Francis Bacon: The Logic of Sensation*. There, 'pure' abstract art is described as an operation of effectuation in terms of a 'plane of organisation' – a description which carries negative connotations in that in *A Thousand Plateaus* (published a year before *Francis Bacon*) a 'plane of composition' was attributed to authentic artistic process. This inauthenticity or need to name the authentic reappears in the citation from *What Is Philosophy?* in the term 'architectonic' but effectively only minimises rather than impedes the necessary reduction of the difference between the two planes and the instances of their usage in terms of abstract art. This reduction is necessary because the later book seeks to outline the procedure of all art: 'all art is sensation', and:

> 'Composition, composition is the only definition of art. Composition is aesthetic, and what is not composed is not a work of art.' (181)

What, then, is happening in the adjustment of Deleuze's position on abstract art? Is it simply a question of ends – from the need to differentiate the singularity of a particular painter to that of minimising differences in a general concept? Rather than tracking the fault lines in the condensed definition of abstract art given above, I want to shift between Deleuze's registers, partly to explore the vicissitudes of his descriptions of various types of painting, and partly to see what is lost in the move to the final delimitation of Art in *What Is Philosophy?*.

The genetic continuity between *What Is Philosophy?* and the earlier works is obvious on all fronts but can be signalled in the aesthetic domain by the following quotation: 'The eternal object of painting: to paint forces' (172). This statement reasserts Deleuze's claims made ten years earlier regarding the painting of Francis Bacon (*Francis Bacon: The Logic of Sensation*, Ch VIII 'Painting Forces'). There he elaborates on Klee's much repeated phrase, 'not to render the visible, but to render visible', as signalling a 'capture of forces' and resolutely not a reproduction of forms (39).[1] It is here that the impotence of a certain type of abstract painting is found, for it functions by an operation of *transformation* and an *optical* spatial organisation. Deleuze gives this type of painting short shrift as merely an idealism of the worst, Hegelian, kind. An original form is merely recoded into an ideal Form which is elevated to a transcendent plane of organisation. The manual act of painting is interiorised and foreclosed; the painting is the realisation of an ideality already existing in an abstract realm. If for the Bergsonian Deleuze, the real impotence of this type of art is that nothing new is produced, for Henri Maldiney (109), Deleuze's main influence in aesthetics, it is the solipsism of abstraction (especially Kandinsky) which is most problematic: *existence* is interiorised into an autonomous subjective world only through the objectification into eidetic structures of 'the pathic moment of the encounter' or sensation. For both Deleuze and Maldiney sensation plays a constitutive role on the plane of immanence or composition while such interiorisation by abstract art is an act of determining transcendence.

Deleuze's resistance to what Maldiney calls the intellectualisation of the pathic is consistent with his philosophical temperament. Thus the procedure of this abstract painting is parallel to the illegitimacy of Hegelian ontological process, whilst its result (transcendence of the sensible) or much vaunted 'purity' is likened to Kantian morality's amputation of the body.[2] The impetus behind Deleuze's anti-abstraction is clear if we consider that the programme of his philosophy, one where aesthetics clearly cannot fill a derivative role, is Nietzsche's 'reversal of Platonism', which he describes as follows:

> Give me a body then – that's the formula of the philosophical reversal. The body is no longer the obstacle

which separates thought from itself, that which it must overcome in order to think. On the contrary the body is that in which thought plunges or ought to plunge, in order to arrive at the unthought – life, that is . . . No longer will life be subpoenaed [*faire comparaître*] before the categories of thought – thought will be flung into the categories of life. (1985; 246)

Rather than setting out from abstract concepts to which the world must conform, thought must go into the world and extract. Since such a procedure aims 'to find the conditions under which something new is produced (*creativeness*)' (Deleuze, 1987b; vii), both a philosophical approach which takes the world as the concretion of the abstract and an artistic practice which merely validates that claim by giving form to the abstract will be anathema to Deleuze: painting cannot have a merely epithetic existence. Thus just as he acknowledges Hegel's and Kant's reversals of Platonism but describes them as only 'abstract' (Deleuze, 1969; 292), so he recognises the radicality of the rupture with classical representation performed by pure abstraction but seeks a painting that breaks with the figurative in a 'more direct and sensuous [*sensible*] way' (Deleuze, 1981; 14). One might think, judging from the quotation from *Cinema II* (1985) above, that Deleuze would find the path he seeks in abstract expressionism.

For nowhere is the *act* of painting, the presence of the body in that act and as that which makes the painting possible, more emphasised than in what Harold Rosenberg christened 'Action Painting'. And if Deleuze challenges Greenberg and Fried he goes out of his way in the book on Bacon to underline Rosenberg's description (1981; 69). Indeed that challenge is itself a vindication of the term 'Action Painting' since it reasserts the act's composition of the space of the painting, the continuity in nature between the act and that space. Deleuze's designation of the space produced by abstract expressionism's manual operation appears to contradict therefore Greenberg and Fried's description of it as 'strictly optical'. However, Deleuze is right to see their differences as purely nominal for there is a certain continuity between his aesthetics and Greenbergian modernism.[3] Essentially the problem revolves around a failure on the formalist critics' part to distinguish between classical representation and figuration. Their term 'optical' is deployed against the imaginary tactile markers of representative space whilst Deleuze's term 'manual' is deployed both against the pure optical space of abstraction and the relative subordination of hand to eye (tactile to optic) in classical representation. For if abstraction breaks with classical representation it remains figurative, 'since its line still delimited a contour' (68). Thus for Deleuze the violence of this new abstract art is primarily ocular, collapsing optical organisation and debasing the optical horizon to a tactile ground. The new painting selects or abstracts 'one of the most prodigious constants of painting' and isolates it as its operation. This element is the *abstract line*, whose autonomy, or non-subordination to form, operates a *decomposition* of matter.

Throwing out abstraction's 'inner optical keyboard' with its binary processing and 'symbolic coding of the figurative' (1981; 70), sewing the hand back on where there was only a mutant digit, does abstract expressionism meet Deleuze's demands for a 'more direct and sensuous' painting? The question cannot receive a univocal answer, for on hearing that this painting releases matter's 'lineaments and granulations' (68) any reader of *Anti-Oedipus* would doubtless answer affirmatively, and *The Fold* goes as far as confirming that 'the Baroque is the *art informel par excellence*' (1988; 49).[4] Indeed, the description of the Baroque-informel in *The Fold* would suggest that Deleuze's aesthetic *tout court* was Baroque: 'Matter which reveals its texture becomes material, as form which reveals its folds becomes force' (1988; 50). The fundamental failure of abstraction, blocking the passage from form to force, appears overcome. Yet as Mireille Buydens (129) correctly notes, it is perhaps only *abstractly* that *art informel* would be the 'absolute art'; after all, Deleuze's aesthetic is not univocally Leibnizian, there is still Spinoza. Thus my quotation from *Cinema II* above continues with one of Deleuze's favourites:

The categories are precisely the attitudes of the body, its postures. 'We do not yet know what a body is capable of' . . . To think is to learn what a non-thinking body can do, its capacity, its attitudes or postures. (246)

To learn how a body is composed (its power) the procedure of decomposition seems a logical enough approach; yet Deleuze seems to suggest that this remains too abstract and that, on the contrary, composition might include most effectively decomposition as its instance. Indeed, 'effectivity' appears to be deployed as the single criterion in Deleuze's consistent search for a *practice* effectuating the diagram of the plane of immanence. Thus if in general he employs the term 'abstract' in the prosaic sense of distancing from 'the concrete richness of the sensible' (Deleuze, 1987b; 54), concentrating the full force of the prefix, it is in empiricism that he finds a practice which short-circuits the positing of abstract first principles and a conception of thought as *experimentation*. This practice, however, does not take place *in* but is an experimentation *of* the transcendental field which is constitutive of all experience – it composes this field. If to experiment is to investigate the question: 'what is a body capable of? what affects . . .?' (Deleuze, 1987b; 61), and if

'painting is thought' (Deleuze, 1991; 184), then painting's task is not only to access the transcendental field, to render sensible the forces that compose molar existence;[5] it is also to experiment it – that is, concomitantly, to create new affects.

To turn to a third strain of painting, a third pictorial space and a third operation is to examine indirectly the statement that *art informel* would only abstractly be the absolute art and does not fulfil the demands of what might be called a Spinozist art. This third strain reaches its apogee with Francis Bacon and the production of a *haptic* space. Bacon's painting does not simply invert the figurative's tactile-optical space into abstract expressionism's non-figurative manual space, neither does it sublate the tactile-optical difference into the pure optical space of abstraction (where figuration is internalised): it works *figurally* within the figurative to produce a haptic space, which is when 'sight itself discovers in itself a tactile function [*fonction de toucher*] which is proper to it, and belongs only to it, distinct from its optical function' (Deleuze, 1981; 99).[6] Deleuze declares unequivocally at the end of *Francis Bacon: The Logic of Sensation* that the passage from hand to haptic eye 'is the great moment in the act of painting', since, 'it is there that painting discovers at its base and in its own way the problem of a pure logic: to pass from the possibility of fact to the fact' (102). Moreover, the book concludes with all the rhetorical force of recapitulation in the following hyperbolic equation of the fact with the passage itself:

> But the fact itself, this pictorial fact produced from the hand, is the constitution of the third eye, a haptic eye, a haptic vision of the eye, this new clarity. As if the duality of the tactile and the optical was overcome visually, towards this haptic function issued from the diagram. (103)[7]

Rarely, except when he is invoking Spinoza, do we find Deleuze so evocative. Yet perhaps there is such an invocation here, for in his second book on Spinoza Deleuze had already described the former's capacity as *voyant* in terms of 'the third eye, which enables one to see life beyond all false appearances' (Deleuze, 1988b; 14). Similarly, Bacon's painting accesses the body escaping from its incarceration in organic representation.

But equally the body is raised to a new power, giving it the new affect of haptic vision – here is where figural art appears to supersede abstract expressionism or *art informel*. For it is precisely the localisation or limitation of the manual operation or diagram which makes possible the passage to haptic vision. In *Francis Bacon* the term 'haptic' appears as the component or affect[8] distinguishing two types of art: *art informel* has its abstract line but figural art has its haptic vision. Thus if both types distribute 'informal forces' it is Ba-con's painting which involves 'the creation of original relations substituted for the form' (68): a *site* is provided for those forces via the integration of disequilibrium in a *deformation* (77, 101). This is not a reintegration into a form but a new type of integrity, the rhythm of a Figure. The consistency of this new configuration of forces depends on the contour's different function – rather than its outright abolition as in *art informel*. For this rhythm or tension of contraction and expansion functions *across* the contour which no longer delimits a form but becomes a permeable membrane facilitating a communication between what the colour models and the ground. Yet this different contour is itself an effect or function of the new constitutive role given to colour in modern painting. Colourism is for Deleuze intrinsically haptic, on the condition that it is not abstracted to a code of primary colours. But if this is the case would not most non-(purely)abstract and non-figurative modern painting be termed haptic? Is the haptic fit to serve as a differentiating factor, let alone a criterion?

Colour may be intrinsically haptic but that power must not be reduced by an overcoding elsewhere. In Egyptian art the absence of distance between the planes of figure and ground is considered to produce a haptic space – but this space is subordinated to the geometric contour. What Deleuze's analysis shows is that the modulation of colour itself in Bacon produces a 'shallow depth' or proximity between the two planes which is essentially the disabling of a narrative function (which makes possible the purity of the pictorial fact), with the contour communicating between the two planes. Yet planar proximity is precisely what Bacon shares with abstract expressionism and, according to Deleuze, what distances him from Cézanne. On these grounds it would seem that abstract expressionist space would indeed have to be termed haptic as well. And so, in *A Thousand Plateaus*, it is. There, Deleuze and Guattari do the work that makes Deleuze's use of the term 'haptic' in the Bacon book possible. This work involves the extraction of the term from its usage in art history, where its properties were determined by the empirical study of a proposed original occurrence, so that it can be attributed transhistorically as an affect, a function of vision. Hence the haptic *cannot* be defined 'by the immobile background, by the plane and the contour' but must find its definition through *derivation* from a pair, the smooth and the striated, whose 'primordiality' rests on the distinction between them being determined according to 'the mode of spatialisation' (482); where the haptic and optic are always found in relative combinations, the smooth and the striated function theoretically as abstract poles. In brief, the distinction returns us to that between com-

position (immanent) and organisation (transcendent).

Smooth space, then, is defined as 'filled by events or haecceities, far more than by formed and perceived things. It is a space of affects, more than one of properties. It is haptic rather than optical perception' (479). The 'haptic function and close vision *presuppose* the smooth, which has no background, plane, or contour, but rather changes in direction and local linkages between parts' (496; my emphasis). This last description effectively attributes the haptic to the abstract line, and, indeed, 'the haptic-optical, near-distant distinctions must be subordinated to the distinction between the abstract line and the organic line; they must find their principle in a general confrontation of spaces' (499). *The* aesthetic model of smooth space is the abstract line, and *the* modern art that 'realises abstraction as such' is abstract expressionism with its line 'stirring up a close-lying haptic visual matter' (575).[9] Deleuze and Guattari have adhered to Wilhelm Worringer's definition of a *Kunstwollen* (or will to art) as being a will-to-abstraction; but, in outlining their version ('nomad art'), have had to extract the non-organic (or abstract) line from Worringer's qualification of it as geometric which is based on a reading of Egyptian art where 'the Egyptian line is negatively motivated by anxiety in the face of all that passes, flows, or varies' (496). It is thus that an immanent-affective abstract line can be dissociated from the transcendent-abjective abstract (or geometric) line that characterised much abstract art earlier this century. Indeed, the originality of Deleuze's aesthetic finds its source in his 'conception of life as non-organic force [*puissance*]' which makes impossible any reduction of his aesthetic theory to a simple modernism.[10] This extraction complicates the problem, however. Where in the Bacon book the abstract line was only '*one of* the most prodigious constants of painting' (68; my emphasis), here it becomes *the* differentiating component of the privileged category of 'nomad art' and what makes its genealogy possible. If the 'manual space' described in the Bacon book is actually the haptic smooth space described in *A Thousand Plateaus* then the haptic, which served to distinguish figural art from *art informel*, seems to have been rendered ineffective.

It is not a question of insisting on an essentialism of the haptic, where only one procedure would produce it, but of locating an obfuscating ambiguity in order to unleash an affect from its possible exploitation as a criterion of judgement. That is perhaps the problem of the presentation in *A Thousand Plateaus* – the problem with working at a general level of aesthetics and with a programme in mind. What Deleuze's more nuanced analyses in the Bacon book show is that the haptic is not an exclusive property but a variable affect. It would seem, therefore, that the problem of the function of the haptic in Deleuze's reading had been exacerbated by its presentation in the final chapter of the Bacon book. It was claimed there (a claim underpinned by the chapter's rhetorical construction) that the localisation of the diagram (which in effect inhibits the abstract line) was the condition of possibility for the 'great moment' of the passage to haptic vision. On returning to *Francis Bacon: The Logic of Sensation* having read *What Is Philosophy?* it becomes clear that the emphasis on the haptic was to some extent a distraction from the real import of the inhibition of the abstract line. For the terms 'haptic' and 'third eye' are lost in the move to *What Is Philosophy?*, and, I would suggest, necessarily lost. This loss not only makes a resolution of the tension between *Francis Bacon* and *A Thousand Plateaus* possible but it marks the distance between *Francis Bacon* and *What Is Philosophy?*, between the description of a type of painting and the ethical determination of a field of aesthetic effectivity. In the final chapter of *Francis Bacon* this move is being made in earnest, but the later, more general, project is still being expressed in terms of the particular one. In the light of the second book's treatment of more recent types of painting which concentrate on the composition of the ground or support it seems that Deleuze's equation at the end of the first book was indeed hyperbolic, *if read as signifying more than the specificity of Bacon's pictorial fact* – a reading, however, that the text encourages one to make.

The 'great moment in the act of painting' (Deleuze, 1981; 102) is not then the passage to the haptic, but the fact of the *passage* itself, to whatever affect painting will invent. But this invention's condition is the passage and as such it is the architecture of the passage which provides the criterion at work: not the haptic but the limitation of the diagram. This answers to Bacon's criticism of abstract expressionism as lacking both 'clarity' and 'duration'; a criticism, Deleuze stresses, identical to that made by Cézanne regarding impressionism. For there to have been haptic vision there had to be a Figure, both clear and lasting, and for there to have been a Figure there had to have been a limit, an immanent hold on the catastrophe or diagram. This thought of restriction inaugurating duration is what makes it to *What Is Philosophy?*.

If we recall that the 'eternal object of painting' is 'to paint forces' (1991; 172), then it can be seen how *What Is Philosophy?* continues the project of a 'logic of sensation' since sensation is produced by a force acting on the body and painting works in or with sensation to exacerbate it to its conditions. We know from *A Thousand Plateaus* that 'all art is abstract' (575) but now Deleuze and Guattari hone in on

the term 'abstraction', no doubt to distance it from the negative connotations that they themselves load the term with: abstraction no longer figures a separation from the sensible but plunges into the sensible, it is *extraction*.[11] In brief: sensation is composed of percepts and affects and is extracted by art from, and deployed by art against, opinion which is composed of perceptions and affections. Art is to extract the percept from the perception and the affect from the affection. But above all the work of art must be autonomous, must 'exist in itself', 'conserve itself', 'hold fast' (154-6); it must endure as a monument endures. This internal consistency or immanent composition recalls the description of Bacon's Figure: the integration of a disequilibrium into the rhythmic tension of a duration. The problem with abstract expressionism is that it is vertiginously fixated on the catastrophic aspect of the diagram, which, however, is only such from the figurative point of view; it is only by harnessing the 'germ of rhythm' (Deleuze, 1981; 67) in the catastrophe that the monument can be composed.[12] The Figure, monument or pictorial fact is a composite sensation which must be *realised* – this is how Cézanne described the passage from possibility of fact to fact. Until *What is Philosophy?* when all art is rehabilitated under the banner of Art, there had been nothing to suggest that abstract expressionism was capable of *rendering* forces sensible – that is, of giving force a site: for only then can sensation have clarity and duration. The 'abstract' in abstract expressionism would not, from this point of view, only refer positively to the abstract line but also negatively to the abstract expressionist diagram as an ineffective operation. To be effective the operation must consolidate or harness the forces in 'an act of consistency, capture, or extraction' (Deleuze and Guattari, 1987; 344). It is in this way that abstract expressionism is not to be stamped as formally illegitimate but judged with other types of painting in terms of effectivity.

The introduction of effectivity as a criterion immediately poses the question of the immanence or arbitrariness of the restricting instance. For the sake of brevity I will answer the question affirmatively: effectivity in this case neither requires a transcendent instance nor suffers from the arbitrariness of an extrinsic limitation. In the light of Plateau 6 of *A Thousand Plateaus* this would mean asserting that *effective*, immanent restraint energises dissolution whilst transcendent limitation blocks or represses it and lack of restraint exhausts it.[13] This affirmation, however, would seem to require a Spinozan point of view where effectivity and affect compose the body of sensation. The immanent relationship of these two faces of sensation is perhaps what is sketched in the final chapter of *Francis Bacon: The Logic of Sensation*: and perhaps the

emphasis of the autonomy of the art work as monument-sensation in *What Is Philosophy?* is none other than the expression of this immanence. In the end the very real contradictions which exist in the treatment of the haptic are to be set aside in an acknowledgement of the appositeness of the hyperbole with which *Francis Bacon* concludes: the effectivity of the passage to the fact and the haptic affect of the fact compose one indecomposable Figure. That this sensation endures, is monumentalised, would suggest that although the term 'haptic' had been summoned from art historical oblivion and quickly sent back its qualification as affect means that it survives.

But it survives also to function throughout Deleuze's work, if, that is, the haptic does not qualify a capacity of sight, the sight belonging to a phenomenological body governed by an incarnate subjectivity, but describes a sight/site where the subject is not constituted by either representation or phenomenological *sentir*. This '*vue sans regard*' defines the affectivity of the body not as organism but as composition of power.[14] Deleuze is right to use the notion so forcefully in writing of Bacon's paintings, for their primary affect is of this destitution of the viewing subject before the 'brutality of fact'. It is in that treatment that the implications of Deleuze and Guattari's criticism of the use of the term by Riegl, Worringer and Maldiney in *A Thousand Plateaus* are taken to their full extent. The criticism of Maldiney bears important implications; for if he mediates Deleuze's approach to painting to an unexpected degree, what is unfolded by Deleuze's use of the haptic carries beyond even the sensitivity of Maldiney's phenomenological approach.[15] The haptic names the fact of Bacon's painting and as such bears witness to the composition of a duration, a sensation – but a specifically pictorial sensation. Deleuze's analysis shows that sensation is not inevitably produced and underlines that it is even harder to hold onto. It is this difficulty that risks being minimised by the more general reflection of *What Is Philosophy?*. What I have called the rehabilitation of abstract art is, in effect, the positing of the unity of the concept Art through an assertion of the essential primacy of the plane of composition as artistic operation; all in the name of the delimitation of the propriety of each of the domains, Art, Science and Philosophy. The speed with which all the arts and all the strains within each art are gathered under this banner risks spilling Deleuze and Guattari's emphasis on the artist's 'struggle with chaos' into a hollow rhetorical shell; for what characterises this as struggle is the diagram as plane of immanence – collapsing the distinction *in painting* between the two planes in order to rehabilitate abstraction mutilates this notion of struggle. It is to ward off this danger, to preserve the force of Deleuze's

approach to painting, that I have dug into the grave of the haptic (as *pictorial* diagrammatic affect), finding there only the phenomenological eye, and discovering that the third eye has been lost only because, like the worst kind of sewer rat, it is still tracing out a smooth space beneath the striated City – not Vienna here, but Philosophy.

Notes

1 Klee's phrase is also invoked (*inter alia*) in Plateau 11 of A *Thousand Plateaus.* I do not have the space here to explain in depth how this phrase comes to attach itself as formula for the Deleuzian aesthetic but it must be noted that his emphasis on 'the visible' does in no way contradict my criticism of Bergen (see note 5). As should become clearer in the discussion of 'the third eye', 'the visible' in Deleuze's understanding deviates radically from the phenomenological privileging of the eye, indeed contaminating (or deterritorialising) irrevocably the purity of that Ideal eye.

2 Paraphrasing Péguy, Deleuze describes this morality as having 'pure hands' but only through having 'no hands at all' (67).

3 A claim that needs detailed explanation and qualification – neither of which can be offered here; suffice it to say that this would involve tracking the term 'autonomy' through their works, as well as through the Malraussian inheritance in French aesthetics. (Aside) Deleuze's description of the manual operation as 'catastrophe' can serve to vindicate Greenberg's genealogy of abstract expressionism if we take a diversion through one of Malraux's inheritors (and deviators): Georges Bataille's brief, fatidical article on Joan Miró (1930), where the latter's assassination of painting is described in terms of the painting as 'traces' of its act or 'disaster' such that 'decomposition was taken to the point where there remained nothing but several formless spots [*taches informes*]' (255).

4 Deleuze does not distinguish between abstract expressionism and *art informel*. Whilst this is common practice in art theory it is a highly problematic elision. For the purposes of this article, however, I have decided to retain the lack of distinction as it appears in Deleuze's texts.

5 It is important to emphasise the modality of pictorial experience: it cannot be described in conventional theological-philosophical terms where (various modes of) revelation are figured in terms of empirical visual perception. Thus whilst Veronique Bergen sketches well, if schematically, the role Deleuze gives to art, the terms of her description are to be treated with caution: eg 'L'esthétique *dévoile* les conditions de possibilité de l'aesthesis', 'l'art *révèle* le transcendental d'une genèse des formes' (9; my emphasis). The Deleuzian 'epipathy' is intensive and should not be susceptible to phenomenological pathos.

6 I have treated Deleuze's construction of the difference between figurative art and *figural* art more fully in 'The Fugitive Body: Bacon's Fistula' in *Journal of Philosophy and the Visual Arts No 4,* 1993.

7 One of the strengths of Deleuze's book on Bacon is precisely how it resists abstraction by respecting absolutely the specificity of his painting – deploying a fine array of operative terms which distinguish, compare and describe the complexity of its composition. This vigilance is in evidence here where the term 'overcome' is qualified not only once ('visually') to specify the nature of the operation but a second time ('as if') to underline that this description is fictional, an application of an extrinsic, abstract logic to the real movement of the haptic. It should be clear, then, just how profoundly misguided it is to describe figural art as a 'sublation' of abstract art and *art informel* as does Mireille Buydens (132).

8 It is important to differentiate between descriptive factors and *criteria* of judgement; it is here that I find ambiguities in Deleuze's distinctions.

9 Yet it is interesting to note that where one would most expect the term 'haptic' to re-emerge, in *The Fold*, it does not appear once.

10 The quotation is from Deleuze's preface to Mireille Buyden's book. Dora Vallier, in her preface to the French translation of Worringer's *Abstraction and Empathy*, is keen to prevent any convergence of Worringer's term 'abstraction' and the abstraction of modern art. Whilst this refusal is based primarily on the natural character of Worringer's notion of the geometric, she justifies her point by tracing historically the non-convergence of Worringer and Kandinsky. Not for the first time, then, it is necessary to underline that there exists a form of geometrical abstraction – Vorticism – whose development can be seen to be parallel to Kandinsky's but under the sign of a rather different philosophy. If *Abstraction and Empathy* was only translated into French in 1978 it was TE Hulme who in 1911 met Worringer and introduced his book to England, having the year before met Bergson. Through Hulme continental thought provoked both Imagism and Vorticism into existence; what is important to note in this context, in this complication, is that Vorticism's striving for a philosophy of transcendence obscure its profound (Bergsonian) vitalist impetus. This is not the place to tangle this knot of modernist aesthetics (to which Deleuze belongs) but, unable to resist the seductions of Wyndham Lewis's exquisite prose, here is a taste of what can emerge, if allowed, from all of Vorticism's contradictions: Wyndham Lewis's evocation of Deleuze's *haecceity*: 'Finite and godlike lines are not for us, but, rather, a powerful but remote suggestion of finality, or a momentary organisation of a dark insect swarming, like the passing of a cloud's shadow or the path of a wind'.

11 Henri Maldiney writes: 'To abstract is to extract from the arhythmic world of activity the elements capable of affecting and moving rhythmically' (18). Guattari's simile in his discussion of Fromanger's realism is instructive: 'It has consisted in an experience treating dominant realities and significations, in order to extract from them, as from a mineral, new pictorial materials'. This text includes an implicit (but thinly veiled) attack on the idealism of Mikel Dufrenne's phenomenological aesthetics (specifically, it would seem, the latter's essay 'Peindre, toujours') as well as a refutation of what has been termed (by writers in the journal *Macula* at the end of the seventies) 'matterism', the ideology disseminated primarily by the

French collective *Support/Surface* which exclusively valorised the literally material composition of the work.

12 For Maldiney vertigo is the first response to chaos – or the night of the concept – and rhythm the second cosmogenetic moment which operates the passage from chaos to composition (151).

13 As I argue in 'The Fugitive Body: Bacon's Fistula', Deleuze and Guattari's text makes this a highly ambiguous and problematic assertion. The ambiguity lies in how much restraint the plane of immanence can support before being activated as a plane of organisation.

14 'Vue sans regard' is Vauday's (962) extremely succinct phrase – it can be brutally rendered as 'seeing without looking'; it communicates the passivity or passion of a seeing which is not constitutive, neither of what is seen nor of the seeing subject.

15 Once again I can only indicate the field of another discussion: it is through Maldiney that Deleuze makes contact with both Schelling and Merleau-Ponty. The final chapter of *Francis Bacon* is entitled 'Eye and Hand', a clear reference to Merleau-Ponty's penultimate work *Eye and Mind.* The notion of the haptic will inevitably play a crucial part in the analysis of Deleuze's deviation from this richest strain of phenomenological aesthetics.

Works Cited

Bataille, Georges (1970), 'Joan Miró: peintures récentes' in *Œuvres Complètes,* Vol I, Paris: Gallimard.

Bergen, Veronique (1994), 'L'artiste souverain, le maître hegelien et le surhomme' in *La part de l'œil* no 10.

Buydens, Mifreille (1990), *Sahara: l'esthétic de Gilles Deleuze,* Paris: Vrin.

Deleuze, Gilles (1969), *Logique du sens,* Paris: Editions de minuit;

(1981) *Francis Bacon: logique de la sensation,* Paris: Editions de la différence;

(1985) *Cinema II. L'image-temps,* Paris: Editions de minuit;

(1987b) *Dialogues* (with Claire Parnet), trans Hugh Tomlinson and Barbara Habberjam, London: Athlone;

(1988) *Le pli,* Paris: Editions de minuit;

(1988b) *Spinoza: Practical Philosophy,* trans Robert Hurley, San Francisco: City Lights.

Deleuze, Gilles and Guattari, Félix (1987a) *A Thousand Plateaus,* trans Brian Massumi, London: Athlone;

(1991) *Qu'est-ce que la philosophie?,* Paris: Editions de minuit.

Guattari, Félix (1984) 'Fromanger, la nuit le jour' in *Eighty Magazine* no 4, Paris.

Maldiney, Henri (1994) *Regard, parole, espace,* Lausanne: Editions l'Age d'Homme.

Vallier, Dora (1986) 'Lire Worringer' Preface to Wilhelm Worringer, *Abstraction et einfuhlung,* Paris: Editions Klincksieck.

Vauday, Patrick (1982) 'Ecrit à vue: Deleuze-Bacon' in *Critique, no 426.*

LYDIA DONA: ARCHITECTURE OF ANXIETY
David Moos

I see painting as this molecule that is constantly in the process of its rupture. This is what my painting really is. It's this big molecule, this big map, this big urban construct, this void, this body, this skin. Lydia Dona, 1991

By linking architecture to anxiety I expect two things: first, a better understanding of how the fabricated is fashioned along emotive or expressive urges; and second, a better grasp of how biomorphic constraints mediate their interface. The painting of Lydia Dona roots conceptions of the corporeal in visual tropes of contingency. The human body becomes a figment of contestation that must mediate between chemically fluid genetic codes and a cognisant agent forming culture, society, a world. The sole index becomes that of scale, not a relative notion but rather the introduction, or induction of an absolute scale, the scale of painting. Each of her paintings offers a scaling – where the mind must conceive separate yet simultaneous paradigms of its own purpose. From 'molecule' to 'urban construct', location of the human seeks a multi-tiered synthesis and, inevitably, a constantly shifting scale for itself.

For the practice of painting this strategy has far-reaching implications. The active painting body that leaves clues to its corporeality depicted in paint (field, line, drip, dot, etc), is managed upon multiple plateaus of connotation, and in the process catches up all manner of demarcation that inscribes it with meaning. Historical, cultural, textual, social, libidinal, biological – 'this big map' opens before us, posturing for invention, questing to be deciphered as we travel its trajectory, which is, we must remind ourselves, primarily artistic. Dona is engaged with the production of a painted space into which these separate lineages can be operated, their differences meshed, their likenesses decoded. Before treating the 'content' of her painting, which I assume can only be addressed once the painting's method has been engaged, let me remark upon the milieu in which her meanings are pictured and abstraction can be associated. This essay will attempt to preserve certain breaks or discontinuities within itself, to focus upon a topic but leave it suspended as image. And perhaps this is a valid description of how Lydia Dona's painting functions – it is the posing of visualised questions. What kind of viewer is needed for abstract painting today; who will this person be, in which body, where?

In setting herself the goal of allowing painting, as a singular object, to commute through diverse connotational terrain, Dona phrases her task in a sythesising language. Abstraction in painting becomes a project that is pollinated by and can profit from allusion and intersection:

Colour codes are both cosmetic and cosmic. Cultural codifications of the 'cosmetic bodies' of femininity and masculinity are both quoted and displaced to build a systematized degendered 'code', a third zone of schisms and multiplicities: the zone of techno-urban bodies. The ghostly painting of the ghosts of the body.[1]

Into this syntax, which speaks of 'build[ing]' and the construction of metropolitan 'zones' – adopting the voice of urban planner – the figure of the 'body' becomes the locus of meaning. For painting, despite the use of a novel descriptive vocabulary pregnant with technology's tongue, the site of confrontation remains that of the body. 'Cosmetic bodies', in the manner of cyborgs, are what the painter speaks about. Dona's 'techno-urban bodies' refer less to the act of painting than to the kind of consciousness required for approaching her work. Will the historical gestures of painting remain valid in a future that is capable, through the augmentation of cybernetics, of fabricating conscious bodies?

As our culture continues to evolve from a machine-based technological ethos into an information-based floorplate, the body's relationship to its environment is re-mapped – literally rewired from the outside in. As Paul Virilio observes of his *telecity*: 'Clearly the urbanization of real time entails first of all the urbanization of "one's own body".' An ominous archetypical urban inhabitant is envisioned as the body is 'plugged into various interfaces (computer keyboards, cathode screens, and soon gloves or cyberclothing), prostheses that turn the over-equipped, healthy (or 'valid') individual into the virtual equivalent of the well-equipped invalid'.[2] Human mobility, that great enterprise of the post-war mechano-world, is over-mastered in the electro-information world by a merely localised motility. Planetary environments are distilled into the interactive home managed by a *terminal citizen*,

whose immediate genetic predecessor is the 'motorized-handicapped' – able to control the domestic environment without undergoing physical displacement. The adaptations and re-toolings required of the information age will remodel the (house, city, nation, cosmos) and the body (arms, implants, cells, chemicals), with both converging in the super-consciousness of cyberspace. Mediating the interface will be the human mind, in no prescribed location *per se*, but rather situated at some crucial delta where flows of information – like rivers with tides – go out and come in.

Flows are more constant than the material world that expresses and embodies them.[3] In virtual reality, where technologies splice a human subject into a cybernetic circuit by putting the human sensorium in a direct feedback loop with computer data banks, flow becomes the operative concept: 'the flow of information within systems [i]s more determinative of identity than the materiality of physical structures. Plunging into the river of information implies recognizing that you *are* the river'.[4] When equipped with Virilio's 'interactive prostheses' this plunge is taken 'physically', taking the body along with the mind.

In seeking a human model able to contribute vitally and reflect upon the conditions of culture, Gilles Deleuze discusses the place of the nomad. In the framework of the information age, which enables a globalising projection of presence, the paradigm recurs with particular potency. 'The nomad is not necessarily one who moves,' Deleuze suggests. 'Some voyages take place *in situ*, are trips in intensity. Even historically, nomads are not necessarily those who move about like migrants. On the contrary, they do not move; nomads, they nevertheless stay in the same place and continually evade the codes of settled people.'[5] The notion of 'in situ' acquires magnified connotations within the context of the information environment, and this is especially true for abstract painting. Lydia Dona's work confines itself to the unmediated surface of canvas, restricting the flow of expression to paint alone. Passing through recognisable 'codes' of painting, the canvas surface becomes an arch-site where 'trips in intensity' are navigated. Voyages of mind are pictured by processes of paint that form a compound identity through a dense accumulation of references that can be multiply construed.

The painting of Lydia Dona speaks in two tongues, with two referential codes: the textual (Deleuze and Guattari) and the art historical (Duchampesque diagrams, abstract expressionist icons, minimalist components). From this bi-vocality Dona's own voice emerges, reconstructing these sources onto a plane of polyvocal visual parlance. Her paintings should not improperly be conceived as synthetic or pas-

tiche-based – the now all-too familiar strategies of post-modernism – because with each application of an adopted source, a crucial adaptation occurs. Dona's painterly articulation of recognisable parts allows for her work to defend against mere emulative schemes of appropriation. Her strategy is that of posing visual questions through the display of emblematic origins. The cumulative image thus calls attention to its multiplicity as sources are 'reformulated or redefined according to the relevant context now: the question of post-modernism, the void, the decay, the breakdown'.[6] Her careful enunciation of hybridised imagery subverts the initially recognisable source or referent, questioning re-cognition in the presence of the virtual experience offered by the painting. 'Freedom of meaning', the literary critic Harold Bloom has argued, 'is wrested from combat, of meaning against meaning.'[7]

The first encounter with 'meaning' occurs between text and painting. Before describing the painting, let me cite the discernable source that frames the intention of meaning. Each line, each idea written in the following passage quoted from Deleuze and Guattari's *A Thousand Plateaus* finds its way analogically into the painting *Anatomies Of Molecular Motors And The Segments Of No Beginnings Nor Ends* (1994). The envisioned thoughts appear to narrate the painting's motives:

> There exists a nomadic absolute, as a local integration moving from part to part and constituting smooth space in an infinite succession of linkages and changes in direction. It is an absolute that is one with becoming itself, with process. It is the absolute of passage, which in nomad art merges with its manifestation. Here the absolute is local, precisely because place is not delimited.[8]

Nomad space – smooth space; close-range vision as opposed to long-range looking, haptic space as distinguished from optical space. To trace the integration of 'part to part' displayed in the painting, its 'process' of making must be retrieved. Stand near its surface, at about brush distance. Here the eye can seek the annexation of time, the segmented disparate time involved in its making. Process and time, painting and looking – each an interposing, mapping, mimicking.

We approach the painted image 'moving from part to part', gathering up likeness where we can find it. Match the upper corners, quadrants of the hazy machine diagrammings (Duchamp's now antiquated *Coffee Mill* (1911) cum *Chocolate Grinder* (1913) rotated, concatenated and multiplied), with the triangular components of this same chalk-board-like demonstration. Unite the internal flowing parallel lines, follow them like vectors to the centre, and reverse the flow

outwards to the rim of the ovoid, circulatory edges; the 'infinite succession of linkages and changes in direction'. Commence the linking, travel the walkways of line or begin bounding over the surface, watch how the image imbibes 'becoming itself, with process'. The blue drippings (Pollockesque) accumulating along the curved edges in the four corners, locally attain a manifest difference that is nevertheless linked through colour and application. Switch colours and move with the dripping to the interior, to the dangling, ebullient, frenetic green. Become the painter with your eyes and 'merge with its manifestation'; become embedded with how successive applications of distinguishable paint have arrived to refute priority of application; undermine difference in the effort to bind parts of the painting together.

Such multiple overlaying of processes aspires after the 'absolute [that] is local, precisely because place is not delimited'. The painting is a labyrinthine happening, an insistent subjectively governed eloquence that demands 'close-range' scrutiny by virtue of its intricacy. For example, a faint pencil-drawn grid is seen to structure the smoothness of black exposed at the lower left (a reference to minimalism, perhaps the grids employed by Peter Eisenman). We read out the textual inscription as follows: 'The smooth is the continuous variation, continuous development of form; it is the fusion of harmony and melody in favour of the production of properly rhythmic values, *the pure act of the drawing of a diagonal across the vertical and the horizontal.*' (my emphasis)[9]

With the appearance of the 'diagonal' as key signifier implicating the definition of 'smooth space' (as defined by Deleuze and Guattari),[10] the painted image stands alluringly close to its antecedent text. Dona's composition is forcefully governed by a diagonal that cuts across – an irregular border line, transgressive, antithetical to the horizontal and vertical formula of the composition. The text supplies us with a pantheon of signifieds with which we can inscribe and suture the painterly signifiers. Furthermore, if our aim is to commit the art historical heresy of reading artistic biography as skeleton key to image, the 'nomad' trope could superficially be sustained. As a transplanted person – from Eastern Europe, through Israel, via Germany to New York – Dona's individuality invites speculation as, say, nomadic, rhizometric; 'no mother tongue', 'never send down roots'.[11]

A common tendency in criticism when confronted by abstract painting, especially Dona's, is to rely upon the text, the ideally equipped Rosetta Stone of *A Thousand Plateaus*. Indeed, the ingenuity of the book is such that it declares itself to exist 'only through the outside and on the outside', in relation to other 'machines' (painting) of the world: 'We will ask what it [our book] functions with, in connection with what other things it does or does not transmit, intensities in which other multiplicities than its own are inserted or metamorphosed.'[12] With this model of infinitely connectable textuality, narrative potential blossoms. Indeed, this has been the norm in approaching Lydia Dona's painting. Under the aegis of polyvocal, rhizometric, segmentary, aggregate analysis, recipes for how her work dramatises abstraction have been synthesised.[13] The method has a certain appeal for it ceaselessly throws the signifying power of painting onto a preordained horizon of linguistic certainty. Writing, as the medium within which criticism operates, naturally welcomes this seduction of the textual.

In clearing a creative space both for the painting and its critical appreciation, however, we may stand close with Harold Bloom who has emphasised the critical act of 'misreading or misprision'[14] as emblematic of the position poets (and artists) feel in relation to their predecessors:

> The strong reader, whose readings will matter to others as well as to himself, is thus placed in the dilemmas of the revisionist, who wishes to find his own original relation to truth, *whether in texts or in reality (which he treats as texts anyway)* but also wishes to open received texts to his own sufferings, or what he wants to call the sufferings of history. (my emphasis)[15]

Such insight anchors the relation of Lydia Dona's paintings to the textuality of Deleuze and Guattari. She reads as a 'strong reader', committing acts of wilful misprision in order to acknowledge simultaneously and swerve from the source. As her painting rhetoricises its compounded, adopted imagery gleaned from art historical sources, so too does she tropologically defend against strict emulation of Deleuze and Guattari. The clue occurs in her titles. Titles direct the movement of abstract painting, governing connotation. The title marks the point of entry through which the artist passes, and in this case affords for a dismantling of equivalence between text and image.

Dona's titles are acts of adjacency as much as revision. Curiously, the first letter of every word of all her titles is capitalised. Seemingly major words like 'Molecular' or 'Beginning' are brought into the same orbit with those minor connectors and prepositions such as 'And' or 'Of'. Why the constant capitalisation? The move is syntactical as much as grammatical, emulsifying the ingested vocabulary of Deleuze and Guattari, rewriting it in a supraconscious[16] fashion, welcoming other antecedents. We may think, for example, of Duchamp's string of capitals L.H.O.O.Q. which typo-telegraphically transmits the uttered contemporary voice cyclically onto history. The role of Dona's titles splinter or scatter their referential attachment to the image. They state that she

ABOVE: Lydia Dona, Anatomies Of Molecular Motors And The Segments Of No Beginnings Nor Ends, *1994, oil, acrylic, signpaint on canvas, 147.3x213.4cm; BELOW: Lydia Dona,* Shadows Of Annexation And The Voids Of Paradox, *1994, oil, acrylic, signpaint on canvas, 147.3x213.4cm*

is misreading her sources, recognising many lineages in order to branch out to assert her own. Supplying a mobile army of metaphors with which to scale the painting, the title operates as arch-clue producing an essential swerve from a theoretical orthodoxy.

Moreover, Deleuze and Guattari state that there will be 'no typographical, lexical or even syntactical cleverness'[17] in their writing of multiplicity. But Lydia Dona's titles commit all three of these turns, veering close to Derrida's favourite territory. The task here is not to compose a venue of precedent, but rather to understand the inherent message encoded in this intentional, emphatic act of titling. Taken collectively, her titles speak of a fundamental dysfunction between text and image.

The problematics of properly merging the linguistic with the painterly begin at a very basic level. With colour alone, for example, we realise the disparity. 'Although semiologic approaches consider painting as a language,' Julia Kristeva has remarked, 'they do not allow for an equivalent for colour within the elements of language identified by linguistics.'[18] Not by coincidence colour emerges as perhaps *the* major signifying component of Lydia Dona's work. Colour overrides and specifies the tenor and intentionality of her formal gestures. The title of her recent exhibition – 'Iodine Desire, Loss And Stain' – suggests that codes are merging, colouristically resonating through one another. 'The purple, pink, green and ultraviolet of the paintings,' the artist writes in an accompanying statement, 'are high-toxic tones, chemical types, photo lab colours that provoke a disoriented and diffused gaze'. By virtue of sheer amplification the colours seek to disassemble our vision of historical acuity, while also disfiguring the linguistic.

Giotto's frescos at Padua are the platform from which Kristeva articulates her insights about the role colour plays in painting. 'By overflowing, softening, dialecticizing lines,' she notes, 'colour emerges inevitably as a "device" by which painting gets away from identification of objects and therefore from realism.'[19] The kind of realism Kristeva is referring to is depictive, figurative, didactic – the subservience of painting to 'literal' appearances of the world. But realism, taken as veracity, can also be transcribed onto the text/painting paradigm. The text is *not* an image that can be realistically pictured. It offers possibilities, modalities, pathways, entries and exits into the culture and potentially onto the painting, but it cannot be used to deliver images. Imagery, and especially abstraction, is the preserve of the artist, of a tightly levered subjective, interpretive imagination. If we were to trace the contours of the text onto visualised abstraction, mimesis would become the conceptual content of painting.

Colour is the topic and topology that defends against this move, resisting absorption and over-writing the textual.

One is referred instead to sources belonging to the history of painting, to prior imagery that is now articulated in unique colour. In *Pyramids Of Breakdown And The Tears For Cleopatra* (1994) [see page 96] the colour scheme is, indeed, 'cosmic and cosmetic' – comprised of fuchsias, hot pink, powder blues, orange drips and fiery red enamel. It is Dona's only painting that explicitly and iconically makes use of the triangle as a primary shape governing her composition. Vibrating against two airy registers of blue we find the lacy, garishly coloured Pollockesque drip; a brood of cellular forms consigned to demarcated side-zones; the maniacal painterly jumble of schematised machine parts; a pencil grid structuring the interior of form and the assertion/emergence of primary form posited as conduit, conductor. These components are the pillars upon which Dona's imagination interprets the task of painting. They imbricate abstract expressionist leitmotifs with minimalist remnants with interpolated signs of the Duchampian diagram.

How, and to what end, does a contemporary artist utilise and inscribe such historically diverse sources? Consider the 'drip'. Pollock's infamous 'all-over drip' has been excised from its infinite grandeur, localised and reined in to become a sputtering filiation at the pinnacle of someone else's pyramid. The smooth, flowing labyrinth is now a competing assortment of mismatched colour clamouring like electric, spasmodic energy along the sides of an alien form. The method of application could not be more distant from Pollock's action-oriented improvisations that involved his body in rhythmic movements, achieving a utopian formal signature of gesture. As the sagging orange 'drip' at the upper left reveals, Lydia Dona has applied her 'drips' to an upright canvas, not a canvas unrolled onto the floor *à la* Pollock. Her body does not gyrate around or step onto the canvas to deliver its drip, but instead with a refined, meticulous, and almost effete hand she dabs and then drops the paint onto her vertically posed canvas. There is no randomness, no sudden ejaculation of creative furore, only the close movement of the hand at work, curtailing and managing each local application. The methodical process is obviated by the pink placed at the two lower corners of the pyramid. In the back of our consciousness, when we see Dona's carefully constructed and calculated drips, we liken the process to restricted intentionalites now available through computer programmes – the ghost of the cyborg making its trace felt. This acute placement of the drip begins to formulate questions about how painting is able to generate an identity specific to its creator, pondering whether it will be possible for such an ideal trace of indi-

viduality to be programmatically mapped out, set into prescribed coordinates.

The sign of Pollock is the sign of a precursor, and it instructs that 'influence' be conceived along errant but definite lines – a misinterpretation: 'Influence, as I conceive it, means that there are *no* texts, but only relationships *between* texts.'[20] However Derridean or deconstructive this Bloomian assertion may sound,[21] it allows for positioning painting beyond the game of textual recovery or mere historical source-hunting. In valuing the drip in Dona's work, we ascertain how it has been transmuted. In addition to the process of application there are material concerns. Where Pollock used combinations of oil and enamel to achieve a watery interaction, Lydia Dona focuses on enamel alone. Her drips are hardened, shiny and reflective because she exclusively uses car enamel. In all of her paintings (but especially in those where the dripping densely accumulates), the enamel becomes a surface in which we see a splintered, discontinuous reflection of ourselves looking at the painting. This reflection comes to meta-reflect upon Pollock's mythic painting body, which lies dismembered, scattered peripherally as so many shards. We catch only glimpses, the polish of high-keyed toxic tones, each only able of sustaining one facet of the refracted body – our's, Pollock's, her's. In this manner, the machinery of the contemporary electro-information body (process), the historical improvisational body of abstract expressionism (sign), and the now fractured body of the viewer (referent), all begin to collide.

Material associations subliminally slide across the surfaces of Dona's paintings, unleashing terse parables of contortion. Subversive duplicity is accomplished with Duchamp, who is catastrophised when we realise that on top of a fuchsia acrylic surface, Dona has painted out her Duchampian machinic parts in oil paint. Oil! – for an artist who ceased painting with the declaration that he could not stand the smell of oil paint and turpentine.

The title *Pyramids Of Breakdown And The Tears For Cleopatra* suggests as much, admonishing the thinking that demythologises Pollock and Duchamp and turns them over to Cleopatra's geometry. Trading in formal likeness, however, would commit precisely the project that abstraction and criticism must keep away from. Sourcework such as this is expected and predicted as the currency of our culture. It serves, however, few profound aims that the project of misinterpretation requires: 'Source study is wholly irrelevant here; we are dealing with primal words, but antithetical meanings, and an ephebe's best misinterpretations may well be of poems he has never read.' Indeed, to motivate the form of the triangle we might face a more arcane, equally tenable precedent in order to propose a 'strong reading' of the painting.

We go to *Jericho* and to *Chartres*, to those atypically unmistakable paintings, vertical works that slope as they tower. These triangular paintings maintain a specific place in Barnett Newman's œuvre. The format was new, a late 1960s reckoning with the philosophical tenets that had underpinned Newman's work; his insistence that painting deliver a sense of place, confer the impact of totality where the human self comes to recognise its individuality. Painting engendered for Newman the fundamental tasks and through the expunging of reference and representation the artist sought an originary experience where creation could flourish. 'The onlooker in front of my painting knows that he's there,' Newman stated in 1965: 'To me, the sense of place not only has a mystery but has that sense of metaphysical fact.'[23]

In tackling the triangle Newman shaped his aesthetic schema along provocative lines, immolating mythologies and imploding accrued cultural histories. *Jericho* dramatises the pyramidal component of Newman's antecedent sculpture *Broken Obelisk* (1963-67),[24] subsuming Egyptian mysteries as geographical connotation masters the cultural. The matte black substance of *Jericho* is bisected by a red vertical band, the off-balance total awareness of symmetry revealed to compose its potential obverse. What might this obverse be? What human topic could elude the grasp of painting that rose before us and declared itself to incarnate 'metaphysical fact'?

The topic of the self might suffice, if we are able to destructure and decompose its essence. *Pyramids Of Breakdown And The Tears For Cleopatra* inserts itself at this juncture, beginning to define a self in painting. The uninflected acrylic ground of the triangle – Newman's serene metaphysical surface – is now attacked by vigorous overpainting. Lydia Dona lays siege to the most refined abstract expressionist philosophies of the creative self. Cells crowd in upon the triangle, breaking through the fuchsia wall of the outer pyramid, pink cells feeding off or latching onto the interior pyramid. They hunger for plastic union with the isolated machinery inside the pyramid. The self becomes a 'breakdown' of essence in dissected terms – part biology, part chemistry, part pure machinery – as these topics (cyber-predicates) now overtly occupy the painter (creative self) in abstraction. The pyramid in Dona's figuration offers occasion to let the Duchampian machine madly proliferate, hieroglyphically to postpone hierarchy and rhetorically to muddy the 'high ambition' of Newman's metaphysic.

Contrary to her other titles, which designate processes without naming the components involved, this painting dictates the interior form (as pyramid) and instructs its historical reference (Egypt). The title names 'pyramids', but the

painting physically delivers, as only it can, triangles. A dimensional play is engaged, a transposition crossing through the painting and equally through its figurative histories. We are forced to concoct a leap in dimensionality that takes into account the triangle/pyramid geometric schism. 'Cleopatra' emerges as the operative word requiring 'breakdown'. If we rewrite the name we generate its essence: 'Clio', muse of history; 'patra', as in patrimonial, patron of origins. This word, a name, is preceded by that countermasculine expression of grief, the shedding of tears. Overt or guised, elusive or definable, the 'breakdown' of signification allows for identity to emerge. It takes on the master-trope of artistic incarnation, the trope of origins. The ethos of abstract expressionism, its sanctifying of a self-sufficient empowered creator, is now insurgently reinscribed by a contemporary woman artist who wholly reflects herself through the intention of her own gestures within an intrinsic paradigm.

According to Bloom, 'origins, poetic and human, not only rely upon tropes, but *are* tropes . . . Tropes or defenses (for here rhetoric and psychology are a virtual identity) are the 'natural' language of the imagination in relation to all prior manifestations of imagination'.[25] With the phrase 'rhetoric and psychology are a virtual identity' parenthetically situated by Bloom, we evidently cross into Freudian territory. Mention of Bloom's name instantly conjures his theory of poetry as presented in *The Anxiety of Influence*. Beginning with title, but continuing throughout his analysis, Bloom co-opts Freudian language in an effort to overcome its personalising implications. Although often misunderstood, the Bloomian 'anxiety' a poet (or painter) feels in the face of his/her precursors is not something within *him/her*, it is not part of the psychic economy of a person, but is rather manifest by the text or painting. The trope of misprision or misreading was never internal to a person but always the province of the artistic work itself: 'Every poem is a misinterpretation of a parent poem. A poem is not *an overcoming of anxiety, but is that anxiety.'*[26] This artifactual definition, which Bloom frequently stresses, informs the position of Lydia Dona's paintings in relation to their sources.

Anxiety, conceived in counter-Freudian terms and divorced from the person of artist, is the consequence of a painting overcoming its precursors. The emblem of this quest in Dona's work emerges to be the 'Void'. In *Shadows of Annexation And The Voids Of Paradox* (1994) the interior ovoid space is emptied of vigorous presence. A stilled world, the void is evacuated of markings or painterly tracery, and is only traversed by the lone spectre of a diluted drip scaling the vertical height of form. Colour alone pulsates, a massive dilation of violet. There are no clues to orientation. Gravity

has acted in more than one direction implying that fixity of place and orientation no longer predominate. Here the space of painting is opened up, swept clear of iconic elements. The Duchampian machinery is sectioned off, relegated to subordinate blue rectangular zones. The drip-work is dangled only along the periphery of the oval, somehow prevented from spilling onto the serene field of violet. This pushing of the precursors to the marginal – shaping their existence around the oval, coupled with the peculiar colouration – masters a composition that evades absorption into historical streams of connotation, regardless of how we manage to stratify/destratify reference. Anxiety of departure becomes the essence of this form. Neither subject matter nor content, anxiety *is* the experience of this work.

Such is the space of abstract painting, a reality of visuality that must doubly contend against a century of overwrought artistic production and an increasingly abstract world. Lydia Dona heightens the task of painting by taking on explicit textual concerns – additional sources such as *A Thousand Plateaus* – that inform the kinds of associations we may integrate analogically. The play of reading text into image is precarious, and by choosing Bloom I have tried to plot a course that stays close to poetry (a sister art of painting), rather than impulsively latching onto those ever-appealing, constantly proliferating language machines of contemporary critical theory.

In recognising its position in the culture of today, abstract painting strongly presents itself only when the necessity of looking becomes paramount. The subjectivity involved in its making shuttles artist and viewer over diverse terrain. Seductively, at times erotically, it moves through topical paradigms of connotation, each expressed through a situating of how to look. From an aerial vantage-point; with microscopic powers; in the scale of a brush stroke; at the poetic remove of self-contemplation – all of these modalities of sight validate an approach to Dona's painting. Her historical tropes escalate possibilities, throwing sight onto a metonymic temporal plane. The methodical time taken to draw the grid, the systematic timing of the drip, and the smudgy diagrammatic sequence of Duchampian machine parts – each represent a separate making time, each a different historical site in time.[27] All issues implode to intersect on the surface of canvas, a subjective territory that welcomes analogy, yet continually denies an orthodoxy of interpretation.

To grasp the subjectivity of painting, one merely needs to measure Lydia Dona's distance from post-modernism as adeptly expressed by one of her contemporaries. Moira Dryer's work, which seems to trade in similar territory, assumes a vastly different material position. Dryer's painting unfolds

across frequently separated or disparate surfaces, remarking upon the inadequacy of the single rectangle as format for painting. The painting surface may have holes punched into it, alien appendages (such as metal handles, aluminium implants), or might curvilinearly present irregularised frame edges. Such devices materially literalise – that is, visually illustrate – such concepts as the 'segmentary', 'assemblage', 'aggregate', to name some obvious concepts from Deleuze and Guattari. Recalling observations made earlier about the body, what kind of parallels can be drawn, now that the natural body, unmodified by technology, is displaced by a cybernetic construct consisting of body-plus-equipment-plus-computer-plus-simulation? Dona's work emphatically states that the canvas alone, freed from material paraphernalia, will generate all routes to meaning.

For over a decade now, Lydia Dona has conducted her discourse in painting with the traditional tools of the craft and has done so confined to the single canvas. Dona's is a brush-made world, one that the hand alone produces. Within these limitations, painting necessarily focuses intention. In compliance with the canvas, that inveterate surface of subjectivity and template of defined absolutes, we turn out towards the world, in towards ourselves. Maurice Blanchot, the magnificent scaler of night, whose thoughts about artistic creation haunt the ends of all critical inquiry, figures the dream onto itself: 'One seeks the original model, wanting to be referred to a point of departure, an initial revelation, but there is none. The dream is the likeness that refers eternally to likeness.'[28]

The text always allows us to speak about the painting, but that is only what it can do. Whether this task restores or diminishes meaning, it is a different flow. Painting is never text; like the world, text is only commentary:

There are no individual statements, there never are. Every statement is the product of machinic assemblage, in other words of collective agents of enunciation (take 'collective agents' to mean not peoples or societies but multiplicities). The proper name (*nom propre*) does not designate an individual: it is on the contrary when the individual opens up to the multiplicities pervading him or her, at the outcome of most severe depersonalisation, that he or she acquires his or her true or proper name. The proper name is the instantaneous apprehension of multiplicity.[29]

Notes

1 Lydia Dona, Statement accompanying the exhibition 'Iodine Desire, Loss And Stain', Galerie des Archives, Paris, April, 1994.

2 Paul Virilio, 'The Third Interval: A Critical Transition', in Verena Andermatt Conley (ed), *Rethinking Technologies* (Minneapolis: University of Minnesota Press, 1993), pp 4-5.

3 See for example Michel Serres, *Hermes: Literature, Science, Philosophy*, ed Josué V Harari and David F Bell (Baltimore: Johns Hopkins University Press, 1982), pp 71-83.

4 N Katherlne Hayles, The seductions of Cyberspace, in *Rethinking Technologies*, p 174.

5 Gilles Deleuze, 'Nomad Thought', in David B Allison (ed), *The New Nietzsche: Contemporary Styles of Interpretation* (Cambridge, MA: MIT, 1977), p 149.

6 Lydia Dona, interview with Klaus Ottmann in *Journal of Contemporary Art*, vol 4, no 2 (Fall/Winter 1991), p 27.

7 Harold Bloom, 'The Breaking of Form', in *Deconstruction and Criticism* (New York: The Seabury Press, 1979), p 5.

8 Gilles Deleuze and Félix Guattari, *A Thousand Plateaus: Capitalism and Schizophrenia*, trans Brian Massumi (Minneapolis: University of Minnesota Press, 1987), p 494.

9 *Ibid*, p 478.

10 For a complete definition of smooth space and its ideological implications See Deleuze and Guattari, '1440: The Smooth and the Striated' in *A Thousand Plateaus*, Ch 14, pp 474-500.

11 *Ibid*, pp 7, 23.

12 *Ibid*, p 4.

13 In a recent catalogue essay, for example, Klaus Ottmann adopts the strategy of sheer quotation where approximately one quarter of his text is comprised of passages culled from Deleuze and Guattari. see Klaus Ottmann, Lydia Dona, exhibition catalogue, Galerie Barbara Farber, Amsterdam, 1993. See also Maia Damianovic, 'Paradox View: New Paintings by Lydia Dona', *Artsmagazine*, vol 63, no 4 (December 1989), pp 70-73. In this article the various section headings are direct textual lifts from *A Thousand Plateaus*.

14 Harold Bloom, *A Map of Misreading* (Oxford University Press, 1975), p 3.

16 I use 'supraconscious' along lines that Roman Jakobson implied. The slavic word *Zaumnyj* (supraconscious) alludes to the particular form of poetry practiced early this century by the Russian Futurists, notably Khlebnikov, which in its most drastic instances verges on total verbal delirium. 'Zaum' aspires to stand outside language and grammar in an effort to dismantle traditional meaning and produce significations predicated on the sudden impact of the trans-sense utterance. See, for example, Roman Jakobson, 'Supraconscious Turgenev', in Marshall Blonsky (ed), *On Signs* (Baltimore: Johns Hopkins University Press, 1985), pp 302-307. A longer discussion of Lydia Dona's relationship to language could certainly benefit from the 'zaum' paradigm.

17 Deleuze and Guattari, *A Thousand Plateaus*, p 6.

18 Julia Kristeva, 'Giotto's Joy', in *Desire in Language: A Semiotic Approach to Literature and Art,* trans Thomas Gora, Alice Jardine and Leon S Roudiez (New York: Columbia University Press, 1980), p 216.

19 *Ibid*, p 231.

20 Bloom, *A Map of Misreading*, p 3.

21 Bloom himself measures his distance from Deconstruction as follows: 'Nietzsche, according to Derrida, inaugurated the decentering that Freud, Heidegger, Lévi-Strauss and, most subversively, Derrida himself have accomplished in the Beulah-lands of Interpretation. Though I am myself an uneasy quester after lost meanings, I still conclude that I favor a kind of interpretation that seeks to restore and redress meaning, rather than primarily to deconstruct meaning. To de-idealize our vision of texts is a good, but a limited good . . .' See *A Map of Misreading*, p 175. For commentary on Bloom's differences from Derrida and de Man see Peter de Bolla, *Harold Bloom: Towards Historical Rhetorics* (London: Routledge, 1988), pp 25-35, 105ff. Christopher Norris expresses ambivalence over Bloom's self-differentiation, but nevertheless writes that Bloom's argument, 'shrewdly undermines the deconstructionist position by insisting on the conflict of wills to expression behind the encounter of text with text. This struggle, he urges, must not be lost sight of in the undifferentiated merging or free play envisioned by Derridean deconstruction.' See Norris, *Deconstruction: Theory and Practice* (London: Routledge, 1982), 122ff.

22 Harold Bloom, *The Anxiety of Influence: A Theory of Poetry* (Oxford University Press, 1973), p 70.

23 Barnett Newman, Interview with David Sylvester, (BBC, November 17, 1965) reprinted and amended in John O' Neill, *Barnett Newman: Selected Writings and Interviews* (New York: Knopf, 1990), p 257.

24 Newman distinguishes between the pyramid and the triangle, regarding one as form and the other as shape. The pyramid strictly belongs to the domain of sculpture and the triangle to painting. See Barnett Newman, *Chartres* and *Jericho*, *ARTnews*, vol 68, no 2 (April 1969), p 29. Lydia Dona counters this formality, instructing that the triangles within her painting be conceived as pyramids.

25 Bloom, *A Map of Misreading*, p 69.

26 Harold Bloom, *The Anxiety of Influence*, p 94.

27 In the context of scaler analogies, one may recall Virilio's tracing of the trajectory of speed in this century. with the acceleration of instantaneous communication and supersonic travel: 'every city', Virilio notes, 'will exist in the same place – in time'. See Paul Virilio and Sylvère Lotringer, *Pure War*, trans Mark Polizotti (New York: semiotext[e], 1983), p 60.

28 Maurice Blanchot, *The Space of Literature*, trans Ann smock (Lincoln: University of Nebraska Press, 1982), p 268.

29 Deleuze and Guattari, *A Thousand Plateaus*, p 37.

OTHER ABSTRACTIONS: THÉRÈSE OULTON'S *ABSTRACT WITH MEMORIES*

Andrew Benjamin

Perhaps it is possible to start with memory.[1] With memories that are placed before the eye. What here has been remembered? How does painting work to remember? (This question cannot be easily separated from the more strategic question of how painting remembers. This is of course not just a matter of technique but rather one incorporating technique as a question.) In pursuing these areas of inquiry what must be maintained is the recognition that painting will always do more than remember. With these four paintings there is a change of colour that divides the framed; moreover within the framed there are lines.[2] The lines aid in dividing the field; lines on a field that is already divided. Here the surface has been worked. There is therefore the presence of an activity that is itself already the mark of painting. Initially at least it is precisely this aspect that makes these paintings abstract. And yet what is going to count as abstraction cannot be just assumed. Abstraction, if the term is to realise its descriptive potential, will be the consequence of work; the work's work. It will be essential to return to this point by tracing the effectuation of abstraction. However even in provisionally accepting the field as abstract what cannot be precluded is attention being paid to their collective title *Abstract with Memories*. These titles bring more into play than the simple positing of either abstraction or memory. As will be argued here they refer to work rather than to the treatment of topics.

Even if the titles were not accorded a central place, time, and with it memory, would still intrude. The presence of complex divisions within these works – within them as part of their work – would demand that the relation between those divisions be taken up. The realisation of that move – which in itself would amount to the recognition of the ineliminable possibility of time's intrusion – would entail that the divisions within these works, though spaced, gave the complexity of time. Space would have become timed. What this means is that instead of memory being introduced as a topic and thus as the painting's subject matter, it will already have figured as a determining part of the way the paintings work. Allowing memory to figure in this way – no longer as a topic but as part of the work's work – will depend upon maintaining time as complex. Starting with memory will mean having already started. (The field of abstraction is there.)

Construed as always more than subject matter, memory in painting will involve other determinations than those which are given either by the reiteration of a specific theme or the actualisation and thus the instantiation of painting's own memory. Both will be included even though neither will exert an absolute hold on the question of memory. The opening question still insists: How does painting work to remember?

Within the area of Thérèse Oulton's recent work it should not be thought that these are the only paintings incorporating a line and thus a divide. *Transparence No 3* is also divided by a line. Moreover there is a change of colour. A shift in the register of blue marks out a division. With this particular work the activity of interpretation would be initially constrained by the interplay of line and divide. And yet that would not complete the site of interpretation. The interplay would have to be set within the context given by the name. What is initially evident in these works – *Abstract with Memories Nos 1-4* and *Transparence No 3* – is that depth is introduced by the title as well as by the presence of the work. However it will be argued that within the context of these paintings depth is more than that which is present initially (thereby opening up the possibility that depth in painting will always have been more than it initially appeared.) Consequently, to the extent that depth will have been allowed a quality that is neither merely spatial nor just that which is suggested by the work's title, then depth in painting, given the assumption that it remains possible to identify the work of depth, will pertain to that complex arrangement within the frame in which time figures. Once depth is repositioned in this way what will have to be taken up is the presence of framed divisions that enact spatially that which cannot be reduced to the spatial. It may be that, with this site, irreducibility provides another place for depth. Not only will the work open out, it will also open up within itself. These two possible openings will check any attribution to the work of an ontological or interpretive finality. With the abeyance of these ends the works can no longer be attributed the quality of being either exclusively self-concerned or interpretively self-enclosed.

What seems to be emerging are abstract works which resist the possibility of autonomy in two interrelated ways. Firstly, as was suggested, they are not straightforwardly self-

enclosed. What takes place within them could more exactly be described as the enactment of specific reinaugurations. It is thus that they are not purely abstract. The field or site of interpretation brings with it and has inscribed within it concerns that are already familiar. This does not preclude the possibility that they will become unfamiliar – familiarly unfamiliar – within the act of interpretation; within the positioning of the site as given to interpretation. It is rather to suggest that memory, depth, line, division, time etc, are themselves already at work and thus are familiar moments within the history of painting. Secondly, the reason for distancing the centrality of autonomy is that it is too closely connected to a certain conception of abstraction. A conception which, as shall be suggested, is itself almost inextricably linked to the work of the negative. Consequently, to the extent that it is possible to allow these works to take up the question of memory, then, even though they are abstract – in the direct sense of being non-figurative and therefore non-representational – it is still possible that they could be grouped with representational paintings in that what was at play in each was the topic of memory. If this is the case then what it may sanction is the argument that distinctions between figurative and non-figurative painting are simply generic and thus can be countered by the introduction of another generic possibility. The result would be that the release of one hold – the hold maintained by genre – would release the painting, once again, into the interpretive field. The further consequence of this other release is that it would suggest that what was essential to painting can no longer be given by the generic status of specific works but is to be found in the work's own capacity for release. An integral part of that potential would be the impossibility of an absolute restriction. Genre will still insist, however, and thus it must be taken up into the work. Genre will need to be thought in relation to that which is essential to work.

The abeyance of completion, while advanced as an interpretive claim, is not based on semantic undecidability. It is rather that what the work brings with it – bringing it as part of its make-up – is its always being able to be rereleased thus giving rise to the supposition that the essential within art will be linked to this potential. If that is the case then art will demand another ontological description. There will be a movement away from viewing work as fixed and as inherently historically determined, and towards that activity within the work which constitutes it as being work; in other words, towards the work's work. Once work is emphasised then rather than the object being taken as given and as already complete within the act of interpretation, it will demand another construal. What will mark out the possibility of this shift

is the ontological nature of the art work. Instead of its articulation within an ontology of stasis because of the continual release of the work – its being in releasing and rereleasing itself – the work will need to be understood in terms of the discontinuous continuity of the becoming-object.[3]

The value of these works *Abstract with Memories* and *Transparence No 3* is that they allow abstraction – what is meant and understood by the term once it is taken as more than an already determined generic possibility within painting – to be questioned. Nonetheless there is a further consideration. As the object cannot be maintained outside of relations, minimally the subject/object relation, it will mean that even though the presence of the object – present as the reworking of the object in terms of the becoming-object – will come to mediate the activity of questioning, what will also have to be maintained is the presence of the eye. However the eye's presence cannot be just assumed. While present the eye is not just there. Once again questioning will need to insist. What is the eye for painting? What will seeing be? (After all these are the questions for traditional aesthetics.)

Abstraction

What needs to be worked through are the received descriptions of abstraction.[4] It will be in this sense that starting with the negative will give abstraction; in the end however negation merely gives it away. Starting in this way will yield a preliminary threefold definition of abstraction: Abstraction does not refer. Abstraction does not represent. Abstraction is not figurative. In neither referring, nor representing, nor presenting figures the abstract frame becomes a form of pure interiority. It can only refer to itself. In referring to itself it may be able to refer to a more generalised conception of the abstract and the techniques of abstraction; nonetheless it encloses itself within itself. Within the terms of this argument, titles that attempted to free the work from the restriction of this internal space would enact no more than a sustained misconception of the activity proper to what had been framed. It would be as though such titles were redundant. The obvious consequence of this position is that abstract works, almost by definition, should remain untitled. Any name would betray their negative relation to reference, representation and the figure. Here all that is left to abstraction is expression. Expression would not be the genre but the way in which paintings were taken to be present. Abstract painting would be expressive of a particular state of affairs. Such a construal of expression only emerges – indeed can only emerge – because of the location of abstraction within a series of specifically determined structured oppositions: in-

side/outside, non-figurative/figurative and non-representational/representational (these oppositional pairs will for the moment incorporate questions pertaining to autonomy and reference). Here abstraction becomes the affirmation of the first element and the negation of the second. The question that must be asked, however, is whether or not this is definitively to locate and to circumscribe abstraction. The force of this question is that it opens up the possibility that there is another construal, one allowing for an affirmation of abstraction beyond the hold of these oppositions.

It is clear that another answer to this question could be provided by drawing on art history, and accepting thereby a progressive movement through the figural towards the abstract. Fundamental to this movement would be certain works and periods in which the process of abstraction had accelerated and the impulse to be abstract had intensified. Tracing this movement would allow a retroactive rereading of key works – or what would emerge as key works – in the light of subsequent movements within art's history. Here abstraction would emerge as the culmination of painting; a culmination in which the abstract and, within abstraction, the monochromatic canvas – assuming minimalism to be the final point to which the impulse to be abstract ultimately leads – would have become the end of painting. Painting would have become itself. It would have reached its end with the realisation of its end. In this instance an argument concerning paintings's end could be formulated purely in terms of painting. Part of the force of such a position would be its dependence on a complex equation of painting: beauty and form on the one hand and the effective copresence (with that equation) of the teleological on the other. What gives this position its force is the apparently historical dimension it brings with it. It purports to present the incontrovertible presence of the historical. And yet, within the formulation of this position, 'history' only has explanatory power if the time proper to historicism is naturalised, with the result that arguing for the abeyance of such a construal of time amounts to an argument that would attempt to defy nature and would thus be no more than an idealist gesture in the face of an ineliminable material presence. That this is not the case has to be argued for firstly in relation to historical time and secondly in relation to the art object. It is the second of these concerns that will be addressed here. The mode of address will involve a response to the work of specific paintings.

Arguing against the naturalisation of time does not leave time open to a simple relativity in which one time can be countered by another. It involves a twofold move. In the first place it is to concede to the inexorable presence of chronology, but then in the second to suggest that regardless of the way in which history may or may not work, what is essential is to allow for the possibility of an intervention within the pregiven domain of interpretation – the present – which may have the consequence that what is there to be repeated is no longer able to be repeated in the Same way. It is this possibility that is borne by the art object; by the specific ontology of the art work. Moreover, the actual intervention within the present in which an other possibility for the present comes to be actualised is the structure of interpretation when taken as the limit of the possible. (Other interpretive possibilities can never be excluded. However, what may mark them out is the way in which they facilitate the repetition of dominance; in other words the repetition of the Same.) What has to be pursued in this instance, therefore, is the possibility of an interpretation of abstraction in which it is no longer held within the movement towards abstraction – the inexorable teleology of art's progress towards its own end – and, in addition, where abstraction is no longer placed within a series of oppositions that automatically, and prior to the presence of any one painted instance, defines that existence in negative (and thus in autonomous) terms. Pursuing this possibility will be situated in relation to Thérèse Oulton's *Abstract with Memories Nos 1-4*.

While investigating this possibility will take place around these works, as they are works of art what also must be taken into consideration is their visual presence. They are seen. And yet what, here, is seeing? Once the physiological determinations of sight are acknowledged what is left over is what seeing is going to be. The eye will expect. In general it will be confronted by what is expected. Seeing has its conditions of possibility; conditions which are inevitably materially present. The setup within which this reciprocity is played out can always be sundered. And yet even if is confirmed rather that engaged with critically there is an act of transformation. What initially was given to be seen will always become *more than seen*. It is with this movement that understanding comes to the fore. Understanding in this instance is not a cognitive category, it describes the interplay between what is given (to be understood) and its being accepted (its being understood, misunderstood or there being a failure to understand; all are modes of acceptance). This sets the scene for the turn to painting.

Abstracts with Memories

What is it to turn to the paintings? This is, of course, not the simple question of seeing; as though a pure phenomenology of painting were possible. The inscribed presence within seeing of its own conditions of possibility means that all such acts are traversed by the movement from seeing to the *more*

than seen. To the extent that objects take on the latter quality they are already located within the realm of interpretation. Even when an object – an everyday object falling beyond the domain of the visual arts – is *seen* as enacting the minimal requirements for it to be what it is, then the identification and description of how those requirements are fulfilled is already an interpretive act; albeit the most minimal of interpretive acts. What occurs is the attribution of centrality to work. The work must be seen as at work. It is to that extent that works are always *more than seen*. What is given is a structure of enactment. Turning to the paintings is to turn to their work – they are, in being, at work. With interpretation the finite – and to that extent the definite – are both located and dispersed within the infinite. Rather than being mutually exclusive, the finite and the infinite interact with the work. Once more this is an ontological claim about the nature of the object of interpretation – about its being at work – and not one about semantic plurality. (Semantics, or more properly signification, is inseparably linked to ontology.) Their copresence – the infinite/finite – is the mark of an already present complexity; an irreducible anoriginal complexity.[5]

What is the work in question? *Abstract with Memories No1* (though this general point will be true for the majority of the works in this series) presents a worked surface where the application of paint – the method of its application and the effect of that application – yields a complex surface. The complexity involves the work's relation to content. Paint can always be applied such that while it is possible to draw attention to application, the work itself seems to offer a surface that is indifferent to the specific presence of paint because it is concerned with the consequence of the paint's application. In other words its having been applied and its instantiated application are effaced in favour of the effect of that application. It is as though paint – paint's work – gives way to the painting's narrative. In these instances paint's work would only be considered – and therefore would only be there to be considered – after its having been applied. Here, with this series of paintings, there is a different relation. Application is not effaced in favour of its consequences and yet application is not all that there is. Part of the effect of what has been created is that the works project a specific quality. There is a field of painting; a wall of painting. If analogies were demanded, then, with *Abstract with Memories Nos 1-4,* it is possible to suggest that what is present oscillates between a wall and a cross section of rock; perhaps even part of a cliff, though more dramatically a cross section of muscle. (These analogies will be given a certain standardisation by allowing them all to be construed as the varying permutations of a cross section.) In sum a part has been presented; a part presenting and holding depth, a temporalised depth. While a part is present, this on its own is not sufficient as the conventional construal of the part/whole relationship will have been rendered inappropriate by the way in which these works work. Other parts will be at play; with them there will be other abstractions.

Within this series the worked paint projects a surface that cannot be readily assimilated to a painted canvas. The comparison here would be between these works and ones in which the surface was in part free of paint (paint other than a primer) while other parts carried the presence of paint. The application of paint in such an instance would mean that there had been the creation of limits within the frame. In the case of Oulton's works – though specifically *Abstract with Memories Nos 1-4* – there is something that escapes limits. And yet the introduction of the limitless and therefore of that which delimits the role of limits should not be seen as simple excess – especially when the latter is given within the general problematic of representation. (What is at stake here is not the sublime.) Other limits will play a determining role These other limits are derived in part from the possibility of taking the frames as presenting cross sections and in part from what had been established by the presence of lines within the interpretive site. Prior to turning to the cross section it is essential to stay within the field of painting. What is significant here is the totality of what is presented. The field is complete as a field of painting. And yet to describe it as complete is to suggest that what is occurring is necessarily and naturally delimited by the painting's physical boundaries.

As a point of departure what characterises such limits – the work's physical boundaries – is their material presence. The painting ends. Its begins and it ends. What is seen can be measured. The measurements can be given. The seen is able to be housed. Whether or not there is a frame, in this instance, matters little. What is significant is the moment of fixity. With it a real exteriority and interiority are constructed. This state of affairs is itself a limit; a limit that is overcome – even though its content, the delimited, is retained in its being reworked – in the move from the seen to the *more than seen*. With this move terms such as 'interiority', 'exteriority', 'fixity', even 'material presence' and 'real' will not be abandoned. On the contrary they will have taken on necessarily different qualities since they will have been inscribed within the interpretive; the contested field of interpretation. It will be thus that their meanings are important because they are not fixed. Even when set, definite, they are still open to negotiation. This is the already present infinite that inhabits the place of finitude. (As with a work's capacity to be rereleased the possibility of negotiation can never be finally extruded.

At the most minimal what endures is the presence of this possibility as an inherent and ineliminable potential.)

Once interiority and exteriority are located within interpretation and no longer just identify material presence then material presence, in being maintained, will have been transformed. Here this transformation means that the painting's limit – what materially was just a border, or the painted surface's end – is no longer just the physical boundary; rather, the presence of the boundary turns the painting into a part, a component of a whole. What gives this transformation its specific hold is that the part in question has neither a metaphorical nor even a metonymical relation to the whole. It is neither a substitute standing for the whole, nor moreover is it that part of the whole providing totality. What is present here is both part and whole. (The part may be the whole though equally the whole is, in part, inscribed within the part.) The part refers beyond itself because it refers to a more that is the same as itself. The more – that which is beyond the limit established by the physical presence of the frame – is neither identical with nor completely different from what is presented within the work. It is rather that it is the same; a relation of similitude which is not that of identity. Sameness, therefore, will have a complex quality in the precise sense that, with the paintings in question, sameness will incorporate difference. These works are excisions – it is as though they have been excised. It is at this point that analogies can be reintroduced.

A section of cliff, an identifiable element within a cross section of a rock or of a muscle is part of the whole but only to the extent that the whole is thought of as a type of movement; one in which the part itself could function as a whole. In this instance movement should not be understood as incorporating the idea of development characteristic in music (with the possible exception of fugal form); it is rather that with these paintings the whole is a progression that has neither *arché* nor *telos*. It is thus that any one part of the whole could equally be the whole itself. This occurs because the work, as part of its work, holds in place its relation to *more*, to the whole. At any one point the cliff, for example, is itself and yet the cliff is always more than this instantiation. The cross section will have a particularity, it may even have that which makes it singular and yet neither particularity nor singularity exist in themselves. An essential part of what accounts for any attribution or identification of a unique determination will be its incorporation into the whole of which it is a part. As with the cliff there is a single instantiation that gives out onto that which is more. It gives, however, whilst holding to the particular and the unique. It is part *and* whole. What endures as a question is the extent to which the more

is to be understood as excessive. Excess however is already inscribed within the structure of representation. Furthermore it is excess – its putative possibility – that structures and sets the limit for representation. Excess is not implicated in the abeyance of representational thinking, it merely delimits it. These works are not excessive, this would be to misconstrue their being as objects. There is a more fundamental dislocation.

Here there is a breach in the hold of autonomy; a breach occasioned by interpretation's response to art's work. The work opens out of itself. Part of this opening is the location of the work's work within an orchestrated movement of which it – the work – is a part. It as though the work has moved from being a jewel to being the excised part of cliff. In the former case, the jewel, the work is done on the object in order to create its uniqueness. It refers to itself. Its relations are to points within itself. Symmetry is a self-defining state of affairs. Allowing the jewel exteriority is to accede to its potentially sculptural presence. With these paintings any hint of symmetry or possibility of a self-defined internality is always undone by the excised status of the work; always parts but always wholes. It is conceivable, then, to interpret the way paint is applied in these paintings as an effect whose capacity for repetition works the paintings beyond their own physical limits. They become projects – literally pro-jections – that maintain internality. Indeed it would be possible to go further and argue that this technique which dominates Oulton's recent work has the effect of allowing abstraction to have particularity. What gives it its specificity is its opening out onto a more, the presence of which has already been inscribed within the frame in terms of particularity; the particularity is the consequence of the technique. Greater detail is still necessary in order that the complexity of these works be presented.

The divides within the works – perhaps more emphatically present in *Abstract with Memories No 3* than in the others – become divisions with the whole, the more, that are equally present within the works. Accepting this reworking of the part/whole relation would allow the divisions – divides which are of course only ever spatially present – to take on and thus to enact a temporal quality. At the most basic level time is introduced by the layering of construction. Not the actual construction of the painting but the effect of a division within that which had been built or constructed, or even of what had evolved or developed. Layering and divisions introduces the inscription of time by the fact that they are time's inscription within the field of painting. A change that is spatially present signals a temporal shift; another laying down of sediment, a fundamental developmental alteration. What is at work within these works is neither merely spatial

nor simply representational. There is something else. The whole's reinscription within the part and the part holding itself open to the more means that what is presented here is both the particular and the generalised movement of change or augmentation or division. What is vital to viewing these paintings is that the temporal difference be allowed to be seen. One way this can be done is by recognising that part of what these alterations or changes bring with them is memory. Once there is a divide that involves a straightforwardly temporal difference the question of relation – the relation between the elements comprising the difference – will come to be posed. With time, within time, the question of relation takes the form of memory. The question of memory is therefore already inscribed in the work; it is part of the work's work. It will be possible to return to the time enacted by the divisions as well as to the question of memory after having taken up the lines that occur within the frame. These lines introduce another time and thus a different take on memory. Time and memory harbour an already present plurality.

Within all of the paintings in this series there are lines. They are coloured lines drawn over what has been described hitherto as the field of painting. They are part of this field. And yet, while they are obviously part of that field to the extent that the paintings are understood as involving the complex part/whole relation described above, then they are apart from that relation. The lines have been placed there after the event (though, as shall be noted, they comprise an integral part of the plural event). They are additions – additions forming part of the interpretive whole – in two different though related ways. In the first place, they appear to be literally additions, added after the surface on which they are painted had been completed. In the second they give particularity to that which does not have automatic particularity. It is because they are additions that the lines' times are different. The line could be dated. In being an addition the time of the line is given by its being an inscription – a line inscribed. On one level it is as though they are lines drawn on a wall or a cliff face. While it is accurate to describe them in this way they must not be taken as afterthoughts. It is rather that they are a fundamental part of the interpretive field. What must be pursued, therefore, is the detail and the consequence of their presence as part of this field.

Here there is a field of painting that enacts different times; they are of course enacted, on one level, at the same time. The divide within the work brings to the fore the question of memory. Memory figures because it is the bridge within a temporal divide. The presence of memory is doubled by the addition of lines. Not only does it take on a twofold presence, but it is as though there is a shift within memory itself.

(Memory will have had more than just one possibility.) In the first instance memory is part of the work's constitution; the presence of additions and developments signals the movement of time. A constitutive move in the process of construction – the work's effectuation as work – has taken place. Instead of spatialising that development and presenting it as though it were no more than a simple alteration of the topos, the movement is being taken as movement. Once this occurs what has to be taken up is relation and then memory. Memory here pertains to the part/whole relation. Within this context a line has been added. The addition diminishes the hold of that initial temporal divide by turning the divide into a surface that is given at one and the same time. The particularity of the line therefore turns the surface into a 'literal' surface; the literal, taking place within the realm of interpretation, is an after-effect of production. What is not lost however is the founding presence of the field of painting. The field moves between on the one hand the presentation of memory as raised by its own construction – the work of the divides – while on the other it enacts what amounts to the effacing of that site of memory. Both pertain at one and the same time. The 'one' here, therefore, is already more than one while sameness contains a constitutive irreducibility. The strength of this irreducibility lies in its being productive.

The site is given by the work's affirmation of the primordiality of relation and effaced by the presence of the lines on the surface. It is the line's presence of course that constructs the surface as a surface. There is a partiality at work here. Affirmation in the sense used above is partial because it is already mediated by the line's presence. Effacing is partial because the affirmation enacted by the divide already mediates it. The work is incomplete in the precise sense that it is caught in an oscillation sustained by an already present irreducibility. It is this movement which is the continuity of the becoming-object: the object *is* in its continually becoming itself. (The full import of this claim would emerge in the attempt to explicate the status of this 'itself'.) What the work enacts therefore is the presence of an already present plurality; the latter being the name here for anoriginal irreducibility. The work is a plural event in the precise sense that accounting for irreducibility will demand recourse to ontology and not semantics. It is this state of affairs that gives depth and which is sustained by depth.

Depth is present in two senses. In the first place it is at work within the founding site of memory; the divisions within and as the work. Depth works within the division once time is allowed its place. In the second it is present within the oscillation between the affirmation of relation and its having been effaced. Both inhere as an essential part of the work's

work. They inhere, however, as irreducible. In this instance it is an irreducibility marked by an inherent reciprocity. Depth can only be identified once space has become timed. In other words, while depth describes that which is spatially present, because the spatial here is the articulation of different temporal possibilities, depth is given by time and movement. Depth inheres as part of the painting's process – the work's work. Time has become the precondition for depth. The surface in holding depth has itself become timed. It is at this stage possible to bring the titles into play: *Abstract with Memories Nos 1-4*. These particular paintings operate in different ways. However despite their particularity what it is that is operated and what it is that is presented articulates time by the works having been staged by what could be described as the productive presence of timed space. It is the effective presence of time that provides these works with an important commonality. As a conclusion therefore it is possible to ask in what way these works are what their title identifies. How are the abstracts with memories? How does painting work to remember? It is thus that the opening question returns. As has already been indicated, part of the answer is provided by the nature of the object in question and another part in the way the abstract nature of these works is to be understood.

What has already been identified with these 'abstracts' is the way in which memory – the work of memory – is presented by the way the works work. Memory is not added on. It was already there. Their abstract quality does not lie in the negative relation to representation, externality and the figure. It is there in the way memory is present. Abstraction is not present because memory lacks a given determination and thus all that is present in these works is memory in the abstract. Abstraction here means a particular type of presentation. It is the adoption of abstraction as an already determined form of painting. (Abstraction is not being generalised. All works of abstraction, what is called abstraction, do not work in the same way.) Part of that presentation and thus part of what allows the work to be abstract, is a confrontation with the convention of abstraction. Engaging with abstraction within abstraction needs to be understood in terms of the framed; in other words in terms of a response to the field of painting in which topics or subject matter can only be identified with their emergence from the way in which particular works work.

Here it is worth making a slight detour. In writing of his own artistic project and the ones with which he associated himself Barnett Newman deployed a language proclaiming the possibility of a radical disassociation:

We are creating images whose reality is self-evident and which are devoid of the props and crutches that evoke associations with outmoded images, both sublime and beautiful. We are freeing ourselves of the impediments of memory, association, nostalgia, legend, myth, or what have you, that have been the devices of Western European painting.[6]

Abstraction within this formulation is necessarily linked to immediacy. The work, it is claimed, is literally immediate. Any form of mediation is denied by the assertion that contemporary 'images' have been freed from the 'impediments' that make up the 'devices of Western European painting'. It is vital to note that one of these 'impediments' is memory. Part of what is on offer here is another variant of autonomy. There is no need to interpret Newman's own work in relation to this claim. Its significance, as a claim, is to be found in the nature of the artistic project it propounds. It is feasible to read the title *Abstract with Memories* as a response to Newman. While one consequence of Newman's position is that the presence of memory in Oulton's work may jeopardise their claim to abstraction, this is not of central importance here. What is significant is that her paintings affirm the presence of memory by holding and presenting memory within timed space; the twofold presence of memory within the paintings forms part of the timing of space. Timed space is part of the way in which the work works. As such it is an integral part of the continuity of the becoming-object. The possibility raised by Newman in which art would become autonomous, singular and without memory is a position that is not only untenable for philosophical and art historical reasons, in this instance its viability will have been undermined by art works. It is possible to go further and argue that it is only in being abstract that these works are able to stage – or be viewed as staging – a critical engagement with the project proposed by Newman. The engagement emerges not because Oulton's work involves either mere critique or simple refusal. The works work in a way that cannot be assimilated to that project. They work otherwise. What is essential is to construe that alterity beyond the hold of negation. A beginning is clear: *Abstract with Memories Nos 1-4* remember.

Painting works to remember by engaging with the history of painting in such a way that the engagement does not stage a repetition that is itself articulated within the reign of the Same. It is another engagement, a different relation. It is thus that there will be an-other repetition. A form of alterity is fundamental here since the type of repetition in which the Same predominates and determines what takes place, leads in the end to the denial of remembrance. Remembrance's denial figures because sameness intends to preclude relation and thus obviate the need for memory. The obvious counter

of absolute alterity will itself be marked by its own impossibility. What makes such a move impossible is the ineliminable presence of memory. In that instance, however, memory would be the insistent presence of history. The proclamation of absolute alterity and new beginnings become similar moves within a more generalised metaphysics of destruction.[7] Painting works to remember in the abeyance of destruction and by figuring complex relations. Within the generalised field of painting this relation may be generic, or it may involve the specific subject of works. Here with these paintings there is a double work of memory; two interrelated forms of memory are present.

The first emerges as part of the work itself. The work allows time and memory to figure as an essential part of the works' work. Both the divide, and the lines working to create the surface, enact different takes on the question of memory. It is thus that memory is already implicated in the work. It is this enactment that brings another aspect of memory into play. Here what is remembered and then worked through is that particular construal of abstraction that is linked to negation and autonomy. The complex presence of the part/whole relation stages a breach in the hold of autonomy. Autonomy, immediacy and the negative are themselves not subject to negation. It is rather that they are no longer appropriate to the way in which these abstract works work. The breach that results in their abeyance is effected by timed space. Timed space becomes the enactment of other abstractions. It is their hope.

Notes

1 What is of concern here are four recent paintings by Therese Oulton. *Abstract with Memories Nos 1-4*. Perhaps the most philosophically acute reading of Oulton's work is to be found in Paul Crowther's *Critical Aesthetics and Postmodernism* (Oxford University Press, 1993). See pp 194-5 and 205-6.

2 By 'framed' what is intended here is the site of interpretation. The presence or absence of real frames is, in this instance, not the issue. Their presence will always need to be incorporated into the activity of interpretation. This point will be developed at a later stage.

3 I have attempted to spell out in considerable detail the consequences of the redescription of the art object in terms of the becoming-object in *Object, Painting* (London: Academy Editions, 1994).

4 All that will be offered here are some provisional statements about the reception and traditional interpretations of abstraction. In general, they refer to the gradual identification of form and purity within the criticism that accompanies abstract art. Left out of any consideration here are the social or pychological accounts of what Worringer described as 'the urge to abstraction' (W Worringer *Abstraction and Empathy*, trans M Bullock (New York: International University Press, 1980)); an expression that has been given a more general range here by its having been moved from the subject to the object. In other words, the impulse has been located in the work. Worringer's formulation and other similiar studies of abstraction – eg Ehrenzweig's psychoanalytic formulation in *The Hidden Order of Art* (London: Weidenfeld, 1993) – warrant a detailed analysis. Hopefully this can be undertaken in another context.

5 For a sustained discussion of the anoriginal see my *The Plural Event* (London: Routledge, 1993).

6 Barnett Newman, 'The Sublime is Now' in D Shapiro and C Shapiro (eds), *Abstract Expressionism. A Critical Record* (Cambridge University Press, 1990). See p 328.

7 The question of beginnings and repetition has been treated in detail in *The Plural Event*. See pp 1-34.

PAINTING AND ARCHITECTURE: CONDITIONAL ABSTRACTIONS
Stan Allen

But the cinema perhaps has the great advantage: just because it lacks a centre of anchorage and of horizon, the sections which it makes could not prevent it from going back up the path that natural perception comes down. Instead of going from the acentered state of things to centred perception, it could go back up towards the acentered state of things, and get closer to it. Broadly speaking, this would be the opposite of what phenomenology put forward. Gilles Deleuze[1]

If cinema is the image in movement, a cipher of change, architecture is often identified with the static and the timeless. Architecture can play the role of frame for movement and event, but cannot participate, except in so much as it functions on a symbolic level. But this is a false (or at least unproductive) opposition. To speak of abstraction in architecture is to risk accepting without examination two related but distinct assumptions. The first would link abstraction with the mathematical and the ideal, and measure architecture's abstract capacity exclusively by its symbolic function. Abstraction in this account resists the complexities of event and time, and sees as trivial the 'accidents' of perception. Seemingly opposed but secretly related is the view that abstraction in architecture has a wholly instrumental value, streamlining design and construction through modularity and standardisation, while reducing experience to quantifiable effects. Paradoxically, while abstraction in this account acquires a negative value, the notion of experience privileged here is itself fundamentally abstract and idealised. Both accounts hold 'experience' and 'abstraction' apart, and define the abstract in architecture as other than its matter.

One way out of this double bind has been the appeal to phenomenology, as a model of perception capable of negotiating both ideal concepts and experience. But the arguments of phenomenology, as they have been applied in architectural discourse, want to link architecture with centered perception.[2] Indeed, it might be said that phenomenology reinvents architecture in order to provide itself with a model of centered perception. The individual perceiving subject is projected as a stable focus for the uncertain flux of meaning. But was it ever within the power of the architect to convert matter from an 'acentered state of things' to 'centered perception'? This question needs to be asked not only of those who appeal to phenomenology but also of those who want to criticise architecture as a simple map of power relations. Architecture needs to be seen as a field where real and abstract already coexist in uneasy proximity.

Deleuze begins with similar terms but proposes different relationships. If we accept the Deleuzian proposition of the reversibility of the trajectory leading from the 'acentered state of things' towards 'centered perception', it follows that architecture could also be dislocated from its identification with the timeless and the static.[3] This might be the first step away from the reductive abstractions of both mathematical ideality and instrumentality. Hence an architecture of the contingent, a *conditional* abstraction: an abstraction which does not see itself as definitive, but proposes an anexact fit between event and structure, between change and duration, between execution and idea.[4] Neither a return to essential geometric beginnings nor a fully realised endpoint, conditional abstraction refuses both origins and linear histories. Abstraction is not to be understood here as historical imperative, but as a diagram of the possible. A conditional abstraction is sceptical of the idea that the task of architecture is to make sense of a disordered world – either by imposing order or by representing disorder. Does the intervention of the designer, for example, who operates according to certain models of intentionality and puts into play certain instrumentalities, in any way guarantee that reality will actually behave according to those intentions and models?

> The painter starts with the real world and works toward 'abstraction' . . . But architecture takes two lines. The architect starts with the abstract world, and due to the nature of his work, works toward the real world. The significant architect is one who, when finished with a work, is as close to the original abstraction as he [she] could possibly be . . . and that is also what distinguishes architects from builders. (John Hejduk)[5]

The discussion of architecture and abstraction needs to be detached from obvious questions of materiality. This is not to elevate the concept of abstraction, but to *lower* it into the realm of matter and things. 'The *movement-image* and *flow-*

ing matter are strictly the same thing', notes Deleuze.[6] Close attention to experience, it is suggested, would confirm rather than contradict Deleuze. Architecture is more intimately linked with an 'acentered state of things' than with 'centered perception'. Nor should this be seen as a simple relativism – it is not enough to say that perception is socially constructed without examining the architecture of that construction. Hedjuk's description collapses another opposition which is key to the discussion of abstraction and architecture, that is to say between drawings and buildings, between graphics and materiality. Architecture's abstract character is often assumed to originate in the drawing. The graphic apparatus becomes the site of exchange between mathematics (geometry and other ideal concepts) and their realisation in built form. As the notations of the physicist describe and predict phenomena, architectural notations describe and predict built forms: abstract concepts to be 'materialised'. But in this account the physicality of the building cannot be anything other than a crude and problematic necessity. Concepts and things are held artificially apart, and things always follow concepts.

Hejduk, on the other hand, suggests that this is not always a one-way street. 'In any case,' he reminds us, 'a drawing on a piece of paper is an architectural reality.'[7] Conversely, a building is also a diagram, a form of notation, a model of new possibilities. Here the analogy with painting can be helpful: in contemporary abstract painting, concepts proliferate in and through the physicality of the work, not as something other than the work. This, in turn, is entirely consistent with Deleuze's analysis of cinema – not as a reflection on something outside, but an examination of the mechanism by which concepts are produced within a practice.

From this point of view, a certain caution is required in the construction of interdisciplinary analogies. On one hand it might be enough to say that the arguments of abstraction have been more thoroughly rehearsed in painting, and that painting is more fully developed as a discursive practice. But the question persists.

Architecture's recurring tendency to place itself in a secondary position with respect to such 'strong' disciplines as philosophy and the fine arts suggests the notion of architecture as 'defective' discipline: architecture as defective philosophy, architecture as defective physics, architecture as defective sociology, architecture as defective painting . . .[8]

Defined in this way, the question of affiliation is not unrelated to the questions of abstraction in architecture. Inevitably implied in any attempt to restore architecture to some 'primary' position in the hierarchy of the arts is a notion of architecture's status as 'arche' discipline, site of the most fundamental and originary definitions of structure, order and hierarchy. The old myths of architecture as the 'mother of the arts' are predicated on an idealised abstraction, one that upholds the autonomy of the concept apart from its matter. In this regard, the notion of architecture as a defective discipline might deserve more positive development: to begin to see the fault that marks architecture as imperfect (incomplete or inconsistent) as the site of productive exchange. The defect is the inconsistency which cannot be explained away and yet, as such, prevents closure. Architecture has never been a circumscribed discipline capable of the 'self-critical' effort to define what Clement Greenberg would call its 'unique and proper area of competence'. In the case of architecture, what is unique to its medium can never be pure and unmediated. Hence the notion of architecture as a defective discipline, always unfinished, is linked to an idea of architecture as a model of complex social and interdisciplinary exchange. Affiliation becomes less a matter of enlarging the domain of architecture as of multiplying the sites of exchange. What is proposed is not simply to invert existing hierarchies, on a filiative vertical model of legitimation, but instead to promote multiple affiliations, which would be complex, branching, interconnected and horizontal.

Implicit in this description is the need to look beyond those practices which would seem to affiliate themselves 'naturally' with architecture. Ironically, when architects look outside their own domain, they return to even more 'essentially' architectural models. I am thinking here of the privileged place granted to the work of artists like Michael Heizer, Richard Serra, or Donald Judd – a kind of land art/minimalism axis – or to those who deal more explicitly with architectural themes such as Dan Graham, Siah Armajani or Mary Miss. Behind this orientation, there is an unspoken assumption that architecture's affiliation with sculpture is based on a shared concern with space, materiality and tectonics: a language of depth and presence.[9] It is no coincidence that sculpture is favoured over painting. Architecture wants to see itself as the repository of the real and as such is distrustful of painting's slippery compromise with representation. The critique of depth and presence in this context might be developed along two lines.

First, in as much as the artists mentioned above are able to defer some of architecture's most difficult questions: event, programme, use (what has been called architecture's 'persistent metaphysics of shelter'), because they are unburdened by architecture's cumbersome and inflexible system of patronage, their work will always function (both institutionally and conceptually) as a kind of impossible aspiration for architects. Architects can never attain the conceptual

and operational freedom, the formal purity or the critical detachment they admire so much in these artists. The effect of setting up such a model is to reinstate the concept as something unattainable, outside of and beyond architecture, towards which architecture is always successfully aspiring. It becomes an inadequate description either of what architecture might do, or the insights sculpture has to offer. The limited success of architects who have worked in the arena of architecture as installation art could only confirm this.

Secondly, and perhaps more problematic, is the way in which an appeal to certain sculptural practices valorises architecture's own most conservative tendencies. To locate the zone of correspondence along an axis of shared concern with space, material and tectonics, is to propose that architecture could begin and end with space, material and tectonics. All of the political, formal and temporal complexities of programme, event, or surface are left out. A sculpture by Richard Serra, for example, or Mary Miss (I intentionally put together these two very dissimilar artists) may look like architecture, but it can never function as architecture. And with a few exceptions, when artists have ventured into architectural constructions, from the Rothko chapel to Donald Judd's sheds at Marfa, it is only the lingering prestige of the artist's presence which prevents us from seeing how deeply conservative these works are. This work symbolically reinforces architecture's persistent metaphysics of shelter without performing it.

Is it possible to imagine a work which behaves like architecture, without 'looking' like architecture? What we are proposing is a more difficult, but perhaps more productive line of affiliation. Rather than space, material and tectonics, the points of contact will be surface, event and time. This is not a 'cross disciplinary' approach, which looks for correspondence and overlap among 'allied' disciplines, but rather proposes to pay close attention to *analogous effects or tendencies within distinct and specific practices.*

There is an important precedent for the idea of specifying analogous effects within distinct practices, that is to say, the essay 'Transparency: Literal and Phenomenal', written in 1955-6 by Robert Slutzky and Colin Rowe (respectively a painter and an architectural historian/theorist).[10] 'At the beginning of any inquiry into transparency,' they state, 'a basic distinction must perhaps be established. Transparency may be an inherent quality of substance as in wire mesh or glass curtain wall, or it may be an inherent quality of organisation . . . and one might, for this reason, distinguish between a real or *literal* transparency and a *phenomenal* or seeming transparency'.[11] Note that phenomenal transparency is detached at the very beginning from any connection with the physical. The phenomenal is not the real, it is not a mere 'physical quality of substance'. It is, rather, a quality of organisation, a property of abstracted structure, something that can be diagrammed. In referring to the simultaneities of Joyce, Cézanne and Apollinaire they clearly signal the high modernist ground they wish to occupy. But this is not a vague demand for painterly effects in architecture, but an analysis of a very specific point of coincidence. As the essay proceeds, it becomes clear that there is a privileged spatial model at work here: 'Literal transparency . . . tends to be associated with the *trompe l'œil* effect of a translucent object in deep, naturalistic space; while phenomenal transparency seems to be found when a painter seeks the articulated presentation of frontally aligned objects in a shallow abstracted space.'[12] Two remarks might follow from here. First, the preference (writing in America in the mid fifties) for 'shallow abstracted space' over 'deep naturalistic space' is not surprising, and would seem to indicate an unspoken agreement with the canons of Greenbergian formalism. More interesting from our point of view is the way in which the description of the space of painting already anticipates the architectural reading to follow. The specificity of the reference to cubism seems to drop away in favour of the frontal presentations of the architectural facade.

But there is a paradox here, which is only incompletely resolved when Rowe and Slutzky state that 'while painting can only imply the third dimension, architecture cannot suppress it'. In the close formal readings which follow, analogous effects of simultaneity, and fluctuating, ambiguous spatialities are uncovered in Le Corbusier's Villa at Garches (1927) and his Palace of the League of Nations competition project of the same year. The paradox, it seems to me, is this: the readings of the architectural projects are conducted at once from the perspective of an imagined observer, often in motion; yet, at the same time, they maintain the privilege of the project as an ideal construct, independent of the contingencies of experience and perception. Built and unbuilt projects are read according to identical criteria. There is a blind faith in the ability of architectural notations to predict experience. They can say without irony that they 'presume the Palace of the League of Nations as having been built and an observer following the axial approach to its auditorium'.[13] Materials, space, light and even trees are imagined and described. This is not pure organisation, detached from the physical, yet as experience, it has been idealised beyond recognition. The notion of transparency begins as an optical effect in painting. But in the course of Rowe and Slutzky's analysis, it is converted into an intellectual construct, and rendered suspicious of the perceptual and the physical – that is to say, of that which belongs specifically to

painting. An ideal viewing subject is invented: disinterested and uninvolved. The notion of time evoked here (again from Joyce) proposes the reassembly of discrete fragments (which are presented to the viewer over time according to the logic of the *promenade architecturale*) into some kind of integral whole. There is necessarily postulated a notion of an autonomous subject who can stand apart and perform that reconstruction. Despite the narrative of the text, it becomes apparent that Rowe and Slutzky are more interested in applying architectural paradigms to painting than in complicating existing models for architectural perception or production. (Note, for example, their suspicion of the pinwheeling diagonal compositions of De Stijl.) In the end, they recuperate the structural/organisational principles not only of architecture *per se*, but of a very specific kind of architecture. Minor disruptions of ultimately stable frontality are the most extreme consequences to be derived from the text.

As an alternative point of departure, we could look to the topologically complex spaces of David Reed's paintings: spaces marked by promiscuous relations of transparency and opacity, which might function as models to complicate and enrich these previously oppositional concepts of literal and phenomenal transparencies. Refusing the either/or of modernist dogma, these works are capable of holding multiple concepts in uncanny suspension. They suggest a deep space, implying both baroque theatricality and cinematic illusion. And yet, the deep illusionistic space is above all an effect of the smoothly sanded surfaces; we could speak not at all oxymoronically of 'deep surfaces' in this work. But the space of Reed's painting is not simple and homogeneous. There are rifts and inexplicable transitions – not the collisions of cubistic, gridded space, but abrupt appearances and disappearances, which set up indeterminant conditions of frontality and render gestures incomplete and tentative. Key in this regard are the somewhat inexplicable rectilinear fields of solid colours which often appear in the recent works. They serve to establish a kind of loose tension in the work. Interrupting the seamless surface, they offset the theatricality of the baroque space and gesture. They are a kind of blockage, making the composition go blank right at the moment when conventional composition would dictate some kind of resolution. With a keen sense (of timing) Reed inserts these implacable blocks as a specific against the seductive sweetness, the expected *dénouement*, the comfortable resolution. But things are never simple in these paintings, and these blocks at times acquire transparency, or become the ground for other gestures, complicating their location in space, and their situation in the implied time of the painting.

The appearances and disappearances in these paintings could be more accurately described using the language of cinema: cuts, fades, blends. The dominant horizontal format is also a film reference, specifically to the cinemascope format favoured in the westerns of the sixties. But this has another experiential effect. The size of these paintings is such that they cannot be taken in all at once, and as they are scanned, another sense of time emerges. This is not a Joycean reassembly of non-linear fragments but rather a progression back and forth in a kind of flux. Not so much linear time cut up, but continuous time made infinitely elastic. This is true of the gestural marks as well. Their machine-made precision resists the reading as an index of the artist's touch, which could only return us to the primal scene of making. These marks can barely contain the movements they imply. A term from Deleuze would seem appropriate here: 'cinema', Deleuze writes, 'does not give us an image to which movement has been added, it immediately gives us the movement-image'.[14] This is not so much time frozen, as with photography, but time infinitely speeded up; not so much movement arrested as movement anticipated.

Anticipation also functions in the work of Lydia Dona. Her paintings could be seen as indeterminant maps in which conceptual and material densities coexist, offering new models for the use of notation. These paintings are partial maps which only imperfectly predict perceptual experience. They play with instrumentality at the same time that they use instrumentality to disrupt the conventions of painting. Paralleling John Cage's introduction of chance into the conventions of musical notation, Dona introduces doubt into the stable functioning of the systems of everyday visual communication. The use of diagrams and symbols from car repair manuals or medical texts, for example, is not in and of itself improper given recent painterly practice (I am thinking, for example of Cy Twombly). What imparts a sense of impropriety, of excess, to this work is its permissive combinatorial frenzy. Here anything can conjoin with anything else, without any real consequence.

As Dona's titles suggest, unlike Reed, she is fully enmeshed in the semiotic. But the linguistic universe in which she is submerged is on the verge of collapse. One consequence of that collapse is that it is no longer clear what is and is not a sign. If all of the 'authentic' marks of gestural abstraction are open to simulation and appropriation, the old centered self of high modernist abstraction begins to lose its footing. As in David Reed's paintings, inert blocks of colour often occupy the centre of the composition. More aggressively than in Reed's case, these ambiguously-defined zones deny access to the space of the painting. And as

such they deny access not only to the viewing space of the painting but also to the meaning space of the painting: these are not emotion-laden 'black squares' of high modernism. In fact they are often painted with slightly repulsive institutional hues such as pea green or sickly yellow. And yet, even when these loosely propped areas dominate the composition, the paintings are far from inert. Paint, colour and meaning seep around the edges and a pervasive liquidity emerges: 'liquid' in both its literal and metaphorical sense. The flow of the dripping paint tropes the liquidation of meaning in the semiotic excess of empty signs in endless circulation.

What is strangely interesting in the work of these painters is precisely their ability to hold together paradoxical concepts. Here we might take note of Lydia Dona's double reference to Pollock and Duchamp – two key, but apparently opposed figures in twentieth-century art – which is reflected in the simultaneous copresence in her work of the touch, the mark of the hand, and the ready-made machine artifact. Or to note the disturbing tension which is established in David Reed's work between the expressive, gestural mark and the machined, impersonal surface. His is a surface which appears to be the product of technologies of reproduction rather than handicraft, something like a Pollock drip under an electron microscope. It seems not coincidental that both artists have predicated their painterly effects consciously on the development of strategies of surface. Both painters are concerned with spatial effects, but they are indifferent to the constitution of that space beyond the shallow reach of the painting's domain. And it is important to note that it is in no way part of their programme that these paintings function as models for any sort of generalised discussion of architecture, space or philosophies of perception. As conditional abstractions, they do not aspire to be universal models.

It might be interesting at this point to complicate the argument by introducing a third example. I am thinking here of the work of Jessica Stockholder, which is ostensibly, and Institutionally classified as sculpture, but which I will call painting in deference to the artist's own description of her work. This is a claim worth taking seriously. We might modify Rowe and Slutzky's statement at this point: 'While painting can only imply the third dimension [sculpture] cannot suppress it.' Noting in passing the curious word choice in the term 'suppress', it might be said that Stockholder sets out to disprove a statement like this. Her objects are constructed out of everyday materials and seem to be absolute diagrams of contingency. As constructions, they manage to avoid any sense of finality, of tectonic closure. And yet I would argue, they are not intrinsically vulnerable, or on the verge of collapse as some critics have suggested. The vulnerability of these works is notated rather than structural. This double condition, at once precarious and at the same time apparently inevitable, an equilibrium of suspension and not balance, is a characteristic property of painting more than sculpture. Stockholder stakes her claim on the territory of painting not on the basis of material specifics – paint, canvas, the rectilinearity of format – but on the ability of the work to enter into the discursive territory of painterly problems: surface, colour, implied depth, etc. That she can do this without the given frontality of the rectilinear canvas, suggests that frontality may be only incidental to painting's self definition today.

The banal materials of Stockholder's work link her to the history of assemblage, and mandate the obligatory reference to Robert Rauschenberg's combines. But there are important differences. These found objects in her work are not containers of memory and history as in so much collage-based work. In Stockholder's case, things are supports, surrogates for canvas and stretchers, a pretext for construction, manipulation and above all, a play of colour and surface. A comparison with Frank Gehry is instructive. While Gehry maintains both a collage syntax and the proprieties of tectonic convention, in Stockholder's work, tectonic boundaries – wall, floor, platform or runway – are constantly being glossed over, not as a transgression which marks a rift, but as a new seam which renders the old border meaningless.

The critic David Pagel has written that 'Stockholder's barely coherent objects play fast and loose with history and representation. They bring form and content into contact, not to reinvest an attenuated abstract art with the physical repleteness of real objects and solid materials, but to demonstrate that abstract concepts and unrepresentable thoughts maintain a force or power unapproached by the mere things of the world'.[15] In this sense we might say that while David Reed inhabits a prelinguistic realm, and Lydia Dona the linguistic, Stockholder belongs to the post-linguistic.[16] Not a simple substitution of surface for depth, but a more complex reconfiguration of surface as depth. These works affirm Jean-François Lyotard's assertion that: 'the postmodern would be that which, in the modern, puts forward the unpresentable in presentation itself; that which denies itself the solace of good forms, the consensus of a taste which would make it possible to share collectively the nostalgia for the unattainable; that which searches for new presentations, not in order to enjoy them but in order to impart a stronger sense of the unpresentable.'[17]

Each of these practices negotiates some form of compromise with an implicit historical dilemma. What does it mean to be an abstract painter today, after what Sherrie Levine has called the 'uneasy death of modernism', under the domains of

Lydia Dona, Solar Holes, Solar Gaze, Passages Into The Solar Plexus, *1992, oil, acrylic, signpaint on canvas, 213.4x162.6cm*

Jacques Herzog and Pierre de Meuron, Housing Development, Vienna Aspern, 1989-90

late-capitalism and simulation, assailed by all the various symptoms of the post-modern? What is the effect on an artist of the awareness of the definitive accomplishments of Pollock, de Kooning or others, or of Duchamp's sustained critique of 'retinal' art? That one works self-consciously and out of a sense of belatedness is a given; yet that belatedness can take many forms. There can of course be no return to old certainties, only varieties of repetition. Note for example the difference between artists, such as Levine or Louise Lawler, who depend on history to sponsor specific incursions into that history, and post-historical artists, like Reed or Dona, who simulate the once authentic gestures of painting indifferently, from an unspecific territory at the end of history. Where the former foreground the discursive functions of art as commentary, the latter take opportunistic pleasure in the impossibility of coherent discourse.

In a recent article, Arthur Danto clarifies what he sees as the consequences of such an 'end of art'. 'Abstraction,' he writes, 'is no longer the bearer of destiny in anyone's mind. It is one of the things that an artist can do.'[18] Proposing the term 'objective pluralism', Danto underscores the demise of the exclusivist modernist criteria, which, following Greenberg, seemed to mandate an ever narrow field of investigation for the visual arts. The return of figuration, the proliferation of installation, performance and site-specific art all served to redefine that field and render the Greenbergian categorical imperatives suspect. Under these conditions could the choice to make abstract paintings be anything other than wilful anachronism? 'On my view, abstraction is a possibility rather than a necessity, and is permitted rather than obliged,' writes Danto.[19] German artist Gerhard Richter, for example, has made this permission thematic, painting and exhibiting figurative and abstract canvases side by side since the mid-sixties, refusing even to define the identity of the artist as a stable point of reference.

And yet, as Richter's work makes clear, this is still a dilemma. In as much as the old categorical imperatives have been discredited, there is also a pervasive sense that to simply combine and recombine the elements of now exhausted languages, to give into an ecstatic circulation of signs is not a convincing alternative. This would be (in Adorno's terms), a false freedom. I think it is possible to say that what abstraction offers is a provisional set of rules to be engaged and reworked; a partial stabilisation within a system open to nearly infinite change and revision. It is not necessary to believe that those rules are definitive or binding in any absolute sense; only that they offer an entry, a point of departure and minimal resistance. Something like commitment without belief. It is a bet against the odds for the persistence of some form of structure. These artists (to the short

list of those already discussed, and limiting myself to Americans, I would add Mary Heilman, Bill Komoski, Stephen Ellis, Jonathan Lasker, Caroll Dunham and Fabian Marcaccio) are not looking for unprecedented freedoms, but for new articulations of constraint and liberty. Their position is necessarily compromised, inevitably complicit; as such it risks absurdity and intellectual failure more than it trusts in clarity and critical insight. They situate themselves cannily with regard to history. They work deliberately, looking not only for the most advanced pictorial concepts to build upon, but also for the ground left unexplored throughout history, and for unexpected opportunities in the overlooked aspects of practices thought to be exhausted.

Postscript

At the risk of simply exemplifying, I want at least to open the question of parallel practices in architecture. If anything, the stakes in architecture are higher. Structure has a more binding force in architecture, and it is more difficult to disengage architecture from the forces of market and institutional inertia. Nor is it a matter of translation, or of transferring concepts; architecture needs to negotiate with the specifics of its own conditions. What can be detected is a similarity of attitude and purpose among a certain generation of architects. Spanish architect Enric Miralles incorporates the moving line not as embellishment or counterpoint to stable structure, but as a structuring element itself. These complex arabesques do not so much oppose stable to unstable, but produce new and unexpected forms of stability. This is not an architecture that sets itself up as an assault on the pure forms of Cartesian geometry, but rather, through the proliferation of fluid effects and anexact geometries, renders their presence unnecessary. It does not register contingent events, but anticipates their unfolding. As critic José Quetglas has written: 'The architecture of Enric Miralles does not start in or pass through illustrations; it can only be described or drawn after it has happened, and then only approximately.'[20]

The work of Swiss architects Jacques Herzog and Pierre de Meuron does not in the least resemble that of Miralles, yet it too exhibits this sense of the conditional. Although with the construction of the Goetz Gallery in Munich (1989-92) to house a collection of contemporary abstract painting, and their extensive contacts with abstract painters, they might be said to approach the subject more thematically, what interests me is a manner of construction. This is an architecture of the interval. They understand that measure in architecture always has a double valence: as mathematical ideality and as real instrumentality. In their case, instrumentality corrupts ideality, without devolving into pure pragmat-

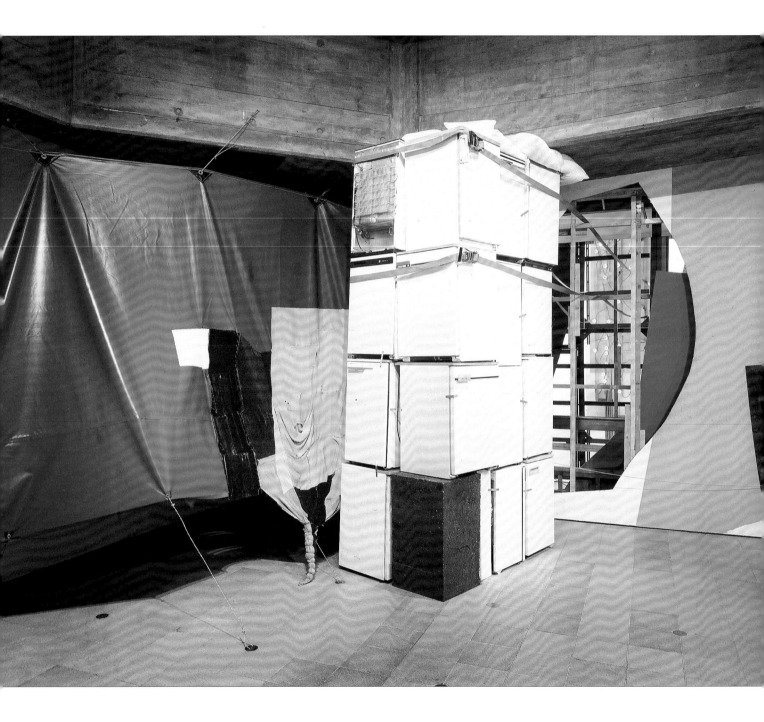

Jessica Stockholder, Fat Form and Hairy: Sardine Can Peeling, *1994, mixed media, installation at Hayward Gallery, London*

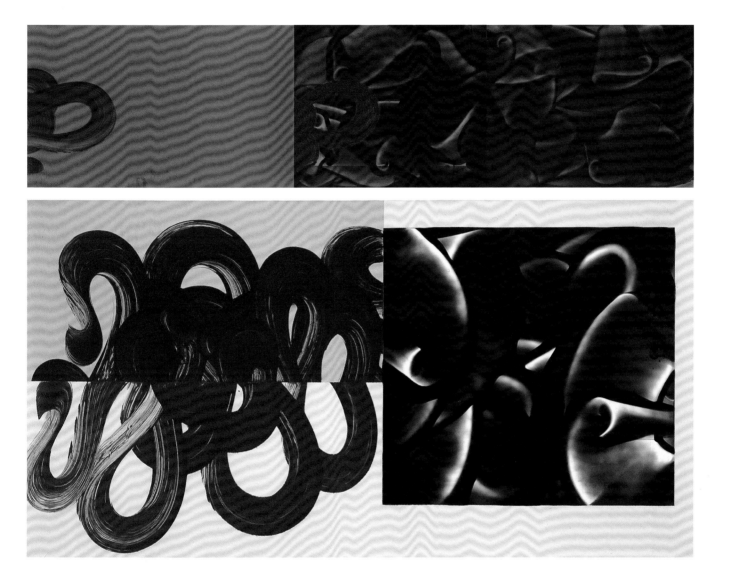

ABOVE: David Reed, No 307, 1991-92, oil and alkyd on linen, 66x274.3cm; BELOW: David Reed, No 328, 1990-93, oil and alkyd on linen

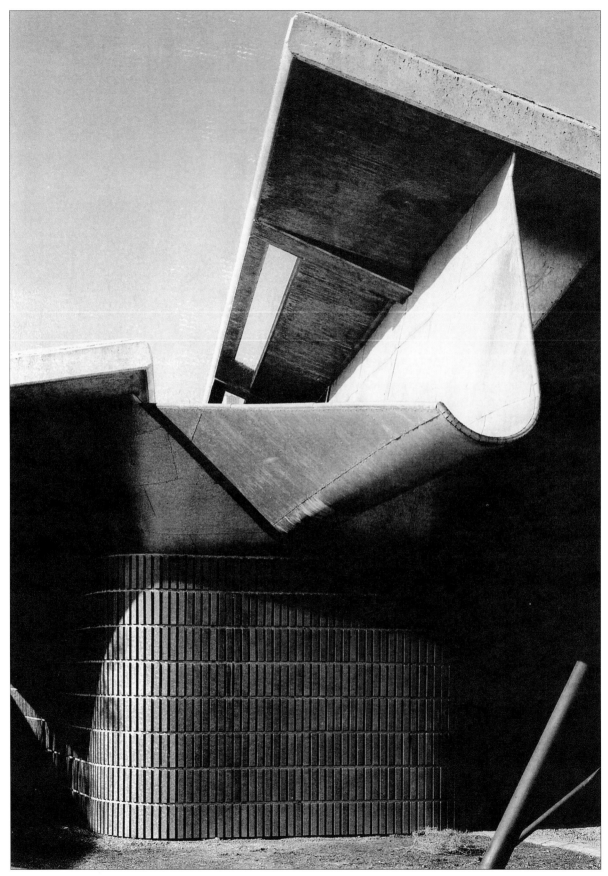

Enric Miralles and Carme Pinós, Archery Range, Barcelona, 1990-92, detail of roof, training area

ics. The emphasis on the interval, the space between, allows them to work with severe, even elemental forms without producing ponderous or definitive constructions. This work is light and deft, not overworking its materials, but simply placing one thing on top of another, with an almost perfunctory carelessness. There is no false aura of meaningfulness. In recent works, pattern and photographic materials do not so much serve to open the work to semiotic interpretation as to emphasise the thinness of the surfaces and the contingency of constructed relations. Like the paintings of Ryman, there is always a back door left open, a way in to the fabric of the construction and the provisionality of its relations.

In closing with these two particular examples, I want to underscore the absence of stylistic criteria, and recall the categories of surface, event and time proposed earlier as a point of contact between painting and architecture. These would be the starting point for a more fully developed description of the operations of conditional abstraction in architecture. But any theoretical effort to dictate a particular direction, or to nominate specific effects, must take into account the double claim made by this work. On the one hand, it refuses to adhere to old hierarchical notions which would situate a world of ideal concepts above, or outside of the work itself. On the other hand, it does not hope to locate possibility for renewal in ever more narrow self-referentiality. This work opens out to the world of things even as it pursues the logic of its own ends. 'All we have ever done has been found in the street.'[21] This not so ironic claim by Herzog and de Meuron signals the extent to which it can be said today that abstraction need not be an esoteric exercise of anachronistic formalisms. It could be nothing more nor less than a realistic way of working in and among an 'acentered world of things'.

Notes

1 Gilles Deleuze, *Cinema 1: The Movement-Image,* trans Hugh Tomlinson and Barbara Habberjam (Minnesota University Press, 1989), p 58.

2 Note here the persistence of such terms as 'anchorage' and 'horizon'. See, for example, Steven Holl *Anchoring*, catalogue of exhibition at MOMA (Princeton Architectural Press, 1989).

3 It might be objected that architecture, unlike cinema, does possess a stable 'horizon', an anchorage, either in structural rationality or in its relation to place. But if architecture constructs its site as much as the site constructs architecture, it may be assumed that it is within the capacity of architecture to construct that site in a variety of ways, and to disturb the assumed stability of such notions as place, centre and horizon.

4 For the term 'conditional abstraction' see the essay by Kate Linker in *Individuals*, catalogue published by the Los Angeles Museum of Contemporary Art, 1991. Speaking of the 'fading power of pure abstraction', Linker writes: 'It follows from this that most abstract painting of the 1980s is conditional abstraction, its intentions always qualified by plays of abstract forms against figurative shapes, pure geometry against narrative structures, formal against historical concern.' I do not pretend here to be developing the argument as Linker would, but rather use her phrase as a suggestive starting point. The idea of a 'conditional abstraction' has also been elaborated in discussions with the painter Michael Young.

5 John Hejduk *Masque of Medusa* (New York: Rizzoli, 1985), p 67 (ellipsis in original).

6 Deleuze, *op cit*, p 59.

7 Hejduk, *op cit*, p 69.

8 This concept suggested to the author in conversation by Jeffrey Kipnis. However, it might be noted that my interpretation is distinct from Kipnis' in the effort to recuperate a positive prospect in the notion of the defective – that is to say, to see the rather always (already) present as a specific property of the architectural, resisting closure, evading control. A position which accepts the defective as a working condition in architecture is therefore distinguished from the attempt to recuperate a primary fullness in architecture, ie an architecture which might encompass the other arts.

9 This is to leave out, for the moment, the more recent attraction for those art practices involved in the 'critique of institutions', video or the electronic media (Sylvia Kolbowski, Judith Barry, or Krzysztof Wodiczko, for example, all of whom have been fairly extensively published in academic architectural journals). Here too there is an assumption of a 'natural' relationship based on shared thematic materials. This is a distinct but related problem.

10 Colin Rowe and Robert Slutzky, 'Transparency Literal and Phenomenal', in *The Mathematics of the Ideal Villa and Other Essays* (Cambrige, Mass: MIT Press, 1976) (originally published in 1963).

11 Rowe and Slutzky, *op cit*, p 161.

12 Rowe and Slutzky, *op cit*, p 166.

13 Rowe and Slutzky, *op cit*, p 175.

14 Deleuze, *op cit*, p 2.

15 David Pagel, 'Jessica Stockholder' *Arts Magazine*, Oct 1991, p 89.

16 Note the distinct formats: Reed's work, like that of, for example, Barnett Newman, is of extended and irregular format, and it is intrinsically difficult to reproduce its effects. Dona's formats, on the other hand, correspond to the printed page. The work anticipates its reproduction. Stockholder's work recognises reproduction as a fact, but is indifferent to its effect on the work or its reproduction.

17 Jean-François Lyotard, *The Postmodern Condition: A Report on Knowledge* (Minnesota University Press, 1984), p 81.

18 Arthur Danto 'Art After the End of Art' *Artforum*, April 1993, p 69.

I9 Danto, *op cit*, p 67.

20 José Quetglas, 'Don't be Deluded', *El Croquis* 49/50, 1991, p 22.

21 Interview with Herzog and de Meuron, *El Croquis* 60, 1993, p 15.

ADD-VENTURE
Maia Damianovic

The relation of language to painting is an infinite relation . . . neither can be reduced to the other's terms . . . But if one wishes to keep the relation of language to vision open, if one wishes to treat their incompatibility as a starting-point for speech instead as an obstacle to be avoided . . . then one must erase those proper names and preserve the infinity of the task. Michel Foucault[1]

Re: citing, Re: siting

Stephen Ellis and Fabian Marcaccio are cosignatories to a special memorandum regarding abstraction. Despite their distinct ambitions, their underlying pictorial concepts enact a complex signing that dramatically entangles abstraction with an unexpected representational dimension. As memoranda remembering, retracing and reflecting on abstraction, their paintings reconfigure and revise familiar self-reflective space at a more nuanced reflective distance. These memos re: abstraction are a promissory gift, a speculative and acutely contemporary endeavour to structure abstraction as an extended communiqué with the Other, as a way of bringing about a creative renascence of abstract painting in general. As is often the case with memos, these paintings retain a certain memory or quotation of the abstract while inherently acknowledging 'miss-takes', 'miss-interpretations' and the inevitability of forgetting. Simultaneously citing and re-citing and siting and re-siting between historical-citational-memory and confounding abbreviations, questionable signatures, 'maybes' and ambivalences, Ellis and Marcaccio's memos re: abstraction can also profoundly mislead, turn astray or confuse abstract form. Nonetheless, these notes to abstraction dramatically succeed in reassessing aesthetic protocols, forcing a crisis of abstract transcription that in our critically weary time suggests the promissory future of abstract painting.

Promises, Promises

As memos to abstraction, Ellis and Marcaccio's paintings are signed as complex, sometimes ambivalent and usually ambiguous promissory notes. They deliberate what they owe or promise to abstract painting. Following an established history of investigations into the physical means of painting, from cubist collage to Ryman's incorporation of hanging devices, Marcaccio introduces various three-dimensional, almost literal elements, such as thick gel or plaster brush strokes and elaborately designed stretcher bars, to break or interrupt the purity of painted illusion. These unexpected revelations transport the spectator beyond the 'willing suspension of disbelief' and beyond the proprieties of traditional painting methods. Marcaccio elaborates an economy of ruse, a visible scoffing not bound to any preset painting conditions. Ellis, by contrast, maintains a closer relation to abstract expressionist flatness, one that prefers the self-imposed limitation of the traditional rectangular canvas. His ambition is subtly to deconstruct a certain traditional aesthetic framework from within. Their methodological differences aside, Ellis and Marcaccio share a desire to recite abstraction and thereby strategically to reread and revise both its protocol and identity. Although both artists freely play with a large fund of influences, conventions and historical precedents (a method broadly comparable to 1980's appropriationism), this citational doubling goes beyond slavish requotation and, more significantly, orchestrates a general scriptorial or textual endeavour – a goal that does little to comfort formalists. In the inherently interdependent manner of a deconstructive strategy, this painting plays its specularity against the structural grid of an underlying abstract armature that indexes or emphasises its delinquent double status, as simultaneously a residue of and a transgressive supplement to abstract conventions. Their underlying pictorial concept is also subtly but pervasively complimented by a visibly forceful asynchronicity, discontinuity and rupture. A network of waves, migrations, vibrations, elisions, and remarkings disavows the ideological linearity of a potentially cynical, nihilist or parodic simulationist position.

Extricated from, but also reconfiguring aesthetic confines, Ellis' sumptuous fluidity may superficially resemble Pollock's overall fields, but, by comparison to the latter's spontaneous gesture and singularity of expression as a succession of static 'nows', Ellis' shifting layers of perspective and different depths disturb fixed time/space divisions, offering a more structural, deliberately inconsistent mode of address. Similarly, Ellis' reiterations respond to Warhol's pop cinematic

seriality, but eschew its iconic and static plateau of resolution. Instead, Ellis' gesture is in flux, more comparable to splintered states of consciousness: internalised, exteriorised, arrested, blocked, fluid.

Much in the manner of the representational device of the mirror in Velázquez's *Las Meninas*, as described by Foucault, 'offering us . . . the possibility of seeing in [its] depths . . . the unforeseen double of what they are observing',[2] the representational device of an eccentric and discomfiting rhythm of configuration pulls us into Marcaccio and Ellis' canvases. Their open-ended structures, elliptical, variable, expanding and contracting, underscore a problematised inadequacy of formal order while opening textual, objective possibilities around the traditionally intuitive and internalised subjective codes of abstraction imposed by modernism. Both Ellis' richly orchestrated high-contrast slivers of translucency, his unexpected windows of colour floating over fluid swirls and Marcaccio's succession of excessive, schizoid and playful modifications of standard pictorial elements are citations of effects that reconfigure the illusionary, specular quality of abstraction as a more literal scriptorial materiality. An abundance of disjunctive and differentiated prosodic operations aggravates abstract spontaneity, supplementing it with a legible strangeness – the canvas becomes a text without words, a figure of enunciation. A sophisticated contrivance, Marcaccio and Ellis' reiterations of successive intonational surges, delayed, interrupted, suspended between ambiguous boundaries of form, impart a quasi-narrative rhythm that straddles semantic and emotive expressive possibilities in order to propose a visual syntactical structure. As one of their conceptual mainstays, a tautological structure resonating with the force of ever-shifting time and space improvisations that resist finite resolution outlines the metonymic presence of eternal returns of consciousness (on the part of both the artists and the viewer). In deference to an autistic homology of Self or identity, its noisy, alliterative capacity advances a sophisticated specular outreach (from abstract interiority) through a visibly externalised idiolect of inconclusive and evolving effects. Marcaccio and Ellis' 'effectology' of alliterations is an act of resistance, both against the endemic protocol of modernist abstraction as a sublimated specular autonomy and Greenberg's ideological categorisation of abstraction as an idealised existential catharsis of clear-edged flatness unmediated by extra aesthetic experience.

Resisting and defying modernist idealisation of static space and time, as well as the cynically frozen space of the simulacra and the spectacularisation of the hyperreal, the mutable and divisionist tautological infrastructure of Ellis and Marcaccio's citationality supplements abstraction with a fre-

quently confounding and sometimes indeterminate, but also perceptively coordinated space of (self-)reflective signifying distance. Staged as multiple 'takes', the intensity of their alliterations recasts this abstraction as a more structurally conscious and systematically cultivated self-referential figurative dilemma which separates and detaches the gaze from an omnipresent immediacy of specular illusion. Instead of idealism, a colloquialism of variable effects, in the nature of slang, plays with abstract protocols, all the while drawing attention to a mutable informality that enables this painting to resist formal overdetermination. Expressively wandering between convention and contamination, at times skirting what formalists would call mannerist elaborations, such tautological structures reactively repeat and simultaneously implode gestures to test significantly the borders of abstract convention. At play between abstract propriety and impropriety, more on the level of a scandal, their conscious errancy forms a complaint against the previous self-referential norm of abstraction.

Im-propriety

By 'miss-taking' abstract identity for something other than pure self-referentiality, Ellis and Marcaccio's dispersal of effects in and around a certain legibility becomes a kind of 'impropriety' that effects an unsettling abjection of conventional abstraction. Some critics of the new painting have interpreted these continual restructurings as an obsessive and compromising index of the exhaustion of abstract painting. Indeed, from a modernist position, the notion of repetitive transformations, incessant remarking, usually emphasising disjunction rather than completeness, is perceived as too self-reflective and rhetorical, and thus a violation of the purity or idealism of a conventional code of abstract transcendence. Whatever their affronts, Marcaccio and Ellis' citational tautology is less a quick and easy commentary on the sublimation or abjection of abstraction than an unsettling laughter directed at the ideological enclosure of abstraction within self-referential ideals (criteria). Arguably indebted to abstract convention, this painting gathers conceptual momentum and visionary impact around its renunciation. Unlike the modernist promise of a transcendent 'master stroke', the multitude of Ellis' spectacular pictorial slivers is nonetheless a figure of renunciation that works against an aesthetic guarantee of fixed reified presence and discreetly abandons the idealism of the transcendent impulse. Less interested in the project of originality than in a notion of ingenious reappropriative doublings, this underlying reiterative structure indeed prescribes an abjection of abstraction conventions of original invention or uniqueness. Nonetheless, while

this incessant fissure of singular signature repeatedly rup-
tures the promissory space-time value of modernist abstrac-
tion, it also poses the possibility of its creative resurgence.
Through citationality the semantic, the material and the social
come together . . . it appeals to an ongoing dialectical mira-
cle of the transformation of matter into meaning, content into
expression, the social process into a signifying system.[3]

Testing the borders of purist taste, assemblages of strange
resemblances, disturbing and frivolous pictorial moments,
systematically disjunctive conjugations, abrupt delays, sud-
den departures refigure semiotic flow as a translinguistic,
quasi-narrative textual 'thingness' whose resonantly distinct
materialism frames the image through a more distant, leg-
ible and conscious space of correspondence with the viewer.
Engaging the viewer rather than creating a sublime tran-
scendent realm becomes its essential generative motiva-
tion. Adopting an almost musical intonation, Marcaccio and
Ellis' visuality proceeds rhythmically, in numerical sections,
by mobile and plural distributions and arrangements, free-
playing abstraction in recognisable rhythms of variable
intensities, speeds, frequencies and resonances that sup-
plement its internalised, auto-affection and self-absorbed
specular immediacy with a figurative dimension that empa-
thetically courts the viewers' perception. Ironically, the flex-
ible economy between abstract and figurative, which for a
formalist amounts to a broken promise, an aesthetic mis-
take or an impropriety, grants these paintings their crucial
contemporary viability. Repetitive, alliterative, tautological,
their structures resemble notes never quite jotted down cor-
rectly. These interrupted memos, continually exercising re-
call, give way to chains of reiterative and discrete differen-
tiation that continually resists visual completeness, offering
up the sense of a structured, somewhat rhetorical, sceptical
pictorial consciousness that hints at the underlying presence
of a speaking subject. From this perspective, tautology is at
once a betrayal of the pure promise of abstraction, as its
discrete transformative gifting: re: citing as a re: siting. In
Marcaccio and Ellis' paintings the deferment of an idealised
transcendence also expresses an imaginative supplemen-
tation with the expressive intimacy of a specific, individuated
and enunciating transcendent ego. The incorporation of this
figurative-citational self-reflective dimension humanises the
heroic and sublime abstract expressionist gesture as it be-
comes – the spectacularisation of the transnational media
machine notwithstanding – a metaphor for the ongoing is-
sues of ethics informing American culture today. In its odd
visual complexity, citational tautology solicits the speaking
subject and the reading viewer as its particular and com-
pelling reality check.

Promissory Notes

As memos to otherness, the painting solicits a dialogue be-
tween a history of abstract self-sameness and a process of
evolving and as yet undetermined and becoming difference.
Against the more untrammelled sublimation of modernist ab-
straction or the existential solemnity underlying the abstract
expressionist gesture, the discomfiting presence of a self-
conscious rhetorical mode expresses a desire for otherness.
This painting consciously thinks of itself in terms of differ-
ence. Instead of a sublime or existential transcendence, a
psychodrama of effects – 'effectology' – creates a space of
reflective engagement between the artist and the viewer that
once again echoes Foucault's words on the representational
function of the mirror in *Las Meninas*: 'to draw into the inte-
rior of the picture what is intimately foreign to it: the gaze
which has organised it and the gaze for which it is displayed'.[4]
Discovering dispatches between a speaking subject and
an addressee as well as a broader field of intersubjective
desires, this painting is in the process of inventing an
otherness for itself as part of a new configuration for ab-
straction. In a period of irony, which formalists call an ex-
haustion of abstract painting, this internal tautological-
citational-disturbance, proposes a dialectic of otherness that
carries significant ethical-political implications. Indeed, in
our current mood of social consciousness, this ethos could
be called the quintessential gift to abstraction.

Moving from self-absorbed interiority to the outside space
of an intersubjectivity of relations between subject/object, self/
other, inside/outside, social/imaginary, semiotic/symbolic, the
visible *re:* behind Marcaccio and Ellis' remarking of abstrac-
tion becomes its promissory signature. Desire and abstrac-
tion come face to face. The face of this painting, 'tainted' as it
is by tautological meditation or rhetorical inflation, acts out an
intense desire to rename the protocol of abstraction. Although
indexing a downgrading of the self-referential, self-respon-
sive aspect of abstraction, the supplement of a reflective
hetero-referentiality is less an expression of abjection than a
desire for continued vitality. Abstraction now premises itself
on the basis of this outreach to representational issues, and
to an exteriority that discovers the face of otherness.

And, And, And

This is not an 'either/or' situation: exclusionary principles are
resisted. Breaching conventional promises, simultaneously,
intuitive, yet highly self-conscious, speculatively suspended
in poetic ambivalence between the unruly force of abstract
interference and effects of consciousness, Marcaccio and
Ellis' effectology evades simple dialectical division and aes-
thetic categorisation. Interlacing a puzzling communiqué of

reciprocal debts and discrete gifts, this painting is able to initiate an intense face-off between poetic spontaneity and rhetorical structure. Despite its rhetorical, representational supplement, the unruly syntax punctuating this abstraction drifts in and out of semantic control, plays differences against each other, favouring an unrestricted generosity of form rather than a tight economy of savings, a structure which reminds us that 'the profound invisibility of what one sees is inseparable from the invisibility of the person seeing – despite all mirrors, reflections, imitations, and portraits'.[5] Strange semblances kept at bay simultaneously become exteriorised as discreet and discrete invitations into a different abstract realm. In an intermezzo relation between representational articulation and its flight into semiotic seepage, a certain signifying excess withstands self-referentiality in Ellis' intensely blue canvas. Its ghostly light and almost scripted figurative rhythms create a mixed context that disrupts abstract irreducibility. Expanding between a hyperreal static linearity and a disjunctive mirror-like refraction, the expansive figuration of effects pitches the painting to a specular threshold between abstraction and the amplified glare of a video screen. Abstraction becomes a rhizomatic chain of enunciation, as multiple desiring relations are caught between a remainder, supplement, sameness and difference, form and its abandon. Driven by this dialectic of passions, Ellis continues to expand on an unpredictable and problematic mid-term relation (between immediacy and distance), juxtaposing an amoeba-like, morphological, serpentine brush stoke associated with intuition and spontaneity and one associated with distance and mechanical handling. Enjoying a labyrinthine syntax, his pictorial concept is a wager between risk and aesthetic recuperation, memory and its off-song. Self-referentiality and rhetoric are collected in a vibrating continuum of aleatory intensity. Driven to the margins of clarity neither lexical, nor generic, nor developed as clear tropes, Ellis' elaborations could be described as a fluid-hybrid-abstract force caught in a semantic grid of alliteration.

Weird Science

An alliterative musical montage of dissonances and changes of key, Ellis' high-pitched, elusive, semi-mechanical network of elisions and flashbacks and Marcaccio's oddly intertextualised requotations of pictorial elements – such as brush stokes cast in plaster or resin next to graphic hyperrealist illustrations of 'raw' canvas – advance like an oxymoron, abstract, yet somehow symbolic. Neither a figurative nor a purely self-referential guarantee, this ephemeral and evocatively vague correspondence between abstract opaqueness and moments that presuppose language de-

fers formalist closure and countersigns the proper promissory note of abstraction as a hybrid, informal slang. Marcaccio and Ellis' intertextual hybridisation preserves a fine and precarious balance between comprehensive visual unity and an accumulation of breaks, transitions and migrations. By quoting abstraction through such an intermingling of checks and balances, this hybrid requires an aesthetically demanding reading. Is it a broken promise or a gift? Is it ugly or beautiful? What suspends decision is a superfluid play or explosion of syntax that neither *gives up nor assumes signs, but corrupts them, turns them around, misleads them.* This inclusive, quasi-abstract, quasi-narrative forms an impure condensation that corrodes the traditional demarcation between a self-referential/figurative dichotomy. Rather than forming a phobic closure, the hybrid works against subjective repression, rejecting both negativity in terms of desire as an expression of loss, and the authoritarian positions of finite or enclosed events of consciousness, in favour of an ebulliently complex semiotic-symbolic admixture of *jouissant* effects of consciousness. Apparently toying with symbolic possibilities, self-referential conventions and issues of representation, Ellis' work expresses an essential dilemma between reflexive spontaneity and reflective distance. The work discovers an intersubjectivity, for instance, when it blurs dialectical separations, slipping back and forth between the tactile and the mechanical. Characteristically, Ellis' rich specularity is held within a deliberately disjunctive orchestration of rectangles and grids. In a state of fluid, Richter-like immanence, each layer of his picturality pointedly collides into the other through a system of eccentric but consistent rhetorical devices. The rhetorical *re:* of citationality (re-marking, re-iterating, re-vising elaborations) matches a casual vernacular and risk-taking specularity. In a similar way, Marcaccio extracts and condenses a more kooky syntax that successively invites casual, non-hierarchical crossovers between narration and abstraction. As if they were the phantasms of a mad scientist, the artist interweaves layers of transparent gel, plaster cast, wooden and conventionally painted brushstrokes. This overflowing phantasmagoria is applied to paintings that suddenly dissolve into streaks painted directly onto adjacent walls or perversely attach themselves to walls. Not a simple metonymy, this intersubjectivity favours a verbal, generative unfolding of entanglements, where bunches of erratic melodic musings effectingly court abstract identity and the viewer.

Who, What, When and Where

What is confusing, then, about this painting, is that we cannot tell if it is this or that . . . 'then one must erase those

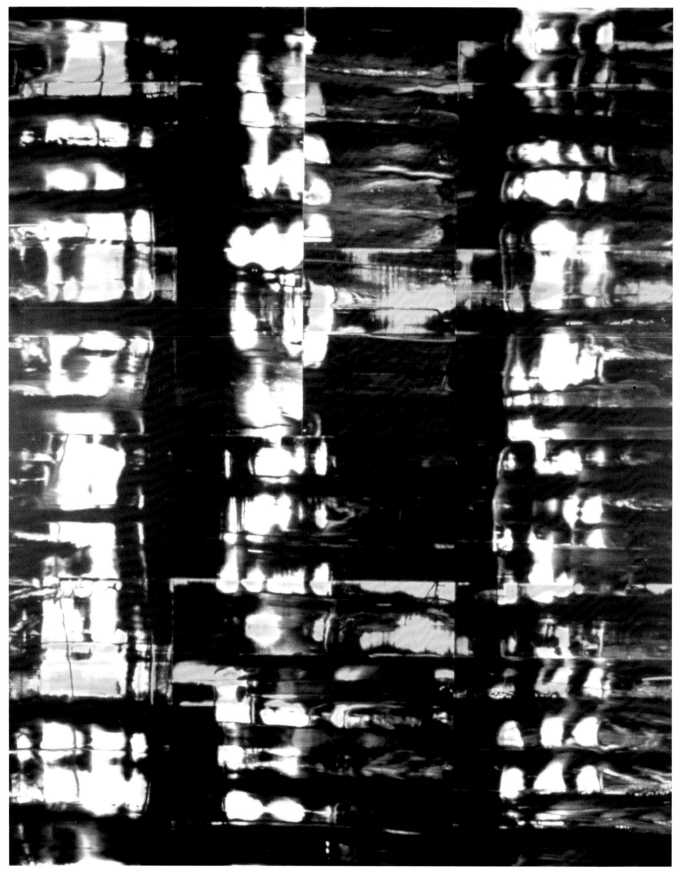

Stephen Ellis, Untitled SEI-61, *1994, oil and alkyd on canvas, 218.4x182.9cm*

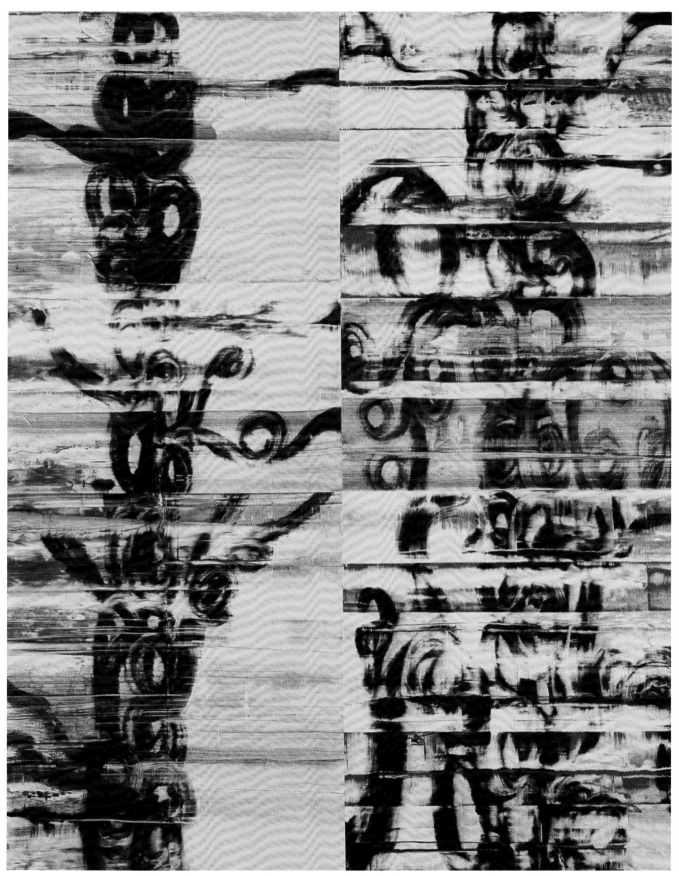

Stephen Ellis, Untitled SEI-63, 1994, oil and alkyd on linen, 182.9x152.4cm

proper names and preserve the infinity of the task'.[6] In both Marcaccio and Ellis' hybrid pictorial language, the intense energy of its underlying *re:* figures prominently as a conflicted remapping of pictorial identity in resistance to any one conclusive clarity. It shifts abstraction from the power structure of various aesthetic closures of edicts towards a relation of desire production that leaves the impression of a picturality still searching for its formal possibilities. The poetic of Ellis' interpenetrating fields of randomly cathartic eminences depends on an ambivalence – somewhat in excess, or beyond, or around the margins of simple correspondences – that acts as a continuous and elusive structure of mutation, a continual permutation without visual maxim or summary. His successive re-elaborations, like stories within stories that never fully end or resolve, are reminiscent of the alluring (and inexhaustive) space/time ambiguities elaborated by Kafka or Lewis Carroll.

Its apparent lyrical whimsy aside, the aesthetic gratuitousness of Marcaccio's images is swept away by a succession of unwieldy neologisms: a retinue of visual replicants, ceaselessly modified refrains and circuitous reconfigurations. Working in the manner of an aesthetic outlaw, outside of abstract protocols, Marcaccio demystifies and challenges abstract identity through an exclamatory, puzzling and unexpected visual syntax that explodes into a cacophony of mixed metaphors that are at once discontinuous, fragmented and fluid. Promiscuous distortions – a frame absurdly metamorphosising into a stretcher bar, a brush stroke becoming a plaster cast – invite the disconcerting force of humour or frivolity to quite literally toy with the outside-inside of the painting frame. Playing on the reciprocal border of (ir)reverence, the dynamism of Marcaccio's micro/macro exchanges counter associations participate with conventional abstract identity to voice a poeticised forgetting or loss of identity. Like a spin doctor, the artist recirculates different possibilities of abstract form. We are exposed to a legacy gone askew. A world of unruly, seemingly haphazard dissonances, mixing gestures, styles and technical protocols distinctly punctuate abstraction with excessive and translogical break-outs of form. In *Wall to Painting Eclipse* we encounter an electric image of formal defiance in the unlikely figure of an awkward plaster prosthetic protrusion that dramatically extends from the canvas and symbiotically links it to the wall. The intrigue continues in *Handicap Painting* where a brush stroke becomes a plaster cast collaged onto a distinctly emblematic unprimed canvas, and continues its transformational journey as an insouciantly drawn black line along the wall. Elsewhere, as suggested by such picturesque titles as

Unpaintable or *Come Un-done*, sudden metamorphoses open to a hyperfluid transformation that quite literally overreaches the 'proper' name of abstraction.

Marcaccio habitually obfuscates conventional aesthetic or pictorial categories, such as hyperrealism, illustration, abstraction, expressing a continuing sense of irreconcilable existential incompleteness regarding painterly form. When a painting continues beyond its canvas support as a series of streaks painted on the wall or when a painted stroke transforms itself into a wooden gesture, there is a disorienting quality of 'not quite', 'more' or 'less' of conventional expectations. Such intriguing refigurations offer a strange promise, sweeping views into the subterranean activities of pseudonymous abstraction.

Through a visuality suspended in ambivalent quotation, or in ellipses of eternal returns and departures, both artists propose a kind of acutely conscious, but also incidental tourism, without guide, across form. All these necessary chance meetings, crowdings and dispersals of effects suspensefully affront the identity or proper name for abstraction. Expressly perturbed, this visuality enunciates a community of discrete and ambiguous variations, invoking double-edged, back – and forth – transformations as an inventive renomination of abstract form. The dense, often difficult, fibre of Marcaccio and Ellis' rhizomatic intertextualities retains expressive relevance – as an argumentative challenge to the encoded 'I' (or eye) of autocratic presence, whether aesthetic traditions or the media cyberspace of fast and easy consumerism. Dramatically disturbed by an intense acceleration of hybrid effects, formal authority is no longer immanent in this painting. Instead, a transformal suspension, implicating diverse semantic, material and social flows, builds into an adventure of abstract forms.

Add-venture

Strange and unreliable promissory notes, they are fulfilled inasmuch as their finely tuned signing remains conflicted and in resistance to systematic categorisation. They are signed from within the paradox of mercurial and indivisible relations, and are liable to an uncertain outline of otherness. Belying conventional dialectical dichotomy, their non-hierarchical pictorial concept elasticises abstraction between a self-referential inside that invites a silent and relentless force of abstraction, and a hetero-referential self-determination that takes as its measure how consciousness is extended to otherness. Discontinuous, dissonant, erruptive, visually stunning, these memoranda to painting use – implicate-subvert – the very concepts they choose to evade. Between its various dissonances and reiterations, abstract auto-affection-

ate interiority and its transformative supplementation by an exteriorising of desiring relations live in a state of speculative tenuousness. We sense the dilemma of the artist trying to use the means of abstraction towards a new genesis: an empathetic encounter somewhere between the 'I' and the eye of the other. This movement towards a mutuality of multifarious, heterogeneous relations becomes a figure of hope and this painting's particular will to an authentic contemporary essence. From within the trickier situation a poetic doubling between residue and supplement, rhetoric and poetics, catharsis and absence, spontaneity and self-consciousness, the broken performative promise becomes the transformative gift. Also a figure of irreconcilable conflict, stretched between the promise of the self-referential and a transformative gifting, Marcaccio and Ellis' paintings interweave the internal joy of narcissistic, self-contemplative, self-sufficient 'want' with an expansive area of effects extended outwardly towards an intersubjective construction of personal, biographical and social presence.

The Longing 'I'

The painting represented by Ellis and Marcaccio revises the aesthetic protocol of abstraction from the 'I' of self-sameness to an inclusive mutuality of desiring relations enunciating a longing 'I'. Keenly aware of this longing, Ellis and Marcaccio's conflicted specularity, much in the manner of the post-minimal reaction of the 1970s expresses an adjust-ment or reality check on abstraction. Ellis and Marcaccio join a generation of abstract painters whose conceptual outline, although not indentured to any one specific method of realisation, synchronistically corresponds to their interpretation of hybridity. Their citationality and inclusion of representational issues is in keeping with a growing number of painters who reinterpret abstraction in response to the crisis of relevancy directed at and experienced by abstract painting over the last several decades. Not disappointing a contemporary social call for a more authentic, interactive subjectivity, this 'correction' of self-referential, idealised enclosure and silence favours the speaking subject living in a field of intense and mobile heterogeneous relations as the timely generative force of abstraction.

Despite and because of this new ethos, a paradox unfolds. These paintings are at once indebted to the history of abstraction and inventively crediting its future. The broken promise of formalist abstraction is also their *rapprochement*, promissory value or gift of otherness to abstract painting. Skirting hetero-referentially in conflict between an inside and an imagining outside of protocol, between specular immediacy and textual distance, self-referentiality and self-reflectivity, between abstract and figural, monologue and dialogue, abstract semiotic intensities and rhetorical devices, Ellis and Marcaccio's paintings become ambivalent promissory notes that diffusely invite all these creative impulses to participate in a transformation of abstraction.

Notes

1 Michel Foucault, *The Order of Things* (New York: Vintage Books, 1973), pp 9-10.
2 *Ibid*, p 13.
3 Gilles Deleuze and Félix Guattari, *A Thousand Plateaus: Capitalism and Schizophrenia* (Minneapolis: University of Minnesota Press, 1987), pp 89-90.
4 *The Order of Things,* p 15.
5 *Ibid*, p 16.
6 *Ibid*, pp 9-10.

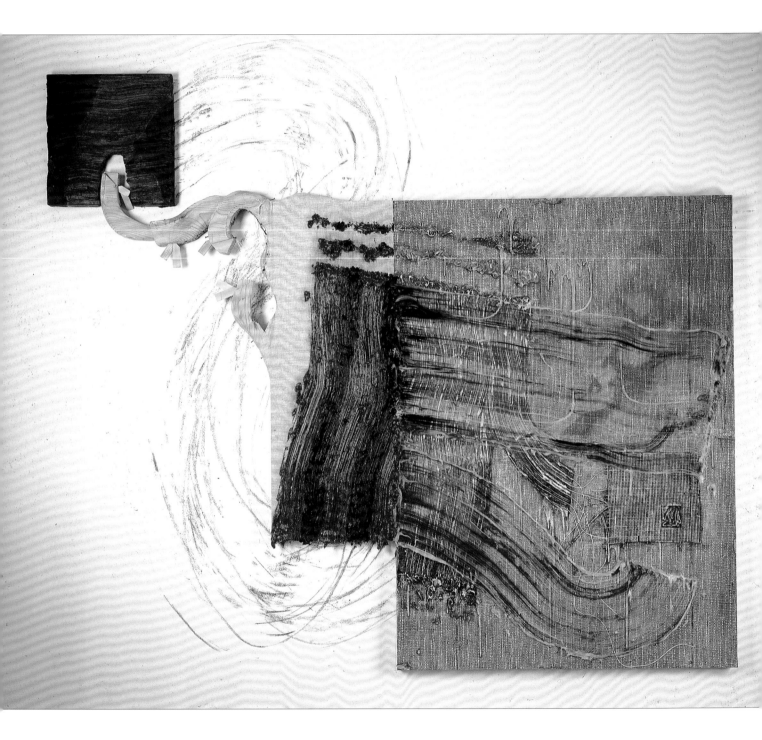

Fabian Marcaccio, Alienation as Ornament, 1992, oil, linen, silicone gel on printed fabric plaster cast, 175.3x231cm (painting), 45.7x45.7cm (plaster cast), installation size variable

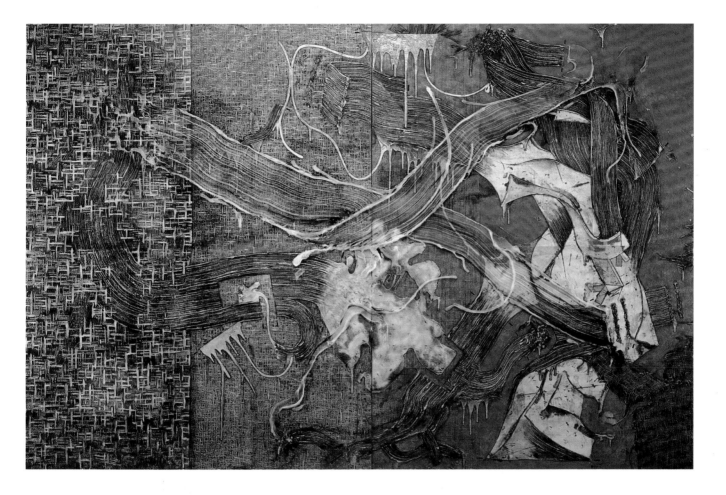

Fabian Marcaccio, Between Titles, *1993-94, oil, silicone gel on printed fabric, two panels: 199.4x310cm (160x199.4cm and 150x199.4cm)*

THÉRÈSE OULTON
Notes on Painting, 1994

Form

The union of something material with something not, therefore concretion, pertains to two impossibles: the abstract and subjectivity.

The notion of subjectivity includes emotions, fears, desires, no less than the political.

The notion of the abstract is idea not divorced from form.

Form is an imprint of those two impossibles: the abstract and subjectivity (ie the idea and the necessity towards that idea).

The 'subject matter', for want of a better term, of my painting, is incurred by the above.

The process is one of concretion; of something there, of nothing there, painting itself – of knowing, doubting that, not knowing.

Recognition and Memory

In my painting though the recognisable has become far distanced from the describable, it has never become totally separable.

The increasing frailty of reference, the more tenuous those links, the more that becomes the subject matter itself.

Reverberations, the chaos of multiplying associations (conscious and unconscious), memories of an already-known, especially an already-painted, the traces of a describable, all conspire towards the instability of what is assumed to be perceived. Memory thus not as a pleasant reverie but as anarchic.

Repetition

In an unstable creation where fugitive chains of associations undermine a hold on perception, repetitions of all kinds are a provisional order.

Interruptions, shifts and collapsings of endless recurrence move considerations from the spatial to an unfolding of time.

Repetition is itself a metaphor since nothing can be repeated. Something is always a surrogate for something else.

Temporally speaking actions extend backwards in memory and forwards In expectation. They can never coincide.

So repetition automatically engages with duration, and more particularly duration attended to

– time that makes itself not invisible. Time structures via repetition in a 1 plus 1 plus 1 sense, a molecular sense; hence its form-making capacity.

Repetition's simultaneous capacity to order and disorder, neither less anarchic, its attendant meanings no less so.

The painting is structured in a 1 plus 1 molecular way but a form, ie that which is differentiated knows where to stop. Some other process or event limits or changes that multiplication, be it line, tone, colour, texture, chemical action, physical property, and so on. It differentiates the undifferentiated or decomposes that form, that limit.

Scale

Means to undermine a sure sense of self or to offer other possibilities of self, fragile, expanded, whatever, involve scale and its dislocation, even simultaneously intimacy and distance.

Temporalities and scale converge in the telescoping of intimate minutiae and indifferent expansions.

Neither one the end purpose of the other, the 'ends' of the opposing processes, the gigantic expanding, the minute contracting, encompassing condensed records of their continuing flux, instability.

Manifest reference via cellular repetition is to the organic no less than to the inorganic.

Tissue, muscle, blood and bone insinuate themselves alongside the vaster time scales of the stony and crystalline.

'Disruptions' across the surface recording patching, staining, shadowing, shrivelling, eroding – this registered duration composes or individuates each picture.

Cause and Effect

Residues of past disturbances forever bear their trace. Present and potential events register cause, effecting new causal repercussions. As imprints of an event, representations present evidence of time and contingencies to come. Light and shadow change form, chemical interactions corrode, etc, but there is no possibility of unravelling such chains of complexity. The interchangeability of cause and effect – the indecipherable – produces acute anxiety, haunts the work. This failure to mediate meaning induces deep insecurities as to the attaining of significance.

ABOVE: Abstract with Memories No 1, *1991, oil on canvas, 185x274.5cm; BELOW:* Abstract with Memories No 2, *1991,*
oil on canvas, 185x274.5cm

ABOVE: Abstract with Memories No 3, *1991, oil on canvas, 185x274.5cm; BELOW:* Abstract with Memories No 4, *1991, oil on canvas, 185x274.5cm*

POLLY APFELBAUM
Varieties of Abstraction: A Partial Taxonomy

The dominant discourses of abstraction have posed two distinct but related trajectories: On the one hand, towards the self-sufficiency of the material support and the autonomy of painting as a discipline (Greenberg); on the other hand, a tectonic essentialism, grounded in phenomenology (minimalism). While in some sense enabling, each of these positions tends towards a teleological end point, and can only serve to close down the possibilities open to an artist today. Faced, then, with what seem to me two unacceptable alternatives, I choose not to choose. These are hybrid works, poised between painting and sculpture; works not so much attempting to invent new categories but working promiscuously and improperly poaching – in fields seemingly already well defined.

This is as much a way of describing work that interests me as the work I do. I have always been interested in those practices which do not fit comfortably within defined disciplinary limits. However, this should not be interpreted to mean that I am in any way interested in the 'critique of institutions'. It is of course impossible not to feel the weight of those institutional limits, but rather than simply react against them, buying into the model of art as critique, reiterating the limit in another form (as an absolute definition of content), I chose to maintain, as much as possible, an indifference to those limits – which is in itself probably necessary in order to work close to them, in and around them. Within this fluid territory I am interested in momentary stabilisations, in the effort 'to fix the proposition, to immobilise it just long enough to extract from it its sense – the thin film at the limit of things and words'. (Gilles Deleuze, The Logic of Sense*)*

I propose a partial taxonomy of the forms the work takes – the concepts which might give them a momentary sense. Much of this is the report of what others have said: hearsay. Concepts neither precede nor follow the work, but nevertheless slip in, out, and through the work. The source is unimportant. The list is necessarily incomplete. I want to multiply categories, not diminish them.

Flows

The materials I work with – both support and surface – are incapable of standing on their own. Instead they flow, taking on the shape of the container or whatever else is in close proximity. Much of the work consists in directing that flow, organising and looking for new organisations in the liquid movements of fabric and stain:

'. . . continuous, compressible, dilatable, viscous, conductible, diffusible . . . That it is unending, potent and impotent owing to its resistance to the countable; that it enjoys and suffers from a greater sensitivity to pressure . . . determined by friction between two infinitely neighbouring entities – dynamics of the near and not the proper . . . that it mixes with bodies of a like state, sometimes dilutes itself in them in an almost homogeneous manner which make the distinction between one and the other problematical.' (Luce Irigaray, 'The "Mechanics" of Fluids')

Spots

The marks made on the surfaces do not designate anything, or represent anything; not brush strokes (an extension of the hand) but daubs or drops, or sprays, they are intentionally neutral, discrete. Yet they are made in the confidence that in combination, and in the uncontrolled effects of the process, an abstract signification appears:

'Even when painting becomes abstract, all it does is rediscover the black hole and white wall, the great composition of the white canvas and black slash. Tearing but also stretching the canvas along an axis of escape, at a vanishing point, along a diagonal, by a knife slash, or hole: the machine is already in place that always functions to produce faces and landscapes, however abstract.' (Gilles Deleuze and Félix Guattari, 'Year Zero: Faciality')

Heaps

This is critic Catherine Liu writing about David's 'Oath of the Horatii':

'What this painting does is produce two contingent and radically incommunicable spaces: the space in which the father offers the swords to his sons and the space in which the women are collapsed in a heap of draped cloth against the wall.'

The work is structured not around a simple opposition of supple and erect, but instead provokes questions about the structurality of the unstructured itself.

Fields

'My friend André Masson and I are soaring through the air like gymnasiarchs. A voice calls up to us: "World class acrobats, when are the two of you finally going to come down to earth?" At these words we execute a flip over the horizon and drop into a concave hemisphere.' (A dream recorded by Michel Leiris in Days and Nights*)*

The complex variety of architectural spaces – gallery, museum – are conceived as a field to be activated in new ways. Not site specificity, which implies confrontation (and because the same piece is installed in several spaces) but an escape, a flight from the specificity of the site.

'Emily Dickinson said: "Nature is a haunted house. Art is a house that tries to be haunted."' (Elaine de Kooning, '5 Participants in a Hearsay Panel')

Patchwork

'Patchwork for its part, may display equivalents to themes, symmetries, and resonance that approximate it to embroidery. But the fact remains that its space is not at all constituted in the same way: there is no centre; its basic motif ('block') is composed of a single element; the recurrence of this element frees uniquely rhythmic values distinct from the harmonies of embroidery (in particular, in "crazy" patchwork, which fits together pieces of varying size, shape, and colour and plays on the texture of the fabric).' (Gilles Deleuze and Félix Guattari, 'The Smooth and the Striated')

Seriality and repetition can signify mechanical standardisation, or more recently digital technology, but they can also signify, as is the case in my work, rote and routine, a certain rhythm of working, related to domestic work and folk arts.

Pointillisms

Repeated, singular marks of unmixed colours set up vibrant exchanges across the empty space of the unmarked fabrics. Recently the affinity with pointillism has been pointed out to me:

'The work process allies itself with a bombardment of discrete unities distributed in layers that articulate themselves on the one or more layers already laid down. It is because texture is constituted by "relatively homogeneous" distinct elements that the work appears to us as an ordered superimposition of layers. The pigmentary mass "unfolds" itself in a certain number of imbricated strata that, between them, offer sufficient similitude to form a system.' (Jean Clay, 'Pollock, Mondrian, Seurat: la profondeur plate')

Wrinkles

'What is the water in a lake? A blank page.

The ripples are its wrinkles. And every one is a wound.

"A lake without ripples is a mirror. A wrinkled lake is a face."'

By this I mean to suggest that the pleats in my work are not so much a Baroque 'folding to infinity' but something more diminutive, more personal, less ordered, but also more provisional, more fragile.

'The wrinkles of the innocent are ripples a breeze sketches and undoes as it subsides.

Wonder is a twinkle of the skin.

God is in the slightest shiver.'

(Edmond Jabès, The Book of Questions*)*

ABOVE: Fine Flowers in the Valley, *1992, dye, sheeting, velvet, dimensions variable; BELOW:* Pink Dalmations, *1992, crushed velvet, dye, cardboard, eight elements of 68.6x39.4x8.9cm each*

Lydia Dona
Reluctance, Ambivalence And The Infra-Language

The Self of painting today, just as other modes of articulation, phases from logic to poesie and back, and finds itself in the most complex time and space for semantic redefinition and re-evaluation. It conditions itself critically with pairs of cancelling metaphors.

The collapse of categories of the high paradigmatic structures of Modernism, self-referentiality, homogeneity, surface and facture and the modalities of heroic scale/gesture, are replaced by what I refer to as the 'virus of excess'.

As the social apparatus finds itself in a broken zone, so does the trajectory of the body, the hierarchy of signs, and all the familiarities become fragmented. Knowledge, Information, Representations and Geometries find themselves in a totality of fragmentation and displacements. The term 'ambivalence', as defined by Julia Kristeva, implies the insertion of history and the social into a text, and of this text into history; for the writer, they are the same. Displacements and condensation are connected to the fissure of discourse between the topologies of discourse and its inner voids, Death and Desire.

It is in the need of regeneration within excess, placed on the margins and the edges of the map and topography, that the questions of painting now begin for me. In my work, the apparatus of the breakdown, sign systems open up to leaks and ruptures, generative liquids for the gaze of re-definition. This crossroad of labyrinthine entanglement of techno-bio-reality is where my interest is. It is in the entrance into the skin of the sign systems, where all of them gaze out into the void, where the margins leave an empty centre, where no limits operate and where painting is a ghost seeking its own shadow for its referents. My usage of machinery is a theme of an abstract machine, a cipher, a technological machine, the Duchampian machine, a desiring machine, or sign systems oppressing discourse. It is a machine where abstraction first used to examine systems of production, then moved into appropriation and reproduction of itself, and then is fragmented into a representation of its abstraction.

It is the machine of the void, and the formal eliminating its authoritarian hierarchy, letting multiplicities enter from another locus and models. This allows another consciousness to re-define, from the borders, the semiotic and the symbolic for the tissue of techno-environment.

I am starting the painting on top of a painted acrylic dry blank plane, on top of which a pencilled grid is drawn, then gets sectioned and divided. I use parts of oil paint where the image derived from car manuals and diagrams of car repairs operating as a ready-made, graphic or photographic, is brought back into a metaphor of man-made image/hand-made image. The

machinery or the diagrams are painted or drawn with the loaded information/sign/operation. The sign/enamel high gloss paint is dripped as the painting is on the wall, not on the floor (ie the 'natural' expectation of 'how it is dripped' is negated). It is the opposite sign of the Gestural Pollock drip. It is the wrist motion letting the paint drip as body fluids or equivalents of the oil in the engine of a machine. It is the drip marking its liquid, invading and excessively marking in itself, mimicking its dysfunction, marking a superimposition through the margins and the divisions. It is the drip detached and disembodied. It becomes another gaze, self-reflective, reflexive and decentred.

In the deterritorialisation of the flood, where liquidity is an index for the subversion of the primary father's drip, we can refuel emptiness with other contents of spectation and articulation.

It is in the speech of absorption, where the world is losing and gaining, in the desire to open the clogged chunkiness of the modern surface, and in the anxieties that language brings with its split identities and the polyvocal schizophrenic models.

Is abstraction a thought, an illusion, a philosophical bridge? It seems still the question, a question which is never going to be of its own on its own, rather relocated within other disciplines. Therefore, I am not interested in the either/or, I am interested in finding out where is the third zone, where the labyrinth is accelerated and the states of in-between are states of unconsciousness, criticality, difference and rupture.

Infra-Circuit And The Abstract Voyages Of The Polyvocal, *1994, oil, acrylic, signpaint on canvas, 122x122cm*

Motors Of Desire And The Flow Of Peripheries, *1994, oil, acrylic, signpaint on canvas, 122x122cm*

LYDIA DONA

Speed And Displacement, And Horizontal Becoming Of Conditionality

In the preceding text (written 1992), I pointed out Difference, Desire, Rupture, Heterogeneity and Criticality. I might add in this new text another tonality – Paradox and Speed, Becoming and Horizontality. Conditional, as a conduit for options rather than solutions, therefore, taking the risk that the collapse will reoccur all over, again and again, refuelling rather than filling itself. In The Logic of Sense *Gilles Deleuze writes in referring to the Stoics:*

'Mixtures are in bodies, and in the depth of bodies, a body penetrates another and coexists with it in all of its parts, like a drop of wine in the ocean, or fire in iron. One body withdraws from another, like liquid from a vase. Mixtures in general determine the quantitative and qualitative states of affairs; the dimensions of an ensemble – the red of iron, the green of a tree.'

But what we mean by 'to grow' 'to diminish' 'to become red' 'to become green' 'to cut' and 'to be cut' etc, is something entirely different. These are no longer states of affairs – mixtures deep inside bodies – but incorporeal events at the surface, which are the result of these mixtures. As he points out, the Stoics are in the process of tracing out and forming a frontier where there had not been one before. In that sense events decentre the subject and displace reflection.

In these lines Deleuze addresses the focal point of the infinite identity of becoming and the whole question of loss of fixed meaning operating within the fixed and the possibilities of transformation and expansion, within the subject, shrinking and expanding simultaneously. Conditionally means: undoing the conditions, shrinking, collapsing, condensing, displacing, liquidating, cutting and making infinite options within. One of the most paradoxical things to look at is a painting where its topography and its topology are also its surfaces; its shine is also its vanishing allusiveness of diffusion; and its borders are the largeness of its matters. Where it stares at you, when your body and its body dissolve their connected fusion, and their fragmentation accelerates into speed. It is not what it is, it is its attempt to become. And in the question of becoming, it re-entered the terrain of painting discourse, its permanent exit. What a deadly serious way to agglomerate and interconnect circuits of empty sublime, with terminal sublimation. Its polyvocal, shifting, sliding, folding, and constantly moving between Desire and Counter-Desire.

My work desires entrances into the fabric of stasis, where loss begins and margins end, and excess or void triangulate as well as schizopolarise. Its seduction or beauty, or attraction repulsion, become cosmetic and cosmic, allowed and forbidden both at the same attempted gaze. It asks viewers to accept their own nervousness of eliminating the first gaze as an answer.

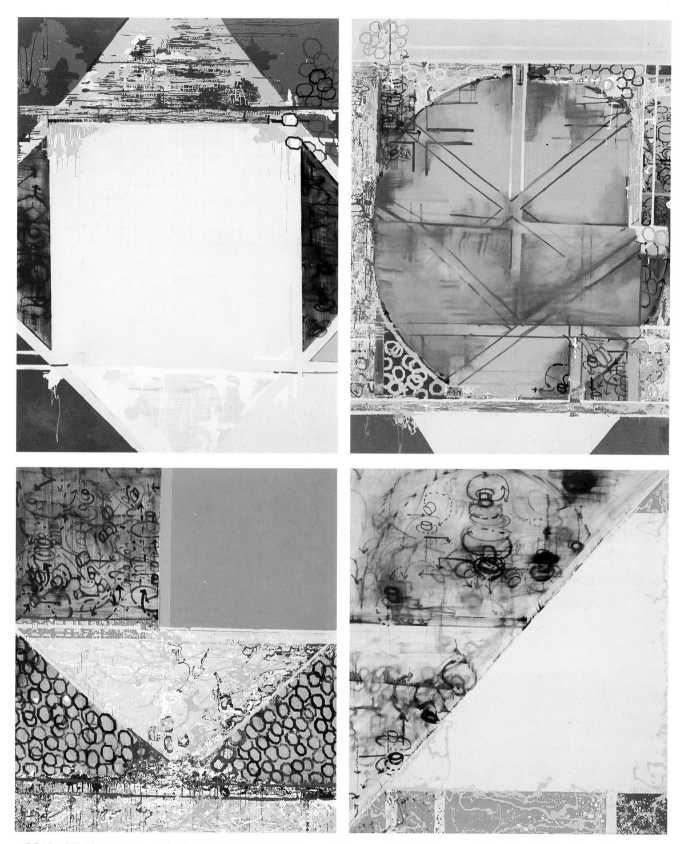

ABOVE, LEFT TO RIGHT: Fear Of Falling Into The Lack, The Dream Of Language And The Ruptures Of The Flood, *1991, oil, acrylic, signpaint on canvas, 213.4x162.6cm;* Machinery Of Ambiguity And The Traces Of Polyvocality, *1993, oil, acrylic, signpaint on canvas, 213.4x162.6cm;*
BELOW, LEFT TO RIGHT: Passwords And Intervals And The Repetition Of Difference, *1994, oil, acrylic, signpaint on canvas, 167.6x152.4cm;*
Nomadic Velocities And The Discourse Of The Broken Zones, *1993, oil, acrylic, signpaint on canvas, 167.6x152.4cm*

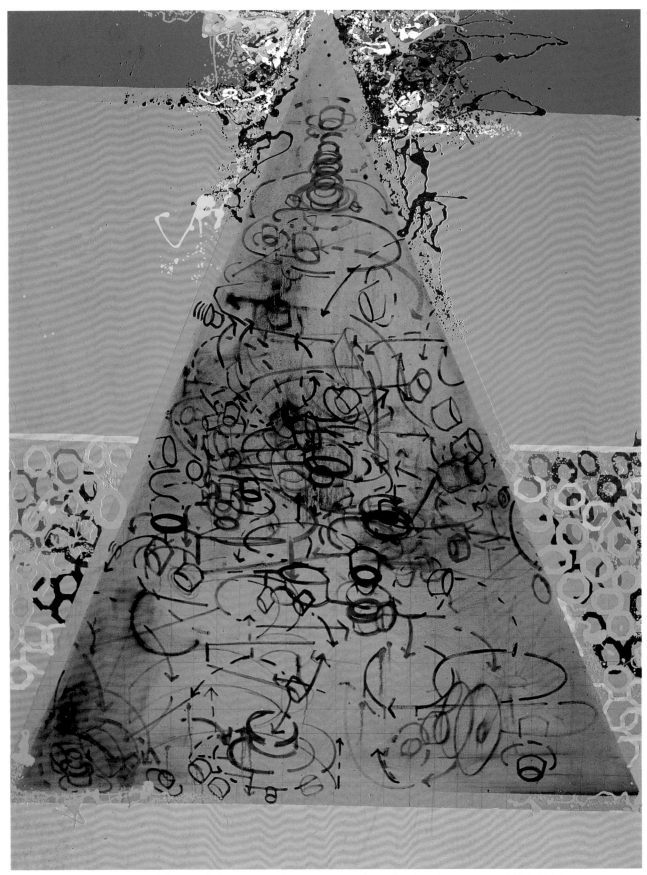

Pyramids Of Breakdown And The Tears For Cleopatra, *1994, oil, acrylic, signpaint on canvas, 213.6x162.6cm*